THE TIMES

A CENTURY IN PHOTOGRAPHS

GARDENING

THE TIMES

A CENTURY IN PHOTOGRAPHS

GARDENING

MARK GRIFFITHS

THE ROYAL HORTICULTURAL SOCIETY

TIMES BOOKS

Layout design
Anita Ruddell
Index
Susan Bosanko

First published in 2000 by
Times Books
HarperCollins*Publishers*
77-85 Fulham Palace Road
London W6 8JB

ISBN 0 00 710409 X

British Library Cataloguing in Publication
Data: A catalogue record for this book is
available from the British Library

Printed and bound in Great Britain
by Bath Press Colourbooks, Glasgow

Acknowlegements
The author and publishers are grateful to the
following people and organizations for their
help in the compilation of this book:

Yoko Boutcher
Camilla Costello
Country Life Picture Library
Mishu Dimitrov
Gina Douglas
Dr Brent Elliott
The Revd Dr Timothy Gaden
Elizabeth Griffiths
Ian Harrison
The Hulton Getty Picture Library
The Linnean Society of London
Susanne Mitchell
The Museum of Garden History
Dr Henry Oakeley
Mikinori Ogisu
Alison Rogers
The Royal Botanic Gardens, Kew
The Royal Horticultural Society
Camilla and Nigel Speight
The Times Picture Library
Rosemary Verey
Jennifer Vine
Marilyn Ward
Michael and Jean Weston
Karen Wilson

Foreword

Gardening has become one of our top leisure pursuits, and in *A Century in Photographs: Gardening*, Mark Griffiths combines photographs and text to stir our memories of its progression through the last 100 years. His words and pictures remind us of the great gardens where, at the beginning of the century, the head gardener ruled his turf, and the lady of the house acquiesced. Today it is the garden owners – distinguished gardeners such as Lady Salisbury, Beth Chatto, The Duchess of Devonshire, and Christopher Loyd – who make the decisions.

Throughout the century great gardening characters have emerged – the likes of William Robinson, Gertrude Jekyll and Miss Willmott, and, later, Vita Sackville-West, Russell Page, and Geoffrey Jellicoe, all of whom influenced us with design and colour. Major influences in the latter part of the century included Beth Chatto's garden and Christopher Lloyd's at Great Dixter, garden designs by Penelope Hobhouse and John Brooks, and newspaper articles by Robin Lane Fox.

During the Second World War we were encouraged to 'Dig for Victory'; now, home-grown and organically grown fruit and vegetables are an increasingly important defence against the harmful effects of pesticides; no longer do we use DDT. Other crises such as Elm disease in 1969, the great storms of 1987 and 1990, and the effects of drought, soon made us reevaluate our notions of practical gardening. All are portrayed in these pages.

Today, television brings both established and instant gardens into our homes but, as balance, the Garden History Society and the Museum of Garden History are important institutions which remind us that not everything is 'instant', and for this we must be thankful.

More and more is written in books and magazines on how to garden, but little has fundamentally changed: while we use the same tools, we gratefully accept the mechanization; we follow many of the same principles as the 17th-century gardeners, but we still wonder: 'Where will the 21st century take us?' What we should not lose sight of, however, is that gardens are for plants.

Rosemary Verey

Introduction

MARK GRIFFITHS

A Century in Photographs: Gardening takes the garden path from the Edwardian era through a series of horticultural revolutions sparked by war, the arts, technology, politics, media, the environment, fashion and an ever-expanding range of plants. In presenting 100 years of garden photo-journalism, it unearths some of the relics and outlines of garden history. It is equally social history of sorts glimpsed through a narrow but revealing lens – the story of a fast-changing society perennially engaged in a common passion, no matter what the circumstances, times or means.

Pictured here are stately acres, dizzying roof gardens, ground-breaking designs, pocket paradises nested in the heart of the city, market gardens, glasshouses and botanic gardens. Floral fancies abound, from the exotic orchid to the English rose by way of hostile cacti and tempting fruit, lilliputian alpines and gargantuan pumpkins. Gardens appear throughout, be they exercises in pure aesthetics or vital resources, as in the Second World War, when every spare yard of soil was devoted to vegetable production. The book's cast includes plant hunters, nurserymen, designers, patrons and botanists, queens and flower girls, barracked ministers and picketing gnomes. The book's brightest stars, the gardeners themselves, appear at work on allotments, competing at flower shows, sweltering under glass, waist-deep in lily ponds, perched in the crowns of trees, pruning, planting, grafting, digging.

A Century of Photographs: Gardening, then, is primarily a celebration of an activity that has always been at the root of civilization but which, over the last 100 years, has come to cross all social boundaries and please all tastes. Since the book presents only one or two pictures per year, this can hardly claim to be a comprehensive commentary on a century of gardening. It is more akin to a transect, running through the years and touching on fashions and themes that show the evolution of gardening over time.

Perhaps the most obvious theme is the democratization of the garden. The century opens with the end of an era of great estates, hothouses and armies of garden staff, much of which was swept away by the Great War. There can be few images so poignant as the portraits of gardeners at Heligan, newly volunteered and kitted-out, all of whom would be killed within months of reaching the Front. In 1920, the Duke of Devonshire, despairing at the condition into which his collection had fallen during the war years, blew up Chatsworth's Great Stove, a glasshouse which had inspired and epitomized a passion among the aristocracy of the previous century for growing exotic plants. Few gestures could be more final; but it was not the end for exotica. One of Chatsworth's specialities was orchids, and the tale of these plants over the century is typical of the development of horticulture as a whole: a progression from rich man's fancy to mass hobby, cut flower and houseplant made available through technical advances and promoted to an ever-growing, ever-more confident public by media, garden centres and flower shows. Not all examples of popularization were so blessed. It is extraordinary to think that the garden gnome, that outcast from the Chelsea Flower Show and most damning of social indicators, first entered British gardens early in the century as a highly prized connoisseur's *objet*. One social indicator of an altogether more positive type is the growth in the membership of the Royal Horticultural Society, which has risen from 4,750 in 1900 to 280,000 in 2000. As the Society approaches its 200th anniversary, interest in gardening, like its membership, shows no sign of waning.

While gardening became the people's pastime during the last century, it was also the case that gardens that could be described as 'great' – whether in terms of their size, status or the resources behind them – continued to be made. Bodnant, Hidcote and Sissinghurst are examples of 20th-century horticultural masterpieces created through the vision and patronage

of individuals. It is significant that all three soon opened their gates to the public and have continued to prosper since through the agency of the National Trust. For many they represent pinnacles of 20th-century horticultural achievement, but the garden was equally susceptible to more radical interpretations. Cubism, High Modernism, even Chaos Theory, are just some of the movements and philosophies to have moulded this most plastic of art forms in the last century, as did influences from China, Japan and North America. The glasshouse is an emblem of the creative dynamism of 20th-century gardening. Chatsworth's Great Stove has not only risen phoenix-like but evolved beyond recognition in the St Louis Climatron, Kew's Princess of Wales Conservatory, and, only this year, in the Xanadu-like carapace of the Great Glasshouse at the National Botanic Garden of Wales.

It was also the century in which gardeners became aware of the history underpinning their art. New gardens were made that revived or reinterpreted the styles of previous centuries. Existing gardens came to be seen as precious elements of our heritage and were preserved or restored. Great gardens like Heligan, which had reached both zenith and nadir within two decades of the century's start, had been returned to glory by its finish. In the closing decades of the century, the subject of garden history gained a society of its own and a museum in Lambeth, London. Not far away, at Battersea Parish Church, the London gardener William Curtis was chosen to stand alongside J.M.W. Turner and William Blake in a series of commemorative windows. The gardener had arrived as a figure of cultural as well as horticultural importance.

Many of the most innovative and influential figures in 20th-century garden-making were women. Gertrude Jekyll, Vita Sackville-West and Rosemary Verey represent the finest flowering of generations of women designers who changed the shape of British gardens. What grew in our gardens was transformed by the experimentation and taste of plantswomen like Ellen Willmott and Beth Chatto. As a craft, horticulture had been welcoming women at institutions like Kew since the beginning of the century. As a women's *profession*, horticulture would become established through the efforts of pioneering educationalists like Beatrix Havergal. It was on the Home Front, however, that women gardeners made what was arguably their greatest contribution as they took responsibility for the wartime production of food. It was a women's century in the garden as elsewhere.

The most far-reaching horticultural revolution that the century witnessed may prove to have been the 'greening' of gardens. By the 1960s and 1970s, a gradual accretion of technological advances had changed the way we gardened. Herbicides and pesticides were used with abandon. Many horticultural operations had become mechanized or automated. Soil-based potting mixes, traditional mulches and soil ameliorants were supplanted by soilless composts, inert media and the ubiquitous peat. Synthetic plant foods replaced organic manures. Among the plants we grew, many older varieties and species fell from favour with the rise of new hybrids and cultivars. In short, gardening had become the victim of its own success. The closing decades of the century saw a drive to reverse these examples of 'progress' as fears grew for the health of gardeners, gardens and the world beyond them.

Horticultural chemicals were used more sparingly, if at all. Older methods of cultivation were revived. The compost heap was once more *de rigueur*. It was judged better to leave peat in the bog where it belonged. Prompted by a perceived shift in the climate and a rash of hosepipe bans, we used water more sparingly and experimented with drought-proof plants. We began to talk of organic methods, of garden ecology, of gardening for wildlife, and of growing native plant species. Gardening became a force for conservation. Organizations like the National Council for the Conservation of Plants and Gardens sought to preserve our heritage of garden plants. We scrupled over growing plants collected from the wild. Botanic gardens took up the task of propagating endangered species. In the last two decades of the century, the garden as therapy was reaching ever-greater numbers of people. Urban greening programmes were instituted; parks and floral decoration enjoyed a revival; garden activists like New York's Green Guerrillas made gardens in even the most horticulturally improbable places.

The garden had become both model and medium for our husbandry of the wider environment – yet another role for an activity which would triumph at the century's end as the most protean, and popular, pastime of all.

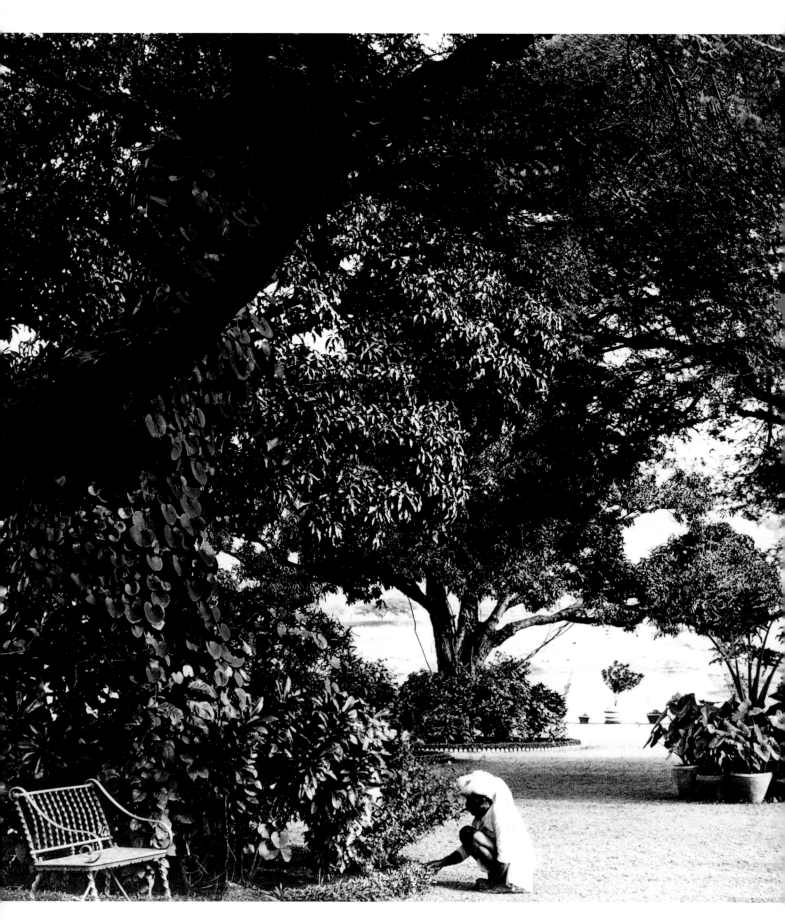

Gardens of Empire

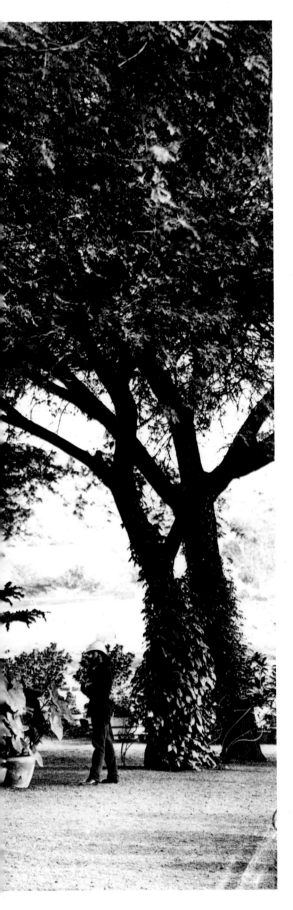

In 1900 this Indian garden featured native Asian plants grown in combination with introductions from Africa and South America. A typical garden of Empire, it possesses an exotic luxuriance which British gardeners were eager to recreate at home. Indeed, many of the plants growing here already featured in British conservatories and one or two have long since become best-selling houseplants. Fig trees support climbers like *Aristolochia* and *Clerodendrum*. Around their trunks stand thickets of *Dracaena reflexa*, a variegated foliage shrub originally from Madagascar and Mauritius but given, appropriately enough for this photograph, the popular name Song of India. Giant aroids are corralled in terracotta urns: a noble specimen of the Brazilian *Philodendron bipinnatifidum* is surrounded by *Colocasia* and inky purple *Xanthosoma*.

European colonization did much to shape tropical gardening as we know it. The earliest horticultural outposts of Empire were the first generation of tropical botanic gardens – Pamplemousses in Mauritius and St Vincent in the West Indies, both in 1735; Calcutta in 1787; Rio de Janeiro in 1808; Bogor in Java in 1817; Peradeniya, Sri Lanka in 1821 and Singapore in 1859. Although they were established to grow new crops and test the economic potential of native plants for the colonizing powers, these gardens soon became clearing houses for species of ornamental value.

A literature sprang up toward the end of the 19th century intended to instruct the gardeners of the Raj. The most successful example of it was *Gardening in India* which had broadened to become *Gardening in the Tropics* by the time its sixth edition was published in 1910. The author G. Marshall Woodrow, sometime Professor of Botany at Poona, addressed himself 'to the cultured races within the influence of the monsoons': 'Intense cultivation of the soil, or gardening, has special attractions in hot climates from the rapidity of growth and early fecundity of garden crops. To plant banana offsets and reap a glorious bunch of fruit within the year; to sow gourds or vegetables, and within eight weeks have the produce on the table, is an experience that familiarity cannot rob of its charm; and in almost every sense...the tropical garden abundantly repays the labour, whether pleasure or profit be the object sought.'

Also this year...

Irish physician, plant collector, arboriculturist and author Augustine Henry (b.1857) returns from China. In 18 years of plant hunting he had sent over 150,000 specimens back to Kew and had discovered many new species including Acer henryi, Lilium henryi, Parthenocissus henryana, Rhododendron augustinii *and* Tilia henryana

Some 264 varieties of sweetpea are shown at the Bi-Centenary Sweet Pea Exhibition staged to commemorate Uvedale's raising of the first plants of Lathyrus odoratus *sent to him by the Sicilian monk Cupani in 1699*

12 June, 3-inch-diameter hailstones destroy glasshouses and crops in Abingdon, Oxfordshire

Garden designer Thomas Mawson publishes The Art and Craft of Garden Making

Birth of landscape architect Geoffrey Jellicoe

Conservatories

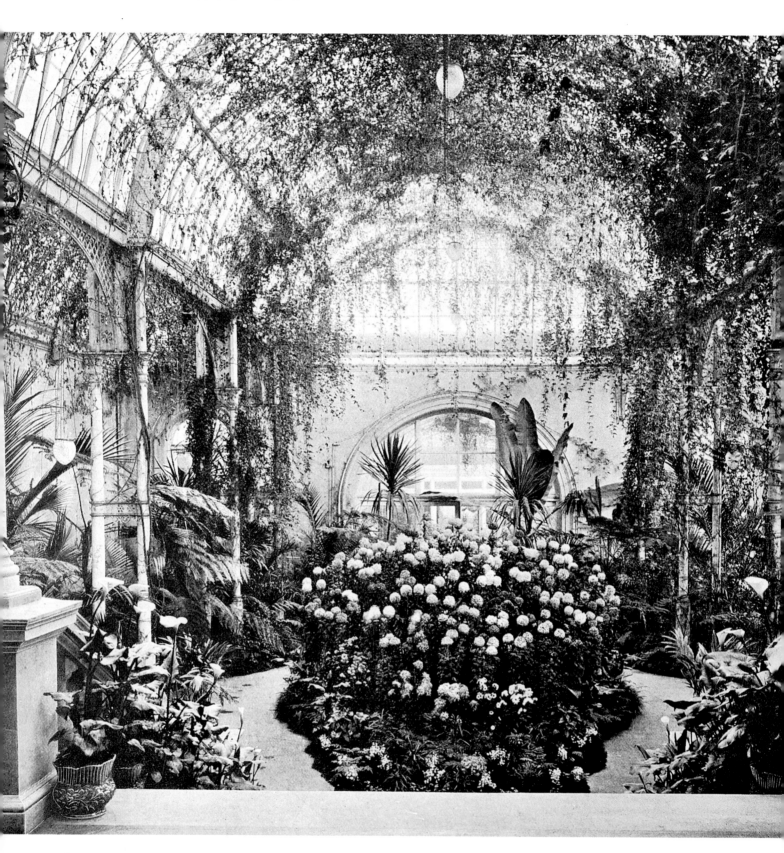

At either end of the century, the conservatory enjoyed enormous popularity. In the 1980s and 1990s planning permissions were granted in the tens of thousands for these structures which had become the most frequent form of house extension. In the opening years of the century, however, they were altogether grander affairs.

The conservatory (left) – or winter garden – at Eastwell Park, near Ashford in Kent, is a fine but fairly typical example of the genre as it was enjoyed by Victorian and Edwardian aristocrats and pluto-crats. Built for Lord Gerard, it was permanently planted with climbers like *Passiflora mollissima* and *Rosa banksiae*. Architectural foliage was provided by palms, Norfolk Island pine (*Araucaria heterophylla*), and bananas. In the foreground is a display of chrysanthemums and calla lilies (*Zantedeschia*) – an autumnal arrangement made by Gerard's gardener (who typically does not merit a credit in *The Gardener's Chronicle* where this conservatory was first described) to mark a visit from HRH The Duke of Cambridge. Such displays would have been replaced each season with short-lived flowering plants grown on in the estate's glasshouses.

As is true today, there was confusion in 1901 as to whether a conservatory was a special place devoted to gardening, or merely another room, which happened to be brighter and be decorated with ill-fated plants. *The Gardener's Chronicle* commented, 'unlike too many such plant houses intended more for exhibiting plants than for cultivating them, [Eastwell Park conserva-tory] is provided with an abundance of light without which few species can be kept for any length of time in perfect health'.

If the great house was extending itself into the garden at Eastwell Park, then at Deepdene near Dorking, the garden, or indeed, the Tropics, was infiltrating the home. The entrance hall (below) of Deepdene, the country residence of Lily, Duchess of Marlborough, and Lord William Beresford, was transformed with colonial gleanings – hunting tro-phies, assegais, tiger skins and sjamboks – from Palladian refinement to oppressive exoticism. The most obvious contribution to this very Victorian metamorphosis came from Deepdene's soaring 'houseplants'. The signature plants of the era, palms brought the Empire home to mansion and saloon bar alike.

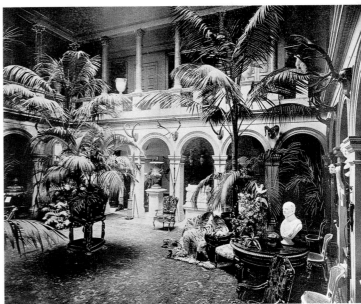

Also this year...

Introduction of Rose 'Roseraie de l'Hay', a hybrid of R. rugosa *with large, rich crimson-purple flowers with cream stamens and a heavy perfume*

US plant collector David Fairchild (b.1869) travels the Far East, Middle East, Europe and North Africa on behalf of the newly created seed and plant introduction section of the US Department of Agriculture. He sends back, inter alia, *water chestnuts, grapes, pistachios, the blood orange, hops, cobnuts and almonds*

The National Sweet Pea Society is founded

William Bateson's translation of Mendel's paper on heredity is published in the RHS Journal

Birth of British landscape architect and planner Dame Sylvia Crowe

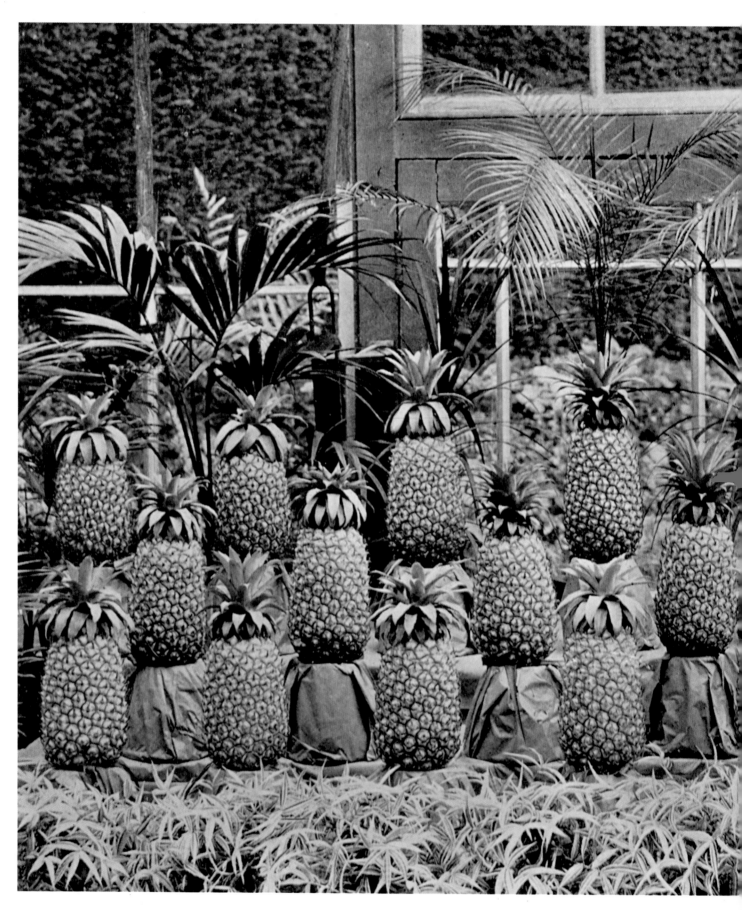

The Queen of fruits

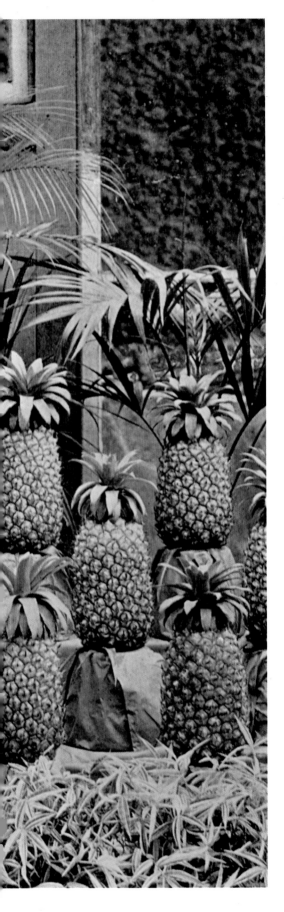

Ever since it first arrived on British soil in the 1690s, the pineapple had been 'the Queen of Fruits', highly prized, excitingly 'alien' and reputedly difficult to grow. By 1902 our domestic pineapple production, which had previously achieved surprising volume in the glasshouses of the great, had begun to fall off. *The Gardener's Chronicle* remarked: 'The pineapple has to a considerable degree lost the high position that it formerly held amongst British-grown fruits; this has resulted from a combination of circumstances, but chiefly through the importation of fruits from abroad having brought it within reach of the masses, and thus made it comparatively common.'

For all their new-found mass appeal, these imported fruits were – the *Chronicle* assures us – greatly inferior to the elite home-grown crop. Thomas Coomber, gardener at the Hendre, Monmouth, was responsible for the striking produce shown here. They were grown in four low-ceilinged glasshouses heated by steam-filled pipes. The pineapples were planted in loam that had been cut in thin turves and stacked for six months 'before being roughly torn apart, and mixed with a 7-inch potful of dry soot and bone meal to an ordinary wheelbarrow full of soil'. The pots were plunged in beds of leaf mould. Mr Coomber set great store by 'ramming' both his potting compost and plunge medium to a concrete firmness. Humidity had to be high, as did light levels. Watering was sparing unless the plants were growing freely or their fruits were swelling, when 'water may be more liberally afforded, and also aids to growth in the form of moderately weak liquid manures, as that made from sheep's droppings, or by mixing water with Peruvian Guano'.

For Coomber one of the most critical factors was the temperature of the plunge bed which had to be 10 or 15 degrees higher than that of the glasshouse atmosphere – in late autumn, something like 80 degrees Fahrenheit. His cultivation regime amounted to constant surveillance and activity. It is little wonder that pineapples imported from countries where little or no such attention was needed should have supplanted the grossly expensive and finicky home-grown equivalent. The Queen of Fruits was bumped from stately home to canning factory in the space of a decade.

Also this year...

Frances, Viscountess Wolseley's Glynde School for Lady Gardeners is founded, with Theresa Earle, Gertrude Jekyll and Ellen Willmott as patrons

Birth of Mexican landscape architect Luis Barragan, whose fusion of austere modernism, native styles and the Islamic garden would inspire a generation of designers

Birth of US landscape architect Thomas Church

Birth of garden writer Arthur Hellyer

Death of British nurseryman William Bull (b.1828). He was responsible for popularizing such Victorian staples as the Japanese spotted laurel, Aucuba. Later he specialized in orchids, sponsoring expeditions to South America

Death of French garden designer Henri Duchêne (b.1841) who, with his son Achille, restored some of France's great 17th-century formal gardens

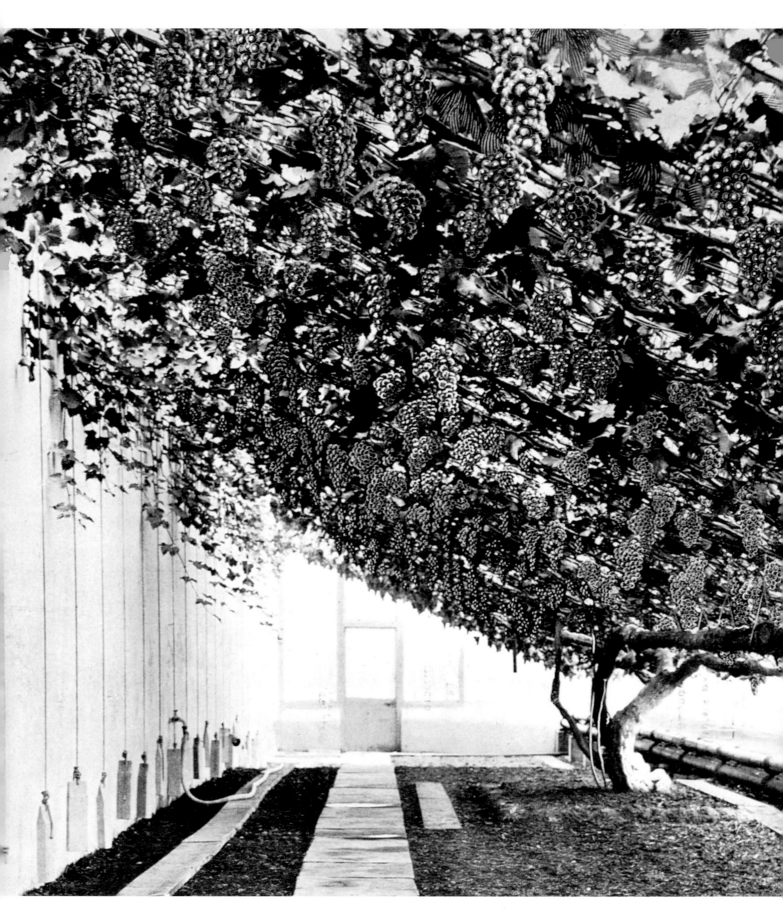

Prodigious plants

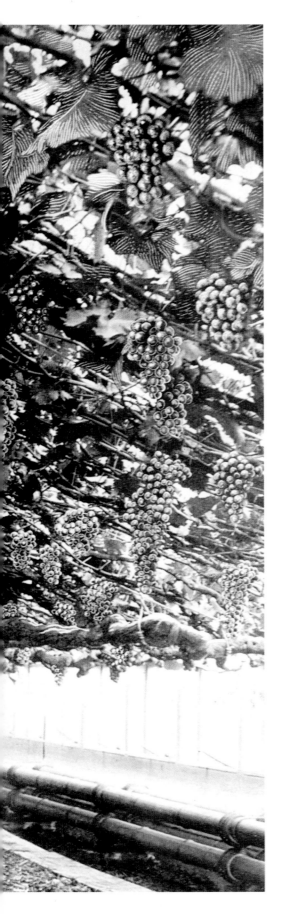

At Cumberland Lodge, in Windsor Great Park, this 125-year-old vine made an astonishing recovery from senility. It had been propagated from the Black Hamburgh vine planted by 'Capability' Brown at Hampton Court Palace, and was possibly the largest grape vine in the land, covering a roof area of over 2,800 square feet and outstripping even its famous parent in productivity. Whereas the Hampton Court vine sometimes received 10,000 visitors per week, its giant offspring led the life of a recluse.

Toward the end of the 19th century, the Cumberland Lodge vine began to suffer. It produced grapes enough, but these seldom weighed more than seven ounces per bunch. The Frogmore gardeners decided to take drastic action. In the vinery, brick flues were replaced with hot water pipes and flagstones were lifted, laying bare the soil to aid watering and feeding. Much of the soil was replaced and the vine was root pruned to encourage fresh fibrous rooting. The branches, too, were cut back. In 1903 the Cumberland Lodge vine bore 750 bunches of grapes with an average weight of one pound. Justifiably pleased with themselves, the royal gardeners looked next to its weary parent at Hampton Court.

In 1903 the pages of *The Gardener's Chronicle* burgeoned with other prodigious plants. Century plants bloomed in east London's Victoria Park. From The Royal Botanic Gardens, Kew, came news of the flowering of a gargantuan orchid, *Grammatophyllum speciosum*. While it cannot claim to be the tallest orchid, this Southeast Asian native is certainly the bulkiest. Since its discovery in the 1820s by the German-born botanist Karl Ludwig Blume, reports had reached Europe of single plants that weighed almost a ton, their ten-foot-long, cane-like stems decked with hundreds of flowers, each of which was five inches across. Blume named the plant *Grammatophyllum*, a reference to the chocolate letter-like markings on its tawny petals. In parts of Java these were believed to be some magical script encoding love charms and other spells. Introduced from Malaysia by Sander's Nurseries in 1890, a specimen was donated to Kew where it formed 'one of the most striking features in that home of marvels and beauties', planted alongside the giant waterlily *Victoria amazonica*.

Also this year...

Thomas Hanbury donates Wisley, a 60-acre estate in Surrey, to the Royal Horticultural Society

William Robinson launches the journal Flora and Sylva

Studley College is established

The National Fruit and Cider Institute is established at Long Ashton, Somerset

The UK's first floral clock is installed at the Princes Street Gardens, Edinburgh

Sir William Waldorf Astor purchases Hever Castle, Kent, and commissions

new gardens from Frank Loughborough Pearson and Joseph Cheal

The first garden city is established at Letchworth

Birth of Thomas Henry Everett, English horticulturist, associated for much of his career with the New York Botanical Garden

Death of William Thompson (b.1823), founder of the seed firm Thompson and Morgan

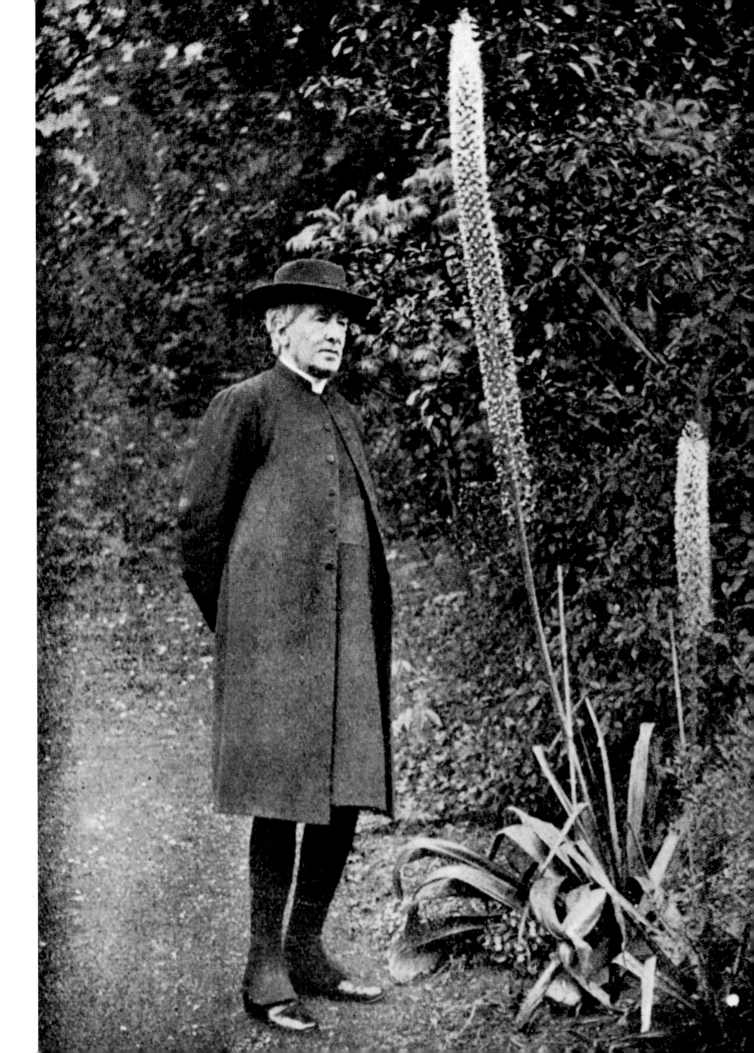

The Dean is dead

Samuel Reynolds Hole, Dean of Rochester and rosarian, dies, aged 85. The son of a wealthy Manchester cotton merchant, Hole was educated at Newark Grammar School and Brasenose College, Oxford. In 1844 he returned to Caunton, the parish of his birth, becoming curate and then vicar. Enacting Bishop Stillingfleet's advice to young parsons in William Gilpin's *Three Dialogues on the Amusements of Clergymen* (1797), Hole left off his youthful passions for hunting, shooting and archery and began to take an interest in roses. He was inspired at first by the intense crimson-pink double flowers of the Gallica rose 'D'Aguesseau' which had made its first appearance in the gardening world some 20 years earlier.

Hole's love of roses became a crusade as he found that his 'Queen of Flowers' was accorded nothing like the importance it deserved at the flower shows he was invited to judge. In 1856 he proposed through the pages of *The Florist* a Grand National Rose Show. Although his rallying cry was met with some indifference, Hole managed to convene a meeting of rosarians at Webb's Hotel in London's Piccadilly. There they planned the first national rose show, which took place in 1858 at St James' Hall, London. Within two years the show had moved to the Crystal Palace and was welcoming over sixteen thousand visitors.

In 1861, a newly married Hole found he no longer had time to organize the show – by now a major annual horticultural event – and the Royal Horticultural Society stepped in. Married life did nothing to distract him from his own roses, which he continued to grow in abundance and with brilliance, taking, for example, first prizes in 14 categories at the 1868 RHS competition. In 1869 he published *A Book about Roses* which at once sold out and later ran through 20 editions. Other works include *A Book about the Garden* (1892) and *Our Gardens* (1899).

In 1876, Hole, now Canon of Lincoln, chaired a meeting at which the National Rose Society was formed, and was elected its first President. He advanced as a cleric no less than as a rose specialist. In 1889, *Dean* Hole of Rochester presided over a groundbreaking RHS Rose Conference, a rôle he would repeat just two years before his death. Among the first 60 to be awarded the newly minted Victoria Medal of Honour from the RHS in 1897, the Dean remarked that 'it was with a very humble thankfulness that [he] had been permitted to add to the purest of human pleasures'. Oddly, he appears here not with a rose but the magnificent foxtail lily, *Eremurus*.

Also this year...

Scots plant hunter George Forrest arrives in Yunnan, China, where he will operate for much of the next 28 years. His first trip yields such garden treasures as Camellia saluenensis, Gentiana sino-ornata, Jasminum polyanthum, Mahonia lomariifolia, Pieris forrestii *and* Pleione forrestii

Cambridge Cottage and its garden are added to the Royal Botanic Gardens, Kew, following the death of the 2nd Duke of Cambridge

Property developer John Innes (b.1829) dies, leaving a bequest of £325,000 for the establishment of a horticultural research school at Merton, Surrey

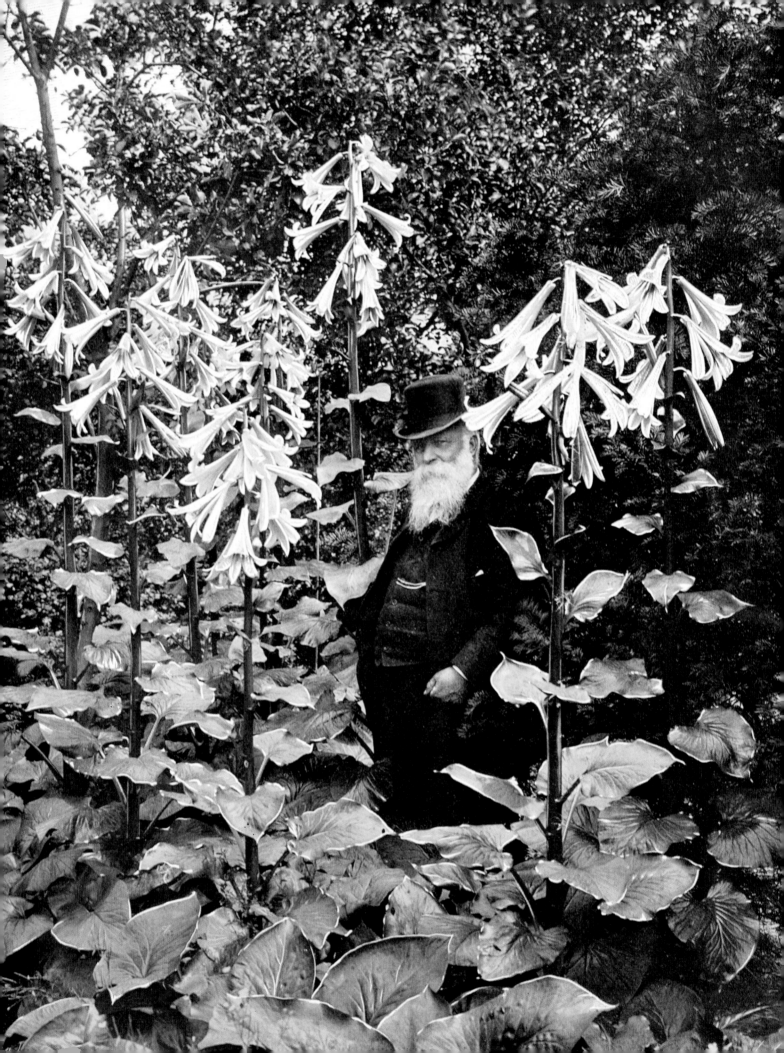

Consider the lilies

In 1821 Danish-born plant hunter and Superintendent of the Calcutta Botanic Garden Nathaniel Wallich encountered a remarkable lily in the eastern Himalayas. As much as 14 feet tall, its flower spikes were hung with 10-inch-long, funnel-shaped flowers. These were white tinted with green and flushed dark wine red within. As Gertrude Jekyll would remark in 1901, their perfume was 'powerful and delicious', carrying far 'in the still summer evenings when the light is waning, at which time these grand lilies look their best'. Wallich sent the papery seeds back to England preserved in jars of brown sugar; but it was not until 1852 that the giant lily, *Cardiocrinum giganteum*, began to make an appearance in gardens and it would be another 50 years before its habits and needs were properly understood.

Unusually for a lily, each *Cardiocrinum* bulb perishes after flowering, leaving a cluster of daughter bulbs which grow on to flower within a few years. Equally confusingly, its luxuriant appearance at first led gardeners to assume that *Cardiocrinum* was tender – they were killing it with kindness. Dwarfed by the giants at his Wisbech nursery, in the summer of 1905 G.W. Miller confided to *The Gardener's Chronicle*: 'Several hundred plants of this lily are growing freely in different parts of the grounds. I started growing [them] as pot plants in houses many years ago, but they did not succeed well; however on growing them outside without any shelter I find them perfectly hardy.' At the same time 'The Father of the English Flower Garden', William Robinson, spoke out to help to dispel the mystery, if not the mystique, of this majestic plant: [*Cardiocrinum*] 'is one of the hardiest lilies and gives very little trouble... A woodland clearing among summer-leafing trees where the soil is deep and rich, and where the bold leaves and flower stems are sheltered from wind, will suit this giant among lilies to perfection.'

Also this year...

Henry McLaren, 2nd Baron Aberconway, begins making Bodnant's Italianate terraces

On a single spring day, Sunday school children pick 27,336 bunches of primroses to decorate Brixham Parish Church. The Gardener's Chronicle fumes, 'If this is "Sunday School Education", we shall have a much spoiled England in the future...It should be everyone's business to help maintain our lanes and woodlands as attractive [sic] as possible.'

A mile-long avenue of grape vines planted by De Beers Mines Ltd at Kimberley, South Africa, yields 40 tons of fruit

Death of Frederick William Burbidge (b.1847), gardener, botanist and artist. He published works on botanical drawing, daffodils, chrysanthemums and his plant hunting trips. It was from one of these, to Borneo in 1877, that he brought back the giant pitcher plant Nepenthes rajah

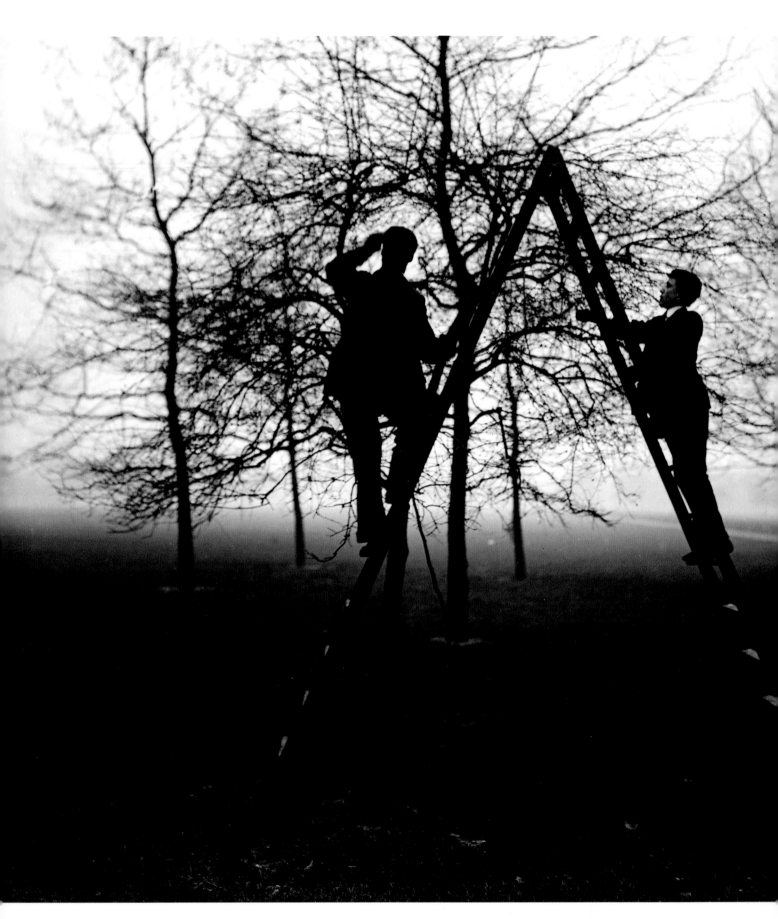

Preventative steps

On a foggy winter morning two gardeners pick cocoons from trees in London's Hyde Park. Their targets are most likely the larvae of the codling moth, a pest of apples, ornamental crabs, pears, quinces and walnuts. The moths lay their eggs on fruit and foliage in summer. Once hatched, the caterpillars tunnel to the core of the fruit, leaving via the other side once they have had their fill. They pass the winter sheltering under loose bark and in branch crevices and pupate early the following spring.

Caterpillars have long vexed gardeners. Writing in the 1st century AD, Columella thought they should be picked off by hand, or shaken from their host plants in the morning, 'for if they fall to the ground when they are still sluggish with the cold of the night, they will not have the strength to creep back into the branches'. Writing nearly two hundred years before Christ, Cato recommended a sticky, noxious blend of boiled olive oil, pitch, sulphur and bitumen: 'Apply this around the trunk and under the branches, and caterpillars will not succeed.' Variations on such sticky traps are still in use.

In his 1569 *Booke of the Arte and Maner, howe to Plante and Grafte all sortes of Trees*, Leonard Mascall recommended lighting springtime bonfires on the windward side of the orchard – the fuel was a mix of straw, hay, chaff, dried dung, sawdust, tanner's waste, human and horse hair, spent thatch and old shoes. Whereas in *The New Orchard and Garden* of 1618, William Lawson deprecated fumigation ('I like nothing of smoake among my trees'), preferring to pick off caterpillars by hand – the technique still inflicted on these young gardeners nearly three centuries later.

Today they would trap the caterpillars in artificial overwintering sites, bands of sacking or corrugated cardboard placed around the trunk and branches and removed and burnt once full. Alternatively they might spray or fog the trees with insecticide just as the eggs hatch in summer. The correct timing of this operation can be judged by using a pheromone trap – a box which emits the same scent as a female codling moth and lures gullible males to a sticky end. Nearly 100 years after these lads climbed their ladders and despite all the pesticidal ruses in the interim, their actions would probably win praise today for being green, if laborious. And maybe green is best? Certainly few human strategies are quite so effective against codling moth caterpillars as the hunger of that other denizen of the park, the blue tit.

Also this year...

St Albans' orchid nurseryman Frederick Sander publishes his List of Orchid Hybrids. *This record of all registered orchid crosses is regularly updated. At the beginning of the 21st century it lists over 110,000 hybrids*

US industrialist Pierre Samuel Du Pont purchases Peirce's Park and 203 acres of Longwood, Pennsylvania, where the 100-year-old gardens and arboretum

had fallen derelict. Du Pont begins to create Longwood, the greatest private garden in the US

The Third International Conference on Hybridization is held by the RHS: William Bateson coins the word 'genetics' for the new discipline

La Mortola

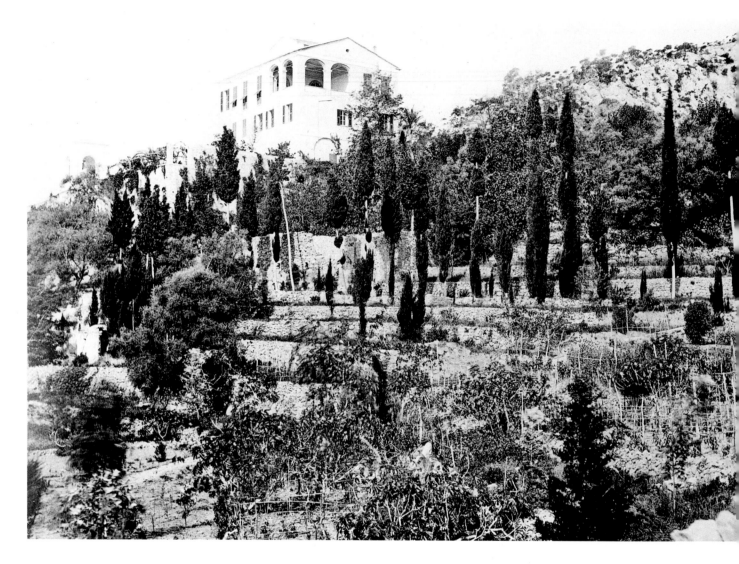

The gardens at La Mortola, near Ventimiglia on the Italian Riviera, photographed in the year their creator Sir Thomas Hanbury died. Born in 1832, Hanbury made his fortune as a merchant in Shanghai. Even at this early period, his philanthropic streak was apparent: he planted public gardens, served on the Municipal Council and campaigned against slavery and opium. After 18 years in Shanghai, Hanbury returned to Europe, and in 1867 he acquired the decaying Palazzo Marengo and its 200-acre estate at La Mortola. Here he created a private botanic garden whose mission was the acclimatization of exotic plants, notably from arid and semi-arid regions in South Africa, Australia and the Americas. He was assisted in the task by his brother Daniel (1825–1875), a chemist and gifted amateur botanist. The result was a garden of exceptional beauty and sci-

entific importance, a sequence of groves, gulleys and terraces where palms, cacti, aloes, cycads and even epiphytic orchids luxuriated as if they had never been parted from their native habitats.

La Mortola became famous throughout the gardening world. Queen Victoria sketched its dream-like landscapes from the comfort of the pale rose palazzo. Director of Kew, Sir Joseph Hooker remarked that, 'in point of richness and interest [La Mortola] has no rival amongst the principal collections of living plants in the world'. Hanbury made no such claims for himself, preferring to get on with the business of gardening and commenting that his purpose in life was simply 'to distribute seeds and plants, and to encourage others in their love of nature'.

His largesse extended along the Riviera to Ventimiglia and

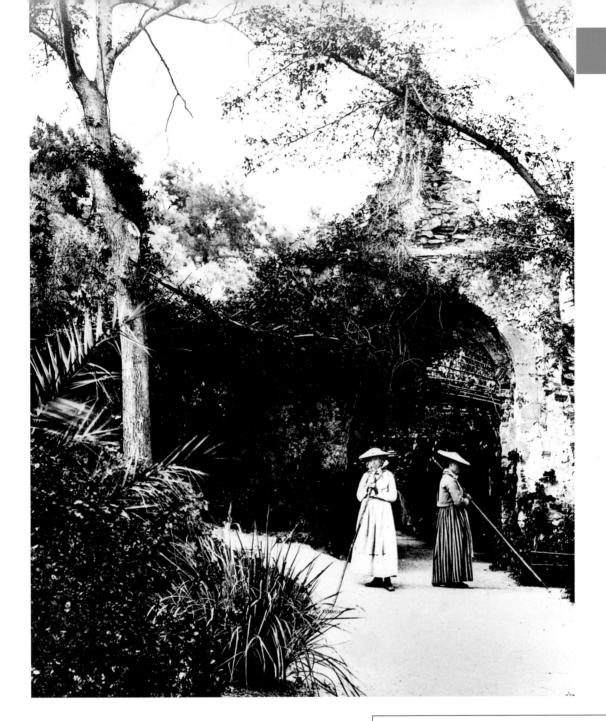

Alassio, where he made public gardens of great beauty. Hanbury also endowed Genoa's Botanical Institute and gifted it to the University in 1892. In England he bought a 60-acre Surrey estate and presented it to the Royal Horticultural Society in 1903. Wisley has been the Society's main garden ever since.

Hanbury's ashes were buried among the cypress trees that had stood sentry on the slopes of La Mortola since long before the exotics arrived. The Hanbury Botanic Garden was given to the Italian State in 1959, since when its fortunes have fluctuated. By 1988, the garden had declined so steeply that fewer than 1,500 of Hanbury's 7,000 introductions survived. Today it has begun to flourish again, thanks largely to the efforts of the Friends of La Mortola and the two British institutions Hanbury did so much to benefit, Kew and the Royal Horticultural Society.

Also this year...

Plantsman Ernest Ballard exhibits a fully double Michaelmas daisy at the Royal Horticultural Society – Aster novi-belgii *'Beauty of Colwall', named after his Herefordshire home*

William Robinson publishes The Garden Beautiful, Home Woods and Home Landscape

Kew receives two pairs of grey squirrels – a gift from the Duke of Bedford

Lawrence Johnston acquires the Hidcote Bartrim estate in Gloucestershire, where he will soon begin making a celebrated garden

Passage of the Destructive Insects and Pests Act, giving the Board of Agriculture powers to ban the importation of any plant material likely to introduce foreign pests or diseases

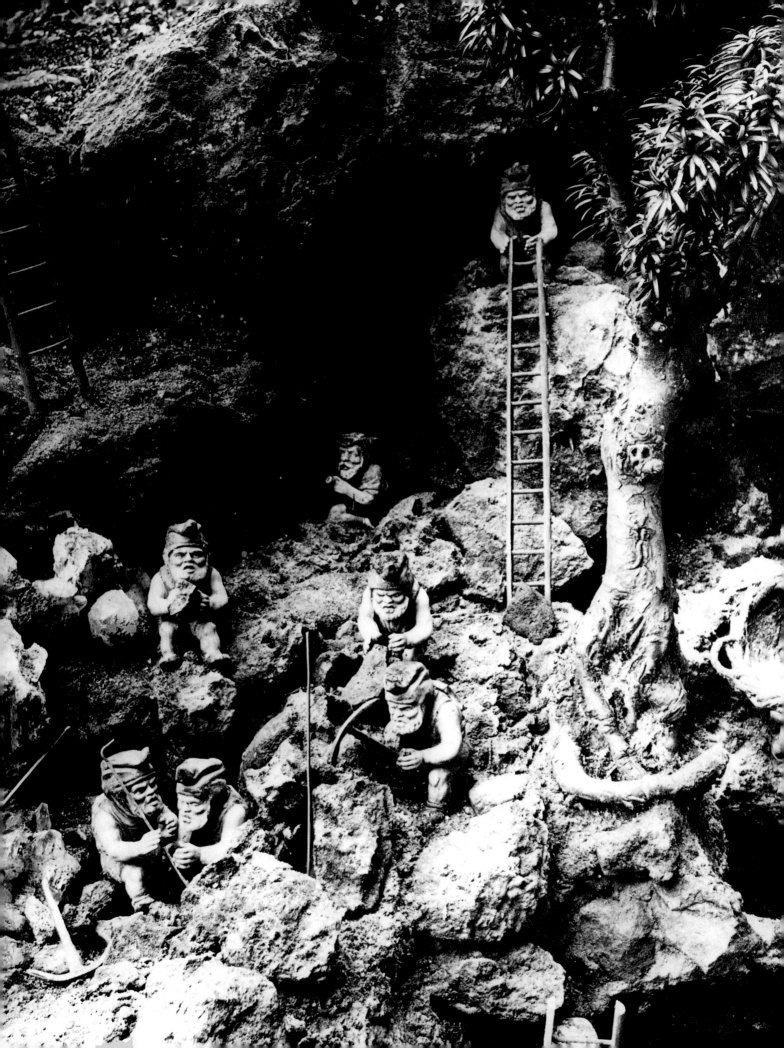

Short shift

So read a double-page advertisement for gnomes placed by the Wahliss Galleries of London's Oxford Street in the October issue of *The Connoisseur*. The notice went on to proclaim that one of the galleries' clients (Sir Frank Crisp of Friar Park) had over a hundred of these gnomes 'in his famous subterranean passages and gardens'. Wahliss claimed to be 'the sole proprietors of the original moulds of the defunct Imperial State Pottery of Vienna', which suggests a rather grander pedigree for the garden gnome than one would usually imagine. The galleries were, in fact, riding a fashion for 18th-century revivalism. In the 1890s, 18th-century English china had become collectable. So coveted were pieces like the grotesque 'Mansion House Dwarves', produced by Derby in the 1790s, that forged dwarves began to flood the market.

For the earliest English *garden* gnomes we must look to Sir Charles Isham. In 1847 he created a rock garden at Lamport Hall, Northamptonshire. Some 20 years later, he began to people it with miniature figures and, by the 1890s, a porcelain population explosion had taken place. The rockery swarmed with gnomes artfully posed to depict miners. Isham had bought them in Germany, where they were sold for the house, not the garden. Although models of dwarves had appeared in 18th-century German gardens, and several British garden writers had tentatively suggested using miniature figures as early as 1850, it was Isham who first took a fancy to what we would recognize as gnomes and who decided to deploy them outdoors.

A spiritualist who claimed to have experienced 'authentic cases of fairies', Isham believed his statuettes represented an order of dwarvish subterranean spirits responsible for the Earth's geological activity – an idea that had circulated since the word 'gnome' was coined by Paracelsus in the 16th century, and which appears in authors as diverse as Alexander Pope and Erasmus Darwin.

Despite their mythical origins and Isham's high-minded intentions, the gnomes pictured here were about to plummet in horticultural esteem. Within a few years it would be unthinkable that any gardening grandee would give them house room, let alone associate them with matters artistic or spiritual. In most gardens today, the gnome is as welcome as ground elder, and only one of Sir Charles Isham's miniature miners survives at Lamport Hall.

Also this year...

W.J. Bean begins his great work, Trees and Shrubs Hardy in the British Isles

The first of many Underground Railway posters depicting Kew Gardens appears

The RHS publishes A Classified List of Daffodil Names, *the first register of* *daffodil cultivars to appear*

'Gruss an Aachen', the first Floribunda rose, is introduced by the German firm of Geduldig

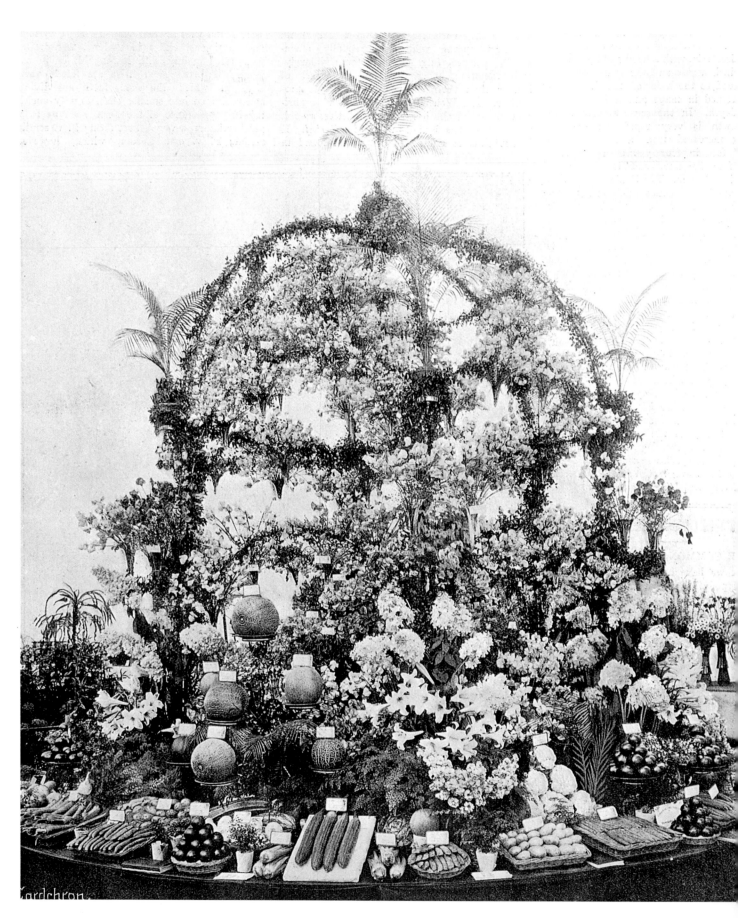

26

Show stopper

July had been one of the coolest and wettest ever recorded. In Leamington Spa disappointed gardeners struggled to keep the fruits of their labours unbruised and the flower of their achievements unblemished. They had a single target in sight – 28 July, when the Leamington and County Horticultural Society held its first-ever flower show on the muddy fields of Victoria Park.

The sun shone briefly on the Mayor as he opened a competition that comprised no fewer than 141 classes from peas to palm trees. One of the oustanding exhibits was a mixed display of sweet peas, lilies, melons and vegetables staged by Messrs E. Webb and Sons of Wordsley. Webb's display tells us much about the range of Edwardian horticultural tastes – sweet peas vie with hothouse melons and dwarf coconut palms; *Lilium regale*, recently introduced from China by E.H. Wilson, sits alongside old-fashioned pinks; vegetables are presented with all the finesse one might expect to see lavished on an orchid or rose.

Not all the exhibitors at the Leamington Show were professionals like the Webbs. The competition had 'restricted classes for amateurs and gentlemen's gardeners', and special awards were offered 'for decorated dinner tables open to ladies resident in the county of Warwickshire'. One class of show-goers was momentarily overlooked, however. *The Gardener's Chronicle* grumpily noted: 'The inexperienced committee may, perhaps, be excused for the lack of courtesy shown by their action in excluding the representatives of the Press from the tents during the time the awards were being made. This was particularly inconvenient to them as the judges were so long after the scheduled time in commencing their duties.'

Ninety years of progress have more than made amends. On the opening days of most major flower shows it is now near-impossible to see the plants for the Press.

Also this year...

Landscape architect Sir Reginald Blomfield designs the gardens at Mellerstain, Berwickshire

Reginald Farrer introduces Viburnum farreri

Botanist Isaac Bayley Balfour visits China and Japan to study growing conditions – since becoming Regius Keeper of the Royal Botanic Garden, Edinburgh in 1887, he had encouraged the introduction of a wide variety of oriental plants there

Sir George Sitwell publishes On The Making of Gardens

Birth of Brazilian landscape designer, artist and plantsman Roberto Burle Marx

Death of Peter Barr (b.1826), Scots-born bulb grower and author whose nursery, Barr & Son, revolutionized the daffodil

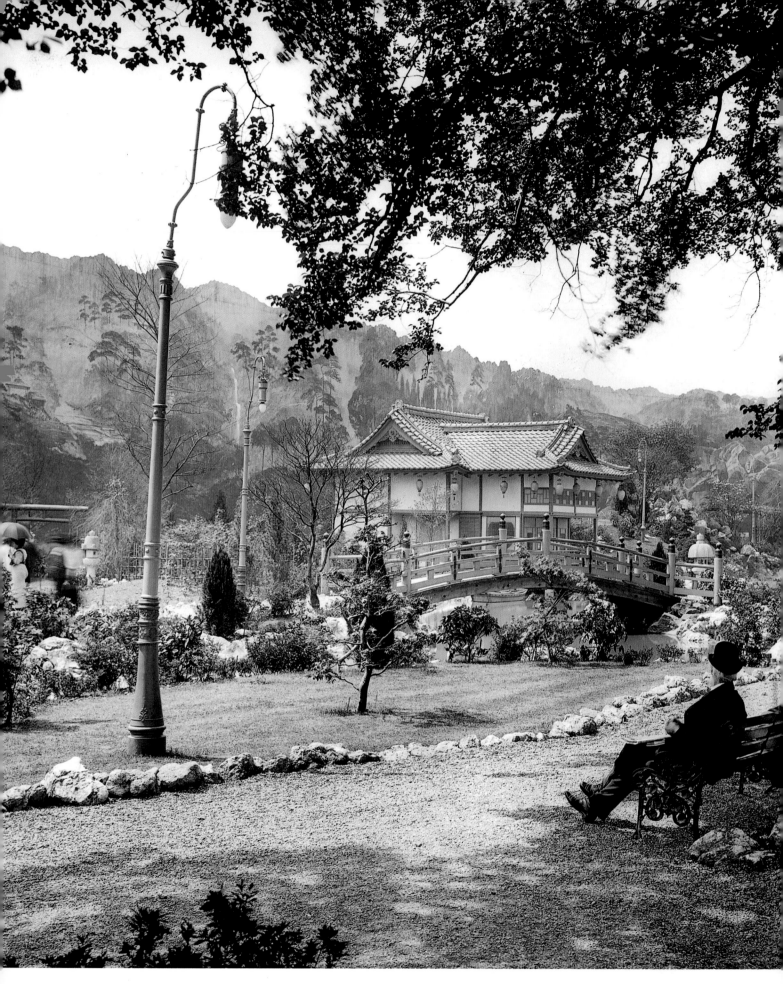

East meets West

The West's flirtation with the gardens of Japan began in 1712 when the German physician and explorer Engelbert Kaempfer published an account of his travels which included two years spent studying the native customs and flora of Nagasaki. Over the next century, there followed a stream of Japanese plant introductions – maples, hostas, chrysanthemums, bamboos, grasses, sedges, turf lilies, *Wisteria* and so forth, and early in the 20th century came floods of cultivars of camellias, Kurume azaleas and flowering cherries. Even in the year 2000, new Japanese plants were still arriving in London, among them variegated sedges and some of the 500 or so jewel-like cultivars of Yukiwariso, 'the flower that melts the snow' (*Hepatica*).

From the beginning of the century *The Gardener's Chronicle* followed the impact of Japanese gardens on our own with curiosity, sometimes appalled, sometimes approving. In 1901 the magazine had reported the sensation caused by bonsai trees at London's Temple Show: 'The Japanese are certainly adept at the art of making some of the greatest of the world's forest trees available for the ornamentation of the dinner table...For such extreme culture as this we have no admiration, though doubtless the unnatural specimens possess a certain amount of interest.' Twenty-three years later, the *Chronicle* spoke excitedly of Tokyo's Imperial Chrysanthemum Show, where a single pyramidal plant, named 'Mt Fuji' by the Imperial Bureau of Poetry, was 18 feet wide by 10 feet high and bore 1,000 snow-white flowers, each 8 inches across.

Over the century, Japanese garden style won as many Western followers as Japanese garden plants. By the 1990s 'stone' lanterns (usually made in various hues of concrete), were available at many British garden centres. Whether direct or indirect, sincere or pastiche, the influence of Japanese garden design on the West became rampant in the second half of the century, with small *tsuboi* subduing suburban backyards and larger Japanese landscapes being created wholesale at such institutions as the Missouri Botanical Garden. Even as early as June 1910, however, visitors to the British-Japanese Exhibition in London were able to enjoy the tranquillity of a Japanese garden, even if the lighting fixtures were somewhat out of place.

Also this year...

Maverick geneticist William Bateson (1861–1926) becomes first director of the John Innes Horticultural Research Institute at Merton, Surrey. The institute would do much to advance horticulture, most notably in its pioneering of a range of potting composts

The Rhododendron Dell at Kew is planted with Chinese species collected by E.H. 'Chinese' Wilson

At the end of the British-Japanese Exhibition, the Royal Botanic Gardens, Kew takes receipt of a vast ceremonial gateway or Chokushi-Mon

Birth of US landscape designer Garrett Eckbo, one of the leading exponents of the California Style

Colour in the garden

In the 1990s a cache of photographs was discovered in the archives of *Country Life* magazine. It was an exciting find, for the photographs showed, in colour, Munstead Wood, the garden of Gertrude Jekyll, one of the century's great horticultural colourists.

The images are autochromes, a single-plate colour process pioneered by the Lumière brothers in the early years of the century. Making them entailed spreading green, violet and orange starch granules over a plate painted with panchromatic emulsion. At first it was thought that Gertrude Jekyll, an enthusiastic photographer, had taken the photographs herself. But autochrome involved long exposure times and painstaking processing methods. By 1911 and 1912, when these images were made, Miss Jekyll's failing eyesight had more or less compelled her to give up photography and her first love, painting. The exposures were in all probability made by Herbert Wood, then gardening editor of *Country Life*.

On seeing them published in 1912, Miss Jekyll remarked that colour photography had yet to reach 'a degree of precision and accuracy to do justice to a careful scheme of colour groupings'. When it came to portraying her gardens, it seems she preferred the power of her own words, or the paintings of watercolourists like Helen Allingham (although these were not without artistic licence).

For all her misgivings, these autochromes capture perfectly the effect of two of Miss Jekyll's hallmark colour schemes. One of them – silver foliage and white or pastel flowers – would remain popular throughout the century and be reinterpreted by other leading woman gardeners like Vita Sackville-West and Mrs Desmond Underwood. The other – burning hot scarlets and smoky purples – would not make a comeback until the century's closing decade.

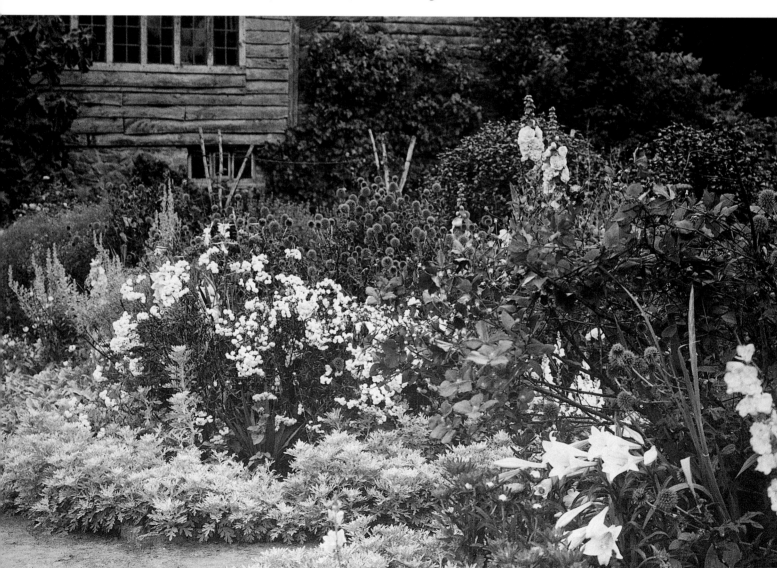

Also this year...

William Robinson publishes Gravetye Manor or Twenty Years' Work round an old Manor House – *an account of his celebrated garden at Gravetye Manor, Sussex*

Sir Philip Sassoon acquires Port Lympne, Kent, where the architect Philip Tilden will create great formal gardens after the First World War

Plant hunter Frank Kingdon-Ward is sent to China by nurseryman and plantsman A.K. Bulley

Death of Sir Joseph Dalton Hooker (b.1817), plant collector and botanist, who succeeded his father, Sir William Jackson Hooker (1785–1865), as Director of the Royal Botanic Gardens, Kew

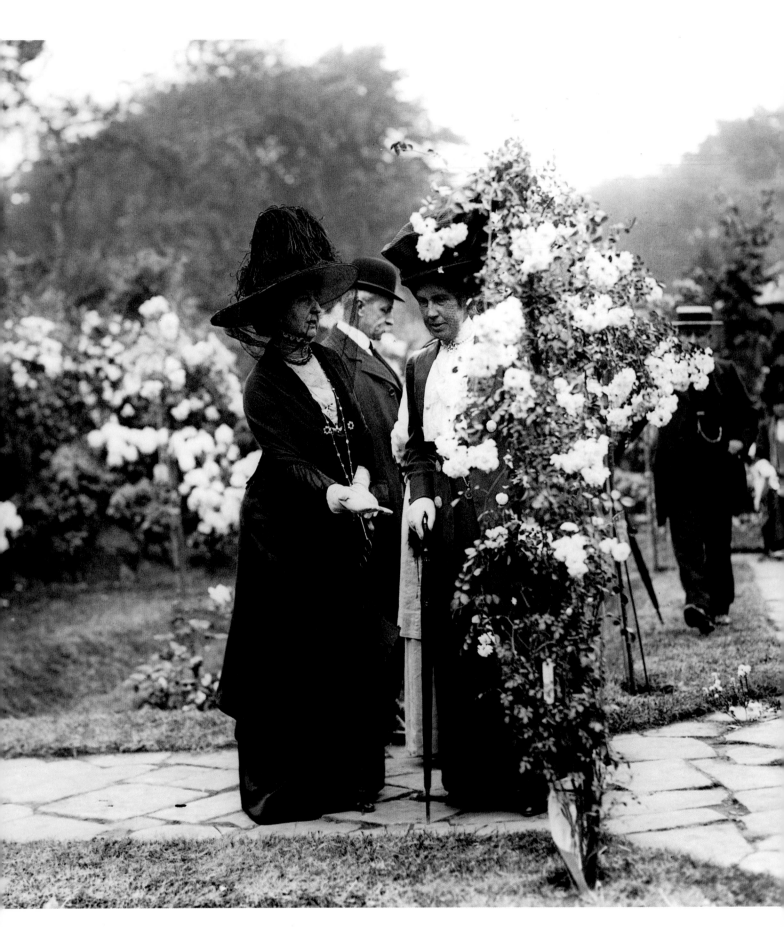

Miss Willmott's ghost

Ellen Willmott (on the right) discusses a climbing rose with the Duchess of Wellington at the Royal International Horticultural Exhibition, in the grounds of the Royal Hospital, Chelsea.

The redoubtable Miss Willmott (1858–1934) was one of gardening's great obsessives. An heiress, she used her fortune to create a magnificent garden at Warley Place in Essex. At its peak, Warley Place employed over one hundred gardeners; but not even that army could satisfy Miss Willmott's horticultural appetites. She went on to create gardens at her chateau in France and her villa on the Italian Riviera. As a patron of plant hunters, she sponsored collecting expeditions in the Near East and Asia. Her patronage was remarkably fruitful and she is commemorated in the names of such well-known garden plants as the azure-flowered Chinese plumbago, *Ceratostigma willmottianum,* and *Rosa willmottiae,* a rose with elegantly arching branches, ferny foliage and lilac-pink flowers discovered in Western China by E.H. 'Chinese' Wilson in 1904.

Ellen Willmott's ambitious monograph *The Genus Rosa* (1910–1914) typifies her refusal to allow any expense or physical obstacle to come between her and her horticultural goals. As she had written to the American dendrologist and Director of the Arnold Arboretum, C.S. Sargent, in 1906: 'My plants and my gardens come before anything in life for me, and all my time is given up to working in one garden or another, and when it is too dark to see the plants themselves, I read or write about them.' Ultimately this passion for plants consumed her private fortune and she died at Brentwood in Essex, the penniless mistress of a derelict wilderness and just two long-suffering gardeners.

Despite her extravagances, Ellen Willmott was a fiercely practical woman, rising at dawn to garden all day, making tools in her workshops and developing photographs of plants and gardens in her own darkroom. Her horticultural achievements were recognized as early as 1897, when, with Gertrude Jekyll, she became one of the first two women recipients of gardening's 'Nobel', the Victoria Medal of Honour. But it is in the common name of the sea holly *Eryngium giganteum* – Miss Willmott's ghost – that she is most often remembered. So-called, it is usually thought, because its ghostly silver flowerheads would appear magically in gardens Ellen Willmott had visited (she always kept some seeds in her pockets and would scatter them when her hosts were not looking). Others have suggested a less generous explanation for the sea holly's name: for all its beauty, Miss Willmott's ghost is tough, spiky and quite irrepressible.

Also this year...

Gertrude Jekyll and Lawrence Weaver publish Gardens for Small Country Houses

East Malling Research Station is established in Kent to investigate and develop apples and other crops

Birth of landscape designer Lanning Roper

A ruling passion

Since the first decades of the 19th century, tropical orchids had held centre stage in botanic gardens and the glasshouses of wealthy patrons like the Duke of Devonshire at Chatsworth. Bywords for wealth, exoticism and the perils of foreign exploration, and notoriously difficult to grow, these remarkable plants seized the public imagination. As the century progressed, the numbers of species available increased vastly, as did the exper-

tise with which they were grown. Among the ruling classes, orchids achieved a cult status that peaked in the 20th century's infancy and vanished with the First World War and the end of the great era of Edwardian hothouses.

One of the most devoted orchid amateurs was the British statesman Joseph Chamberlain (opposite right). Three-times mayor of Birmingham and a minister in both Gladstone's and

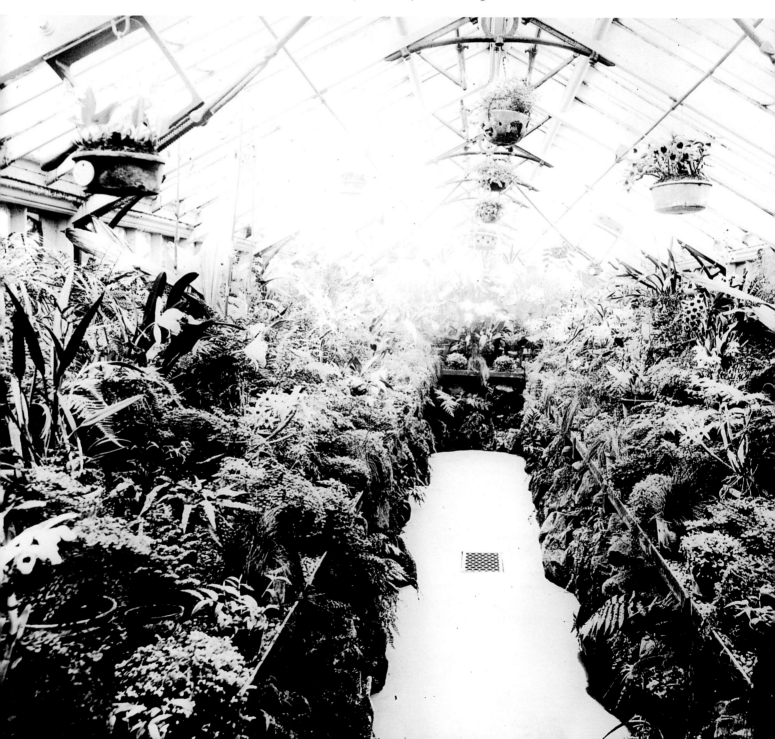

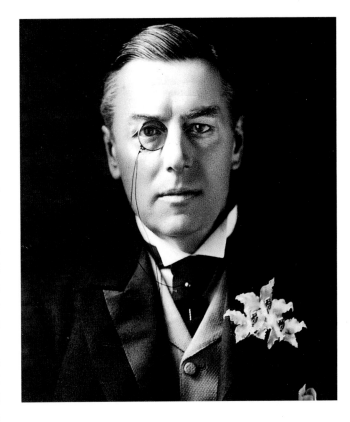

Salisbury's cabinets, he nonetheless found time to create a superb orchid collection at his home in Highbury, Birmingham (left). His trademark orchid buttonhole and monocle made him a darling of caricaturists. So complete was Chamberlain's identification with these extraordinary blooms that in 1903 London's Gaiety Theatre staged *The Orchid*. The plot of this popular, if mercifully short-lived, musical comedy centered on the farcical efforts of a professional orchid hunter to deliver a priceless specimen to one Aubrey Chesterton, Minister of Commerce. In the 1900s Chamberlain and others like him were prepared to pay several hundred guineas for a single plant of a newly discovered species.

One group of activists was quick to associate the orchid with glaring social inequality and the excesses of a privileged patriarchy. In the small hours of 8 February, 1913, the orchid houses of the Royal Botanic Gardens, Kew, were stormed, the windowpanes smashed and plants and pots destroyed. The vandals left a trail of clues that included an envelope inscribed 'Votes for Women', some female fingerprints, a lady's handkerchief and a handbag. The Press rallied to the orchid's cause – 'Mad Women raid Kew Gardens' fulminated *The Daily Express*; 'Orchids at Kew Ruined' cried *The Evening Standard*. The editorial of *The Gardener's Magazine* was almost Jainist in its reverence of living things (women excepted): 'An attack on plants is as cowardly and cruel as one upon domestic animals or those in captivity.'

An ardent populist, Chamberlain disliked the idea that orchids were the preserve of the rich. His own gardener, H.A. Burberry, was one of the first to argue for 'orchids for all'. With a sideways glance at his employer, he wrote in 1900: 'Why are orchids generally supposed to be an expensive luxury and out of reach of all save the most wealthy? I think these notions have arisen from the fact that when orchids are written about in newspapers and periodicals, they are invariably associated with the name of some well-known and wealthy individual.'

Also this year…

Not content with destroying orchids, suffragettes return to Kew on 20 February and burn down the Refreshment Pavilion

Charterhouse schoolmaster William R. Dykes (b.1877) publishes his Monograph of the Genus Iris, *with illustrations by his fellow schoolmaster Frank Round*

Following the success of the 1912 Royal International Horticultural Exhibition at Chelsea, the Royal Horticultural Society moves its Great Spring Show (hereafter known as the Chelsea Flower Show) to the grounds of the Royal Hospital

Marion Cran publishes The Garden of Ignorance

Field Marshall Lord Grenfell becomes President of the RHS. His wartime presidency will involve much work on behalf of war-torn gardeners, both at home and among the Allies

Birth of gardening author and broadcaster Percy Thrower

The lost gardeners of Heligan

An Edwardian gardener shows off a giant gunnera leaf in front of the melon house and pineapple pit at Heligan in Cornwall. Heligan House had 1,000 acres of gardens stocked with exotic trees and flowers; fruit gardens that supplied the country house with pineapples, peaches, melons, bananas and grapes; and vegetable gardens. Once the home of the Tremayne family, the house, gardens and the community which had built up around them went into decline following the First World War. Happily, 100 acres of the grounds and gardens were restored from 1990 onwards by Tim Smit and John Nelson, and are now a living reminder of the heyday of this remarkable estate. With names such as the Crystal Grotto, Flora's Green, the Jungle and the

Lost Valley, these restored gardens set the imagination racing. John Fowles said of them, 'it will also help if you have developed sub-tropical lunacy and can't resist flirting with the sort of plants common-sense gardeners avoid'.

The connection of Heligan with the Tremayne family began in 1569 when John and Sampson Tremayne moved to Cornwall, but it was Henry Hawkins Tremayne who created the framework of the gardens, having undertaken a tour of the great houses of southern England in 1785. On returning to Heligan he expanded the gardens into the surrounding landscape and laid out plantations, follies, rides, walled gardens and shrubberies. The next three generations of Tremaynes developed the gar-

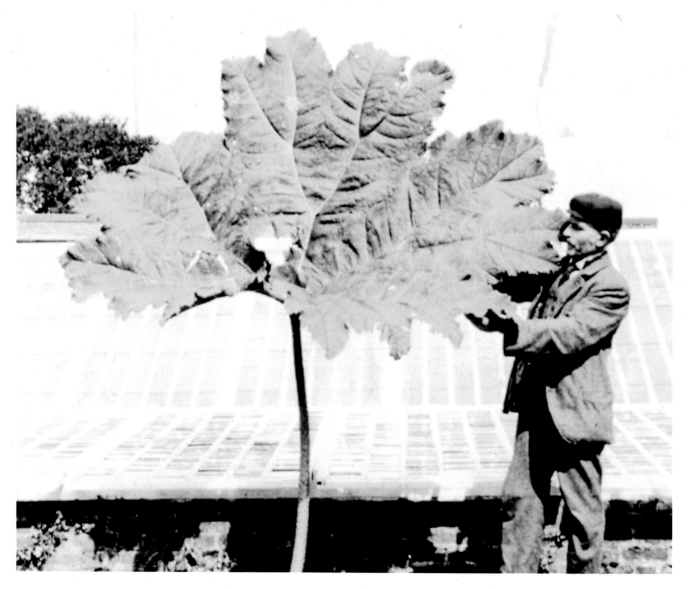

dens, which had their golden age just before the First World War.

John Hearle Tremayne was Conservative MP for the County of Cornwall for 20 years through 5 successive parliaments but still found time to garden. He planted the Long Drive with *Cornus capitata*, a new introduction to Europe from Nepal. John Hearle had a particular passion for trees which led him to develop the Jungle, where he planted *Araucaria araucana*, the monkey-puzzle tree. He was succeeded as squire by his son John, whose speciality was hybridizing rhododendrons, with which he populated the area known as Flora's Green to spectacular effect. One of John's hybrids was a cross of *Rhododendron griffithianum* with *R. arboreum*, whose first recorded clonal name was 'John Tremayne'. A clone was named 'Mrs Babbington' after one of John's daughters, and the finest cultivar of *R. arboreum* itself is named 'Heligan'. The next squire, John Claude 'Jack' Tremayne, introduced Chusan palms (*Trachycarpus fortunei*), tree ferns (*Dicksonia antarctica*) and giant rhubarb (*Gunnera manicata*), among others, to the Jungle. Thanks to Jack Tremayne, Heligan has what is probably the largest collection of tree ferns in the country.

While the squires indulged themselves in designing and planting the pleasure gardens, the head gardener, with a team of 22 staff, supplied vegetables, soft fruit, wall fruit, herbs, cut flowers and exotic plants for the Tremayne family and their guests.

In 1914 Jack Tremayne tried to enlist as soon as war was declared. He was told that at the age of 45 he was too old, so instead he decided to turn Heligan into a convalescent home for officers. Nurses were employed and the gardening staff shrank from 22 staff to just 8. Work was concentrated on the production of food, while the pleasure gardens were left in abeyance until peacetime. Meanwhile the Admiralty was

appealing for donations of oak to rebuild the Navy's ageing fleet of wooden ships: Jack felled the oaks which had provided shelter to the east of the estate and replaced them with fast-growing Monterey pines.

Many of Heligan's gardeners, including William Guy, Charles Ball and Charles Dyer (below), left these magical gardens for war and never returned. Their names can still be seen at Heligan, inscribed on the potting shed wall on the eve of their departure.

Also this year…

Volumes one and two of W.J. Bean's Trees and Shrubs Hardy in the British Isles *are published*

English plant collector and author Reginald Farrer (b.1880) departs for China's Gansu-Tibetan border with William Purdom. Described in Farrer's Eaves of the World *(1919) and* The Rainbow Bridge *(1921), the expedition produced such plants as* Buddleja alternifolia, Aster farreri, Deutzia albida, Gentiana farreri, Geranium farreri, Lilium leucanthum *var.* centifolium *and* Viburnum farreri

Working for A.K. Bulley, English plant collector

R.E. Cooper travels in Bhutan discovering such new plants as Rhododendron dalhousieae *var.* rhabdotum *and* Viburnum grandiflorum

E.A. Bowles publishes My Garden in Spring, *the first of three books describing his garden and plant experiments at Myddelton House*

Landscape architect Walter Godfrey publishes Gardens in the Making

The Veitch Nurseries in London are wound up; the closing sale lasts three days

Ransomes introduces the first gang mower

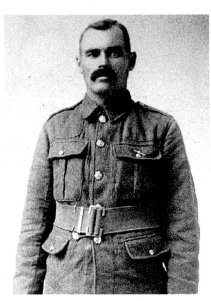
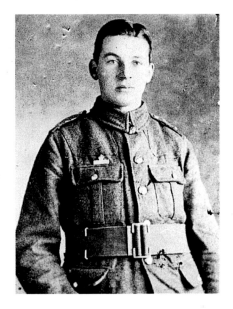

The earth moves

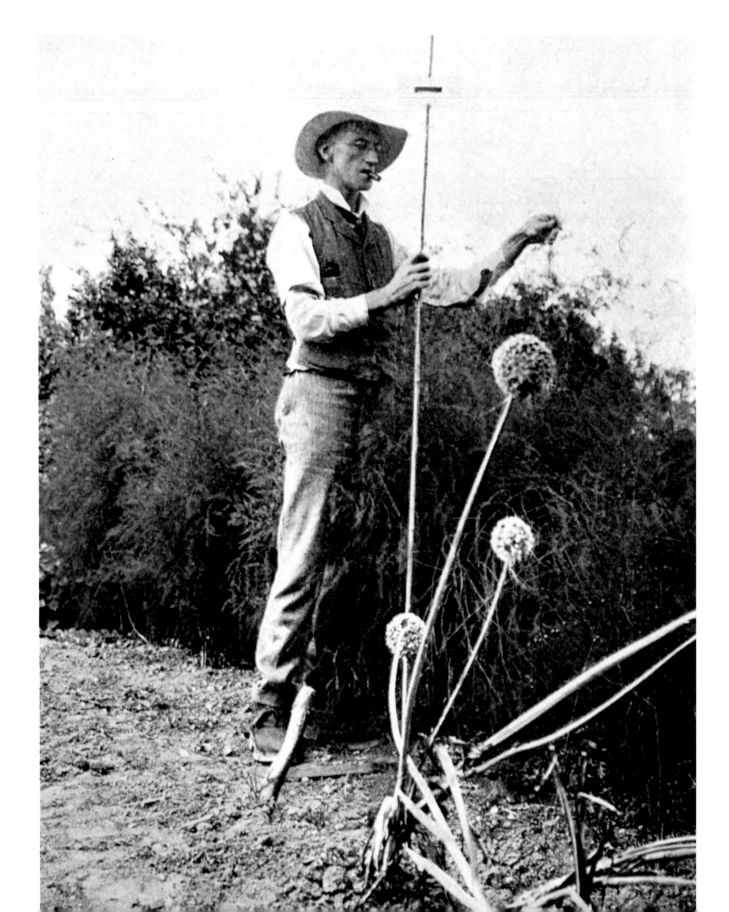

Writing in the *Journal of the Royal Horticultural Society*, Dr Herbert E. Durham offers an earth-shaking solution to the problem of digging:

'The border was about 2 yards wide and 22 yards long, and contained an ordinary mixture of plants such as phloxes, Madonna lilies, asters, *Lychnis chalcedonica*, and annuals. For some reason the western half had never been so luxuriant as the other half, and was therefore chosen for the trial. Three two-ounce charges of cheddite, placed 3½ feet deep, were exploded in the western 11 yards; no other activities were deployed beyond weeding and surface stirring. On July 25 a number of friends were informed that half the bed, east or west of the middle mark, had been exploded and were requested to record their own opinion as to which appeared to be the better grown. Curiously enough, eight recorded in favour of one half, and like-wise eight in favour of the other, so that evidently there could not have been much different at the time, when indeed things were rather 'over'. In respect of the previous poorness of the exploded side, the verdict was in favour of the treatment as was that of two experts who had inspected the bed at earlier dates. The most marked effect was the height to which the *Lychnis chalcedonica* grew on the exploded side, nearly double that of the other; and the Madonna lilies also looked more prosperous...The time needed for thus 'cultivating the soil' was but a mere fraction of that which would have been needed to remove all the plants, dig the soil, and replace the plants; in fact, in half an hour or less the whole work was done.'

Dr Durham found his explosive methods were especially productive with asparagus. Mined and blown up with one-ounce charges, his asparagus bed produced growths that averaged six feet in height. In an *unexploded* bed, no asparagus growth attained six feet. On a patch blown up with *two-ounce* charges, growth was erratic. 'In this soil', he concluded, 'explosives materially assist the growth of asparagus.' Willingness to handle cheddite (a notably lively mixture of castor oil, ammonium perchlorate and solvent) is evidence enough of anyone's dedication to horticultural science, but allowing asparagus to grow past harvesting stage is sacrifice beyond the call of duty.

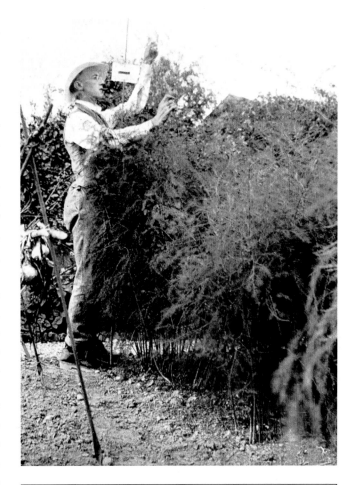

Also this year...

At Kew, women gardeners are brought in to replace men at war

The Rhododendron Society is founded

James Comber raises the beautiful white-flowered tree Eucryphia 'Nymansay' at Nymans, the garden of his employer, Lt Col L.C.R. Messel

A National Diploma in Horticulture is introduced

In a paper read to the Society on 16 March, RHS Professor of Botany George Henslow proclaims 'the passing of Darwinism'

Anglo-Irish horticulturist and gardening journalist Charles F. Ball is killed in the Dardanelles. He was 36

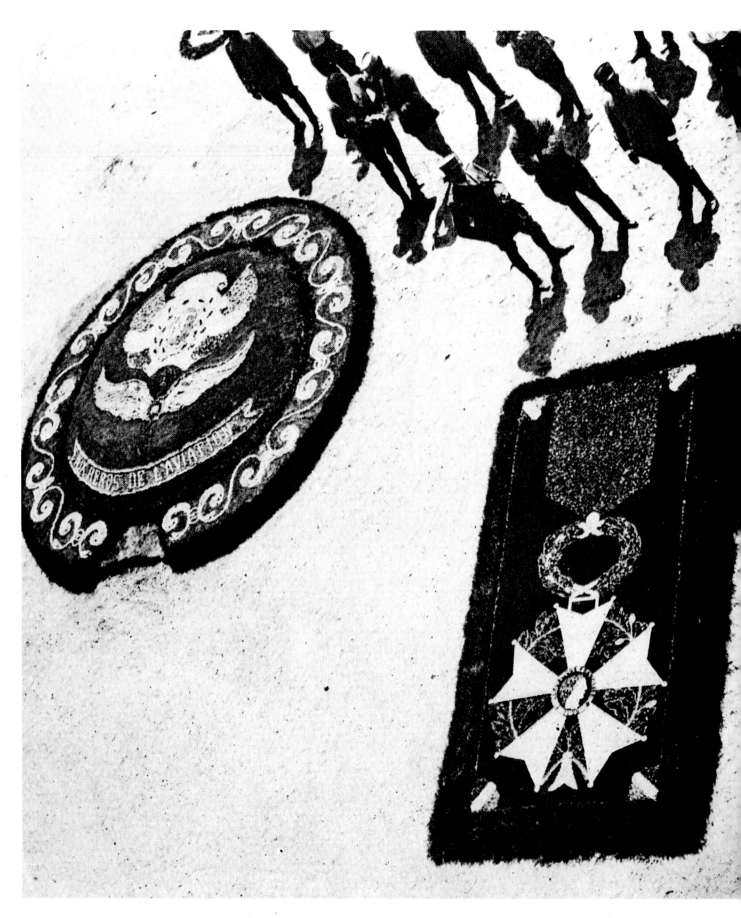

'The Gardeners of Salonika'

French troops at Salonika in the Balkans admire their handiwork – a parterre depicting the insignia of the Legion of Honour. They had landed there first in early October 1915 under the command of General Maurice Sarrail, who had been disciplined following his refusal to withdraw from Verdun. If Salonika began as a dumping ground for a disgraced general, it soon became a sink for a vast number of men. After their first advance was repulsed in December 1915, the force, foiled by poor communications and the lack of Greek assistance, found itself unable to mount an effective expedition. By 1917, British, French, Italian, Russian and Serbian forces on the Salonika front totalled over 600,000 men, all but stranded and locked in inactivity save for a few tussles with the Bulgarians. One German commentator wryly remarked that what might have been one of the war's most decisive theatres had instead become 'its greatest internment camp'.

Unable to fight, many turned to gardening. M. Paul Noir of the Station Agricole d'Athènes was sent to the front to instruct the staff officers in the growing of vegetables and herbs. He found a surprising number of willing students, some of whom had been active gardeners and amateur botanists at home. Many of the gardens they made were typical of formal French style – examples of *prestige du dessin*, parterres and *potagers* that were as ornamental as they were useful. Some of the more adventurous officers interested themselves in what survived of the endemic Islamic garden style, adopting elements of it in their own plots and even restoring the ruins of Turkish *baghs* (gardens). Hard-pressed to obtain more familiar plants (or, indeed, to grow them in the climate of Thessalonika), the soldiers looked to native Balkan species to adorn their borders. They found crocuses, snowdrops and snowflakes, fritillaries, lilies, anemones and iris.

What, demanded the French Prime Minister, Clemenceau, was this huge force up to? 'Digging' came the answer. 'Then let them be known to France and Europe as "The Gardeners of Salonika".'

Also this year...

28 March, a storm blows an ancient Cedar of Lebanon onto Kew's Temple of the Sun; also destroyed are the last three surviving 'Seven Sisters' – elm trees planted by the daughters of George III

The Chelsea Flower Show is cancelled for the duration of the war

Death of The Reverend Henry Nicholson Ellacombe (b.1822), Rector of Bitton, Gloucestershire where he exercised his exceptional talents as a gardener and author. He wrote on the plants that appear in English literature (Plant Lore and Garden Craft of Shakespeare, 1878), and general gardening works such as In a Gloucestershire Garden (1895) and In My Vicarage Garden and Elsewhere (1902). He was also gardening mentor to E.A. Bowles

Let them eat leeks

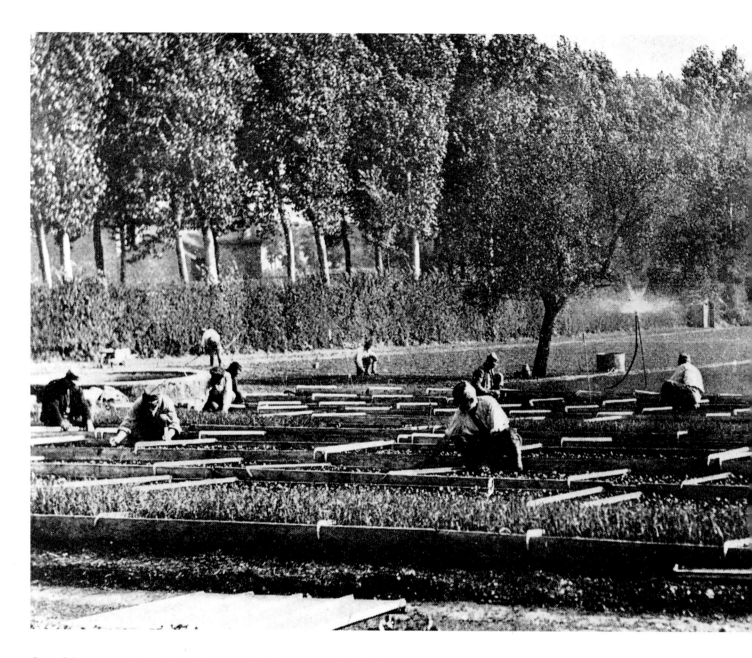

One of the greatest logistical problems posed by the war was feeding the troops at the Front. For the French, one answer was to produce seedling vegetables at a central depot; these could then be transported to the rear of the fighting army to be grown on and harvested. For the main centre of this activity, they chose the most famous French garden of all – Versailles. Scant civilian labour could be found, so a corps of gardeners was formed from a company of Annamite riflemen and veterans of the 1889 and 1890 army intakes. Those without prior horticultural experience were supervised by 10 gardening experts and the whole team was directed by one Lieutenant Truffaut, whose gift for gardening was matched by a sense of military strategy.

On 27 October, 1917, *Country Life* declared itself surprised to find that their prin-

cipal crop was leeks, 'which we in this country are accustomed to think a dish for Scots and Welshmen. Even in the good hotels the recourse in France on a meatless day is to a soup made of leeks and potatoes, and an excellent and nourishing dish it is. It must be regarded as unfortunate that in the south of England the virtues of the leek are not as widely known as they should be, as it is one of the very best winter vegetables.'

The borders and *potagers* of Versailles were steam-sterilized, a new technique for killing soil-borne pathogens that had been under development at English nurseries during the war years. In one respect, however, the technology remained basic – the plants were irrigated with the same watering cans that had been used under Louis XIV 200 years earlier. The great orangery of the Trianon became a vast packing shed, a use for which, said Lieutenant Truffaut, it might have been custom-made as it was large enough to accommodate the transport trucks of the military postal service. (The French railways were too congested and disrupted to allow safe carriage of the tender young plants.)

By October 1917, 25 million seedlings had been produced at the Palace of Versailles. The cost, 40,798.59 francs, was met by the French government and donations from the British Touring Club and Board of Agriculture. At first, calls for a similar scheme to be set up by the British government met with intransigence. Leading the campaign, *Country Life* attacked officials who had run too long 'in the ruts of convention... In this case hesitation would be fatal. The matter must be decided immediately.' The British Food Production Department finally agreed to look into the matter and to cooperate with the French.

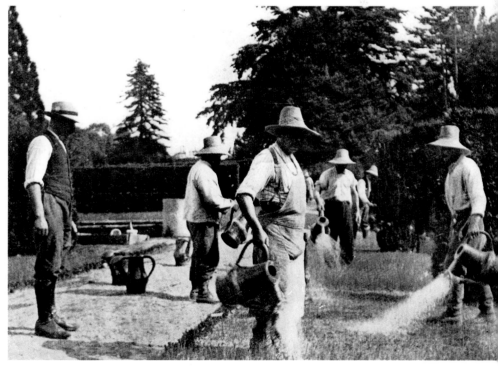

Also this year...

John Ramsbottom, scientist at Wisley, discovers hot-water treatment for daffodil eelworm

E.J. Russell reports on the success of soil sterilization by steam and chemicals as a method of killing soil-borne pathogens

In the glasshouse

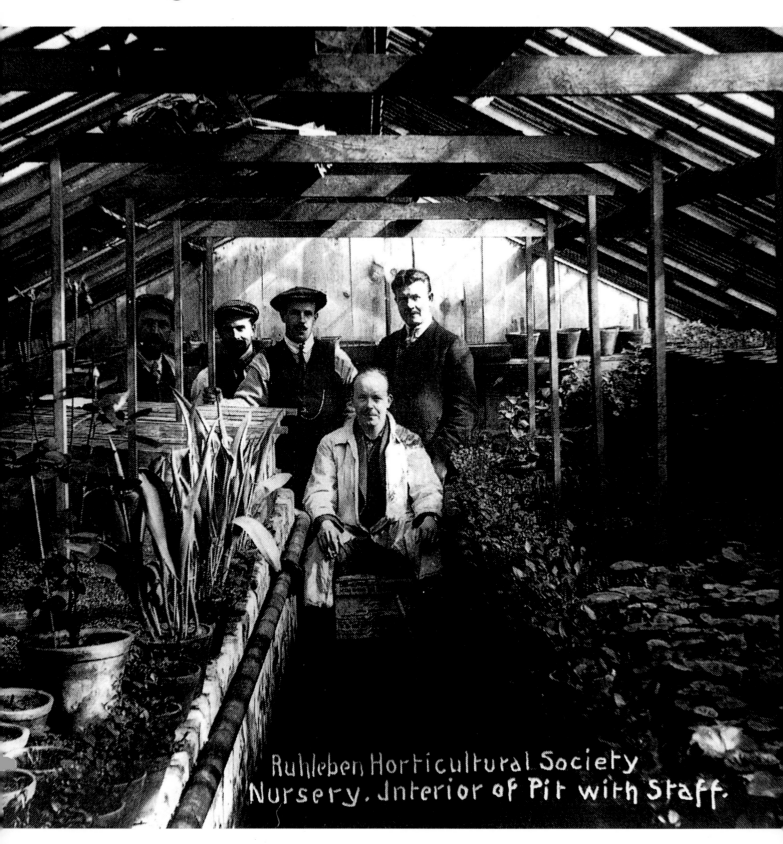

Ruhleben Horticultural Society Nursery. Interior of Pit with Staff.

Prisoners and staff at the Ruhleben Internment Camp are photographed (left) in the camp's pit house – a traditional form of glasshouse with a sunken floor. In November 1914 the German government had ordered the arrest of all British males resident in Germany and aged between 17 and 55. Four thousand detainees were herded into Ruhleben, a 10-acre racecourse near Berlin. Until the building of 12 barracks, the men were held in the Tea House, stables and horse boxes. Nothing dismayed, they formed a variety of clubs, sporting teams, a theatrical company and even launched a camp magazine. One of the most important activities in the camp was horticulture. At first the inmates gardened 'within the walls of biscuit tins', as one of their members reported. This was followed 'by an era of barrack garden enterprise, somewhat sporadic in its outbursts'. Then the Crown Princess of Sweden sent the prisoners a package of seeds, inspiring a wholesale gardening frenzy and leading to the institution of the camp's own horticultural society.

In September 1916, its secretary Thomas Howatt wrote to the Royal Horticultural Society describing their aims ('to cultivate and beautify the ground around the barracks and public thoroughfares in the Lager, and to further the knowledge of horticulture'), and requesting formal affiliation. The RHS approved the affiliation, sending the prisoners seeds, bulbs and pamphlets on gardening. By December 1916, the Ruhleben Horticultural Society had inaugurated a series of winter gardening lectures and membership had risen from 50 to 943. Six hundred yards square, the society's nursery (right) was fed with drain refuse and tea leaves – curiously for a former race track, horse manure was unavailable. At first, cold frames and glasshouses were bought with the proceeds of the annual one-mark subscription fee. In the first autumn, however, a bumper crop of dahlias and chrysanthemums was sent to England for sale and raised somewhere in the region of 300 marks.

Supplied with seeds from such British firms as Sutton, Carter, Cutbush and Barr, and with low-grade pig manure from the Wacht Kommando, the society's vegetable gardens were able to supply the camp's canteen and achieved a profit of 800 marks by autumn 1917. Inter-barrack gardening competitions were instituted. In 1917, first prize went to Barrack 8, which housed naval men, for a simple border of standard rose bushes. Second prize was awarded to Barrack 3 for an artfully designed flower border featuring climbers supported by a rustic frame. Nicknamed 'The Supermen', the occupants of Barrack 3 were

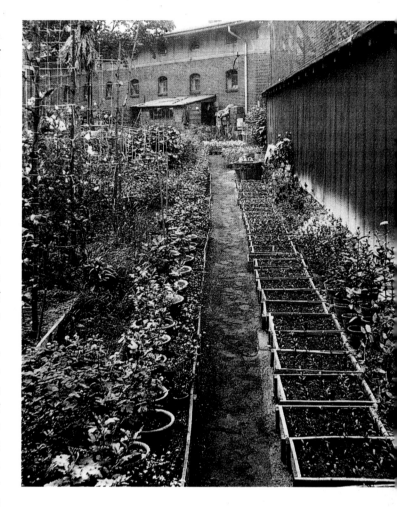

academics, intellectuals and artists. The exclusively aristocratic inmates of Barrack 10 made long borders and a rock garden that would have graced their country seats back home. Their plot was, by popular acclaim, 'The Glory of Ruhleben'.

The Ruhleben Horticultural Society ended with the Armistice. The last prisoners left the camp in November 1918 and Ruhleben became a racecourse again. In 1958 it was demolished to make way for a sewage plant.

Also this year...

Ploughed the previous January, the erstwhile lawn of Kew Palace yields nearly 27 tons of potatoes in August. The lawn would not be reseeded until 1921

Travelling in Japan, plant collector E.H.Wilson finds Kurume azaleas

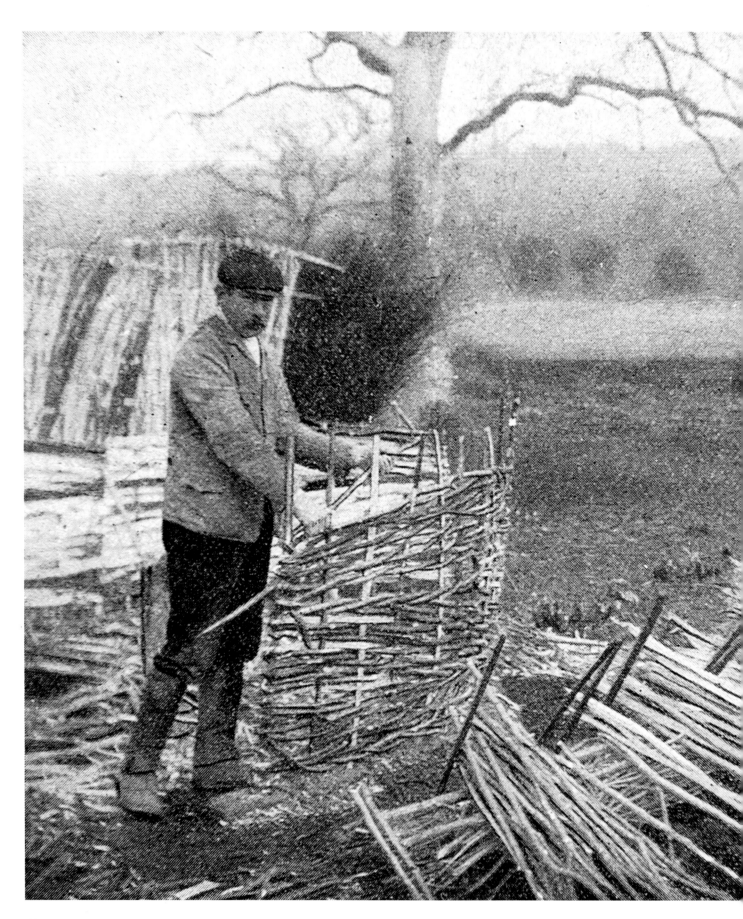

Overcoming hurdles

In 1919 wattle hurdles were used to pen sheep, and it was not until the end of the century that they became fashionable garden furniture. Presciently, *The Gardener's Chronicle* felt they might be of interest to the horticultural community, however, and featured this woodsman at work.

The best hurdles were made from rods of underwood (dense, multi-stemmed coppice) that had been allowed to grow for nine or ten years. The coppices consisted chiefly of hazel but included ash, *Euonymus* and maple. They were harvested between New Year and the third week of March (before the sap was in full flow), then the cut wood was laid in 'breadths' (bundles) to facilitate handling and choosing the best rods. In the region of 3,500 rods were needed to make a single 'pile' (10 dozen hurdles). Each hurdle was six feet long and three feet wide, and an experienced hurdle-maker could produce as many as a dozen in a day, for which he might hope to be paid 9s.6d. In the open field, hurdles were fixed by 'shores' (five-foot stakes) held together by 'wyths' (galvanized wire).

The Gardener's Chronicle feared for the future of hurdle making, 'which is quite a skilled art, and unfortunately likely to become extinct, as the younger generation do not care to learn'. In January 1998, *The Garden* magazine advertised hurdle making courses at the RHS garden, Wisley. The response was overwhelming.

Also this year...

Publication of Reginald Farrer's classic The English Rock Garden

Lionel de Rothschild acquires the Exbury estate in Hampshire, where he develops an extensive rhododendron and azalea garden

A committee is set up, including the architect

Sir Aston Webb, the designer Ernest Law and horticulturist Ellen Willmott, to advise on the restoration of the gardens at Hampton Court Palace to their 18th-century condition

Clarence Elliott founds the Six Hills Nursery in Stevenage, Hertfordshire

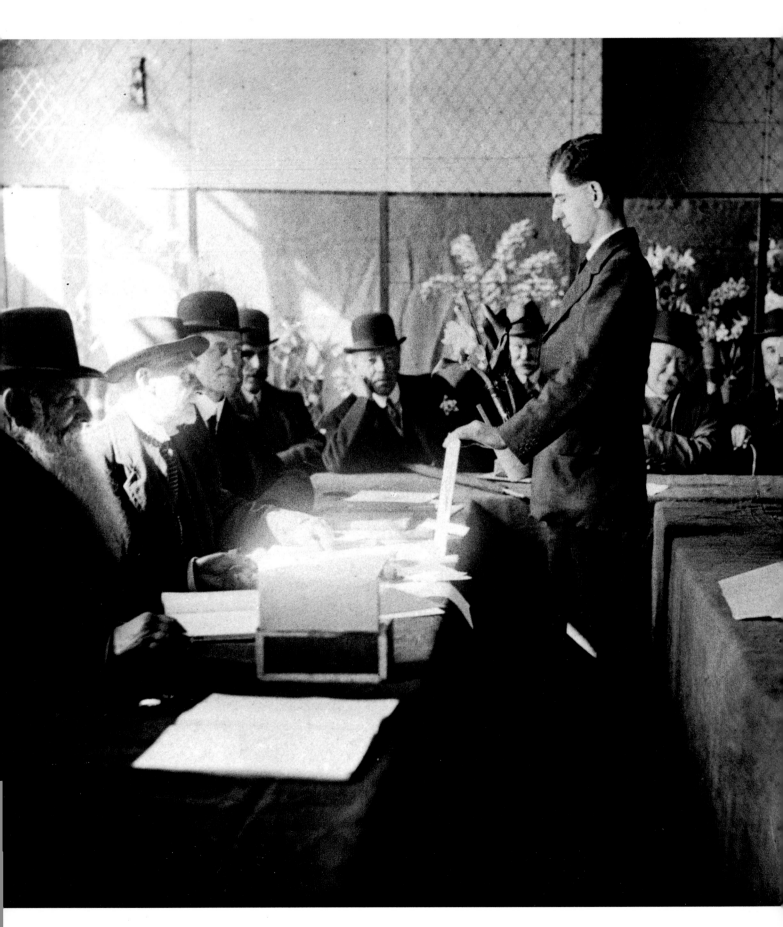

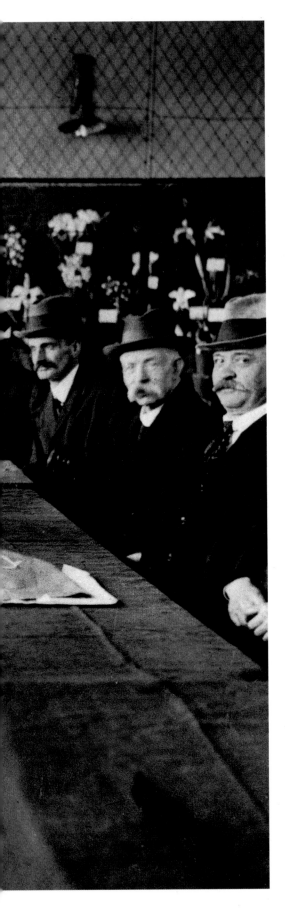

The day of judgement

The Orchid Committee of the Royal Horticultural Society examines a *Cattleya* hybrid. Formed in 1889, the committee still meets on the first day of the Society's flower shows to assess the merits of any orchid presented to them. It can recommend a number of awards – preliminary commendation, Award of Merit (which needs twice as many votes for as against) and a First Class Certificate (three times as many for as against). Especially well-grown plants can be awarded a Cultural Commendation.

Traditionally a student gardener taking a day out from Kew or an RHS garden, the porter at committee meetings waves each plant under the members' noses and with it a painting of any similar orchid that may have been awarded. A portrait of each awarded orchid has been made since 1897. The first RHS official orchid artist was Miss Nellie Roberts who, as a 17-year-old girl in Camberwell, was bewitched by a vase of orchids in a florist's window. She painted them, and continued to paint them for something like 60 years – an achievement celebrated in the name of a glowing pink, crêpe-like *Cattleya* 'Nellie Roberts'.

Bottom left sits the splendid bearded figure of Sir Harry Veitch (1849–1924). A scion of one of Britain's greatest horticultural dynasties, Veitch had taken over the family nursery business in 1870 on the death of his father and brother. In 1853 the Exeter branch of the firm had seen the first experiments in orchid hybridization to be made in the West. In the same year, the Veitch family took over The Royal Exotic Nurseries in Chelsea's King's Road; orchids were a speciality and Harry Veitch was himself an able breeder of these plants, in particular cattleyas like the plant on show here. He attempted to retire from the firm, leaving it in the charge of his nephews, but the business went into decline, and Harry was forced to return to the helm – too late, his health was failing. With the exception of the Exeter nurseries, the firm's several branches closed in 1914. Harry Veitch's most enduring popular legacy is the Chelsea Flower Show, which developed from The Royal International Flower Show of 1912, an event he co-organized and for which he was knighted.

Also this year...

First appearance of Edward Bunyard's Handbook of Hardy Fruits, *one of the great works of pomology*

At Chatsworth the Duke of Devonshire *orders Joseph Paxton's Great Stove to be blown up – the plant collection it housed had declined beyond salvation during the First World War*

Heather Muir begins making the gardens at Kiftsgate Court, Gloucestershire

George Dillistone publishes The Planning and Planting of Little Gardens, *based on the results of a pre-war competition organized by* Country Life

Birth of garden designer, plantsman and nurseryman James Russell

English author and plant collector Reginald Farrer (b.1880) dies of diphtheria in the remote village of Nyitadi, Upper Burma. His second and last great expedition had yielded such plants as Nomocharis pardanthina, Rhododendron calostrotum *and the Himalayan coffin or incense juniper* Juniperus recurva var. coxii, *named for his partner on the trip, Euan Cox*

The green bard

At the end of 1919, the trustees of New Place, Shakespeare's last home in Stratford-upon-Avon, launched an appeal for plants. They were destined for Ernest Law's imaginative recreation of Shakespeare's garden which was to be typically Elizabethan and stocked with plants mentioned by the poet or likely to have been known to him.

Even a cursory glance at the *Plays* will turn up numerous references to plants, gardens and horticulture. These suggest that Shakespeare was at least a competent amateur botanist and gardener. One has only to consider the discussion of hybrid 'gillyvours' (old-fashioned pinks) in *The Winter's Tale* IV.iv, which so eerily prefigures our present anxieties about man's meddling in nature, to see that this was a dramatist whose knowledge was not taken merely from herbals, but was deeply rooted in practice.

When Shakespeare needed a metaphor for a nation torn by misrule and civil strife, he looked to horticulture, and put the message in the mouths of gardeners. In *Richard II*, England is as a 'sea-walled garden', neglected and mistreated until it is

> ...full of weeds, her fairest flowers choked up,
> Her fruit trees all unpruned, her hedges ruin'd,
> Her knots disorder'd, and her wholesome herbs
> Swarming with caterpillars..

While in *Hamlet* gardening is presented as the world's oldest and most benign occupation: 'Come, my spade. There is no ancient gentlemen but gardeners, ditchers and grave-makers; they hold up Adam's Profession.'

With the national poet so clearly interested in the national pastime, it is hardly surprising that so many gardeners responded to the 1919 appeal. In January 1921, *The Gardener's Chronicle* reported the planting of the main Shakespeare Garden built on the ruined foundations of New Place. In Chapel Street, between the main site and 'The Great Garden' (where Shakespeare is thought to have grown fruit and vegetables), they also created an Elizabethan knot garden. No 'disorder'd' knot this, it contained a patterned planting of pinks and herbs edged with box, thrift, lavender and thyme and enclosed by a cleft oak treillage.

Also this year...

First experiments in crop-dusting by aeroplane in Ohio

W.F. Bewley introduces Cheshunt Compound, used to drench soil to guard against damping off

Charles H. Pugh introduces the first motor mower for domestic use (the Atco)

Birth of garden writer and plantsman

Christopher Lloyd

Death of Sarah Elizabeth Backhouse (b.1857), wife of hybridist Robert Backhouse and herself a plant breeder of prodigious talents who produced daffodils and the Backhouse hybrid lilies involving Lilium martagon *and* L. hansonii

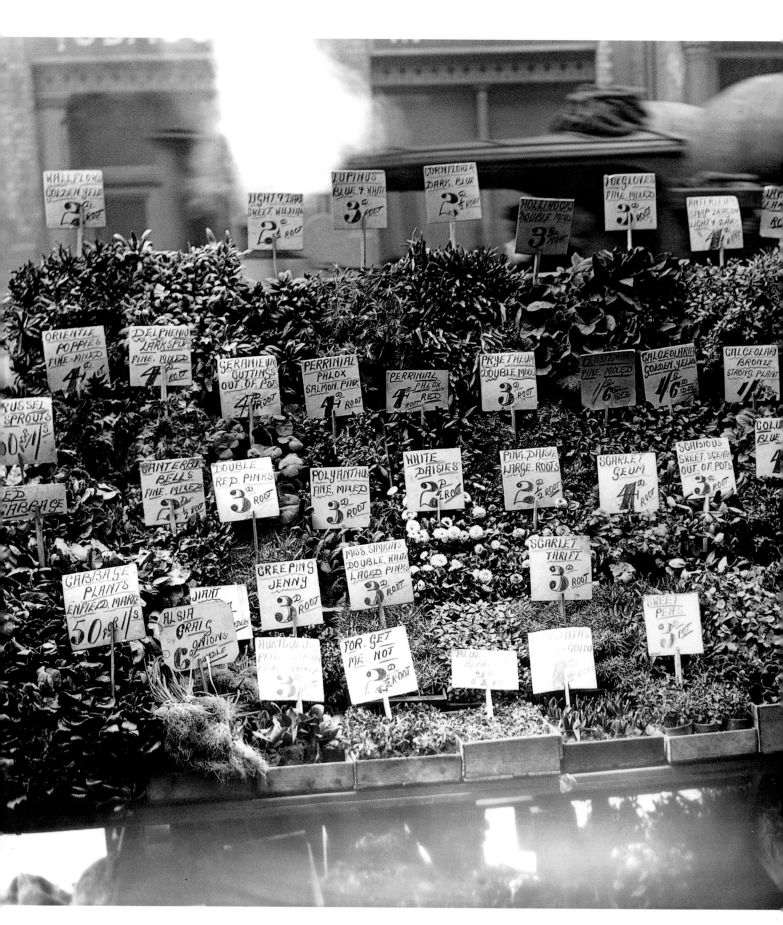

City stock prices

In London's Farringdon Street, a barrow offers 50 different varieties of bare-root plants for sale. Among them are vegetable seedlings – cabbage, Brussels sprouts and onions; tender bedding plants like calceolarias and pelargoniums; old-fashioned florist's fancies like auriculas and pinks, and traditional cottage garden plants – sweet Williams, cornflowers, hollyhocks and wallflowers, foxgloves and forget-me-nots.

Some of the plants on offer were of considerable vintage and soon to dwindle in cultivation – the Malmaison carnation, for example, is only now enjoying something of a revival. Others like *Coreopsis*, scarlet *Geum*, *Gaillardia* and golden creeping Jenny had already slipped in the estimation of gardening pundits from 'desirable' to 'vulgar' by 1922. Seventy years later they would recover their popularity.

The plants were grown in market gardens in Middlesex and carried to London daily for sale to City gardeners and the settlers of the new suburbs (garden centres had yet to happen). Apart from its sheer abundance encompassed in so small a space, two things are especially striking about the Farringdon Street barrow: the cheapness of the plants on sale (no exorbitant prices for imported container-grown stock), and the nurseryman's peculiarly partial spelling. Oriental is 'orientle', perennial 'perrinial' and Canterbury 'Canterby', whereas *Coreopsis*, *Penstemon* and Malmaison pose no problems. He prefers *Lupinus* to lupin, yet Delphinium is 'Delphenio' and *Geranium* 'Geranieum'. In his own idiosyncratic way, the stallholder was on first name terms with everything he sold – what better evidence of the gardener's refusal to be fazed by botanical Latin?

An excellent garden shop continued to trade more or less on this site until the end of the century. Latterly, and all too appropriately for a business in the shadow of Smithfield Market, it specialized in carnivorous plants.

Also this year...

Arthur Hill succeeds Sir David Prain as Director of Royal Botanic Gardens, Kew

The National Fruit Trials begin at Wisley (transferred to Brogdale, Kent in 1960)

The author of Trees and Shrubs Hardy in the British Isles, *W.J. Bean becomes Curator of the Royal Botanic Gardens, Kew*

Death of gardener, botanist, dendrologist, ornithologist, lepidopterist, soldier, explorer and big game hunter Henry John Elwes (b.1846). When not travelling, Elwes lived in inherited splendour at Colesbourne, the family's Gloucestershire seat. He monographed the genus Lilium, *co-wrote* The Trees of Great Britian and Ireland, *helped salvage* The Botanical Magazine *and ensure its continuation by the RHS (1920), and introduced many new plants, among them the snowdrop* Galanthus elwesii

Death of Sir Isaac Bayley Balfour (b.1853), British botanist and authority on Rhododendron *and* Primula

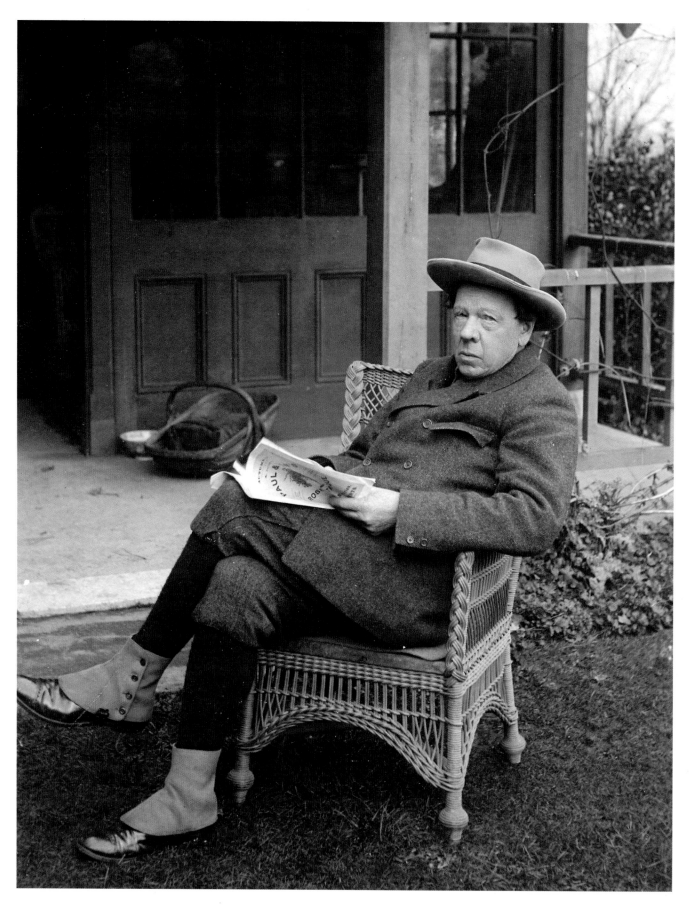

The man who bred the Shirley poppy

The Reverend William Wilks has two claims to horticultural fame. In gardens annual poppies tended to succumb to the disfiguring fungal disease black spot. At his Croydon parish of Shirley, Wilks set about breeding a race of disease-resistant poppies with a wider colour range than the scarlet red typical of their parent, the field or corn poppy, *Papaver rhoeas*. He succeeded, producing what became known as Shirley poppies – vigorous plants with single and double flowers in shades of white, pink and red. Wilks' abilities as a plant breeder were matched by his talents as an administrator, and it is to his credit that the Royal Horticultural Society entered the 20th century in robust health.

William Wilks was born in 1843 in Ashford, Kent. At Pembroke College, Cambridge, he studied Divinity, but was drawn to botany under the influence of Professor Charles Pritchard. After attending Wells Theological College and taking holy orders, Wilks became a curate in Croydon and, in 1879, vicar of Shirley, where he remained until his death in 1923. His garden at Shirley was outstandingly beautiful, and the site of his experiments in plant breeding. The latter qualified him to join the Floral Committee of the Royal Horticultural Society in 1880, and eight years later Wilks was appointed Secretary of the Society. The appointment was neither easy nor remunerative: the RHS had been in trouble for some years. By the time Wilks took office, membership had fallen below one thousand. He set about revitalizing the Society, acquiring offices, a hall for shows, and a research centre for horticulture. Membership rose above sixteen thousand, at which point Wilks, who had refused to take payment from such an ailing institution, thought again and paid himself.

The good vicar was awarded the Victoria Medal of Honour in 1912 and retired from the Society's staff in 1920, although he continued to serve on its Council. His published works include two important treatises on fruit written with the great apple breeder George Bunyard of the Royal Nurseries at Allington, near Maidstone (*Selected List of Hardy Fruits* and *Elementary Handbook of Fruit Culture*); but it is as the progenitor of one of our most irrepressible annuals and the saviour of the RHS that he is best remembered.

Also this year...

The first daffodil with a pink trumpet is exhibited by its breeder, Robert Backhouse, and named Narcissus 'Mrs R.O. Backhouse' *in memory of his wife (see 1921)*

The semi-circular parterre to the west of Kew's Palm House is turned into a rose garden with 113 beds containing over 6,000 rose bushes

Kew Museum keeper and arboriculturist William Dallimore (1871–1959) publishes his Handbook of Coniferae *with A. Bruce Jackson*

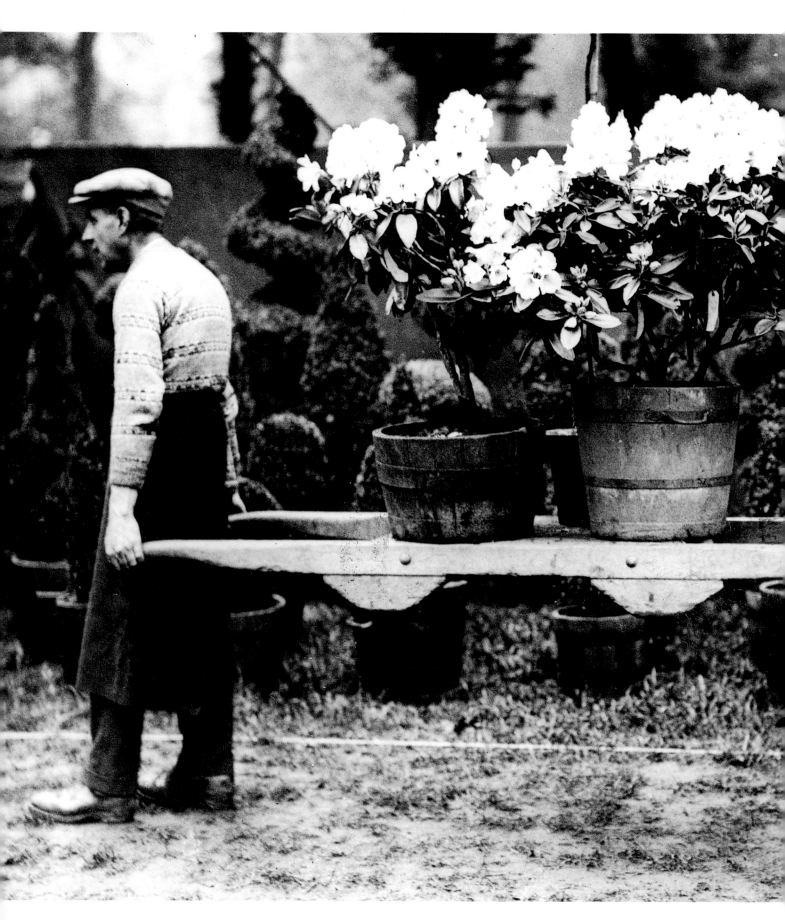

The carriage trade

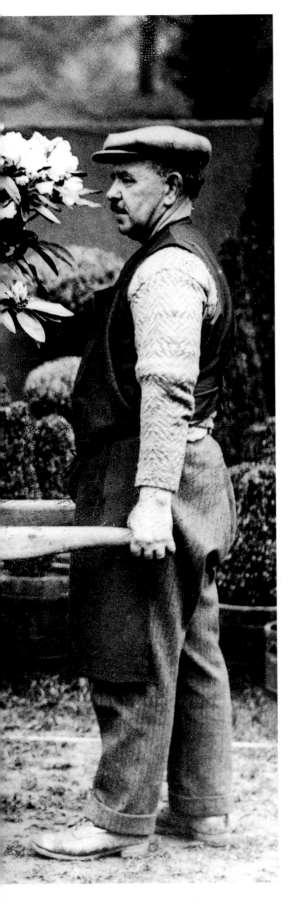

Porters carry rhododendrons to a Chelsea show garden. The *Rhododendron* was as much a phenomenon of British gardening in the 20th century as Chelsea itself. Indeed, the earliest shows to be held in the grounds of The Royal Hospital coincided with a great wave of *Rhododendron* introductions and hybridization. New species brought into British gardens from China, Burma and Tibet included *R. argyrophyllum*, with silver-backed leaves and white or pink, spotted flowers (1904); *R. adenogynum* with rose flowers and felty leaf undersides (1910); *R. basilicum* with rusty leaf undersides and pale yellow flowers tinted with crimson (1912); the dwarf *R. calostrotum* with broad grey-green leaves and magenta flowers (1919); the white or rose, spotted *R. glischrum* (1914); *R. lacteum* with suede-like leaves and yellow flowers (1910); and the bright crimson, dwarf *R. sanguineum* (1917).

These and many others like them were outstanding garden plants, discovered by plant hunters like George Forrest and E.H. Wilson and brought home to the gardens of great *Rhododendron* patrons like the 2nd Lord Aberconway and Lionel de Rothschild. In the first decades of the century, the *Rhododendron* ousted the orchid as the patrician's plant of choice. Within three years of this photograph being taken, a Rhododendron Association was formed, and, in 1930, the RHS established a Joint Committee for *Rhododendron* Trials to keep pace with their proliferation in gardens. Even in the century's closing decade this genus of some 800 species continued to surprise when Vireya rhododendrons (fluorescent-flowered species found deep in the forests of tropical Asia, Papua New Guinea and Australia) made their London debut at an RHS Westminster Flower Show.

For the moment, however, these two porters are charged with the task of delivering potential prize winners safely to what will be their home for Chelsea week.

Staging the show took exhibitors rather less time than it does today (a week), although the labour involved was evidently far greater. As with specimen shrubs and trees, large rocks had to be moved with ropes, trolleys and brute force. The fork-lift trucks and vans that make the show's panic-stricken avenues impassable on the Sunday before judging had scarcely been imagined in 1924. Adding further to the back problems of these two gentlemen was the fact that plastic containers and lightweight soilless potting composts had yet to be invented. Still, this method of transport at least gave the fellow in the rear an unrivalled opportunity to inspect the plants.

Also this year...

In conjunction with the Forestry Commission, Kew sets up the National Pinetum at Bedgebury

Frank Kingdon-Ward goes on expedition to Bhutan and Tibet; this expedition will bring Meconopsis betonicifolia *to England*

The average weekly wage for skilled

gardeners is 38 shillings

The British Iris Society is founded

Ernest Law creates a knot garden at Hampton Court

The RHS gives an Award of Merit to the 'Little Wonder' hedge clipper

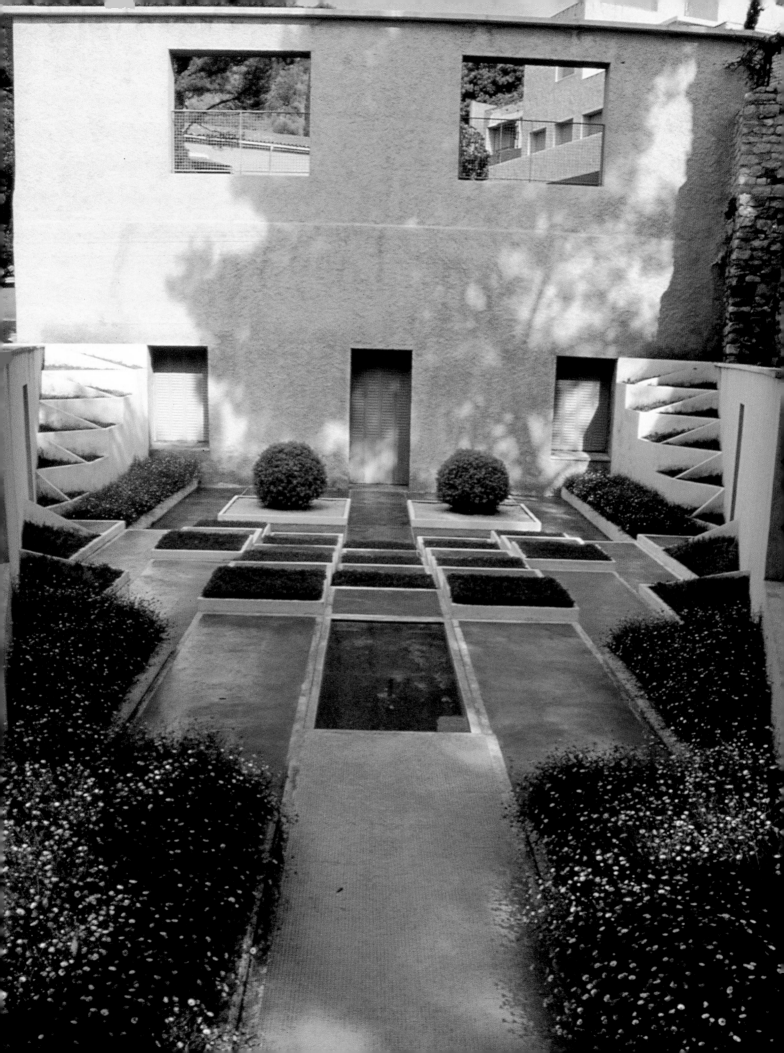

The shock of the new

In the 1910s and 1920s southern France became a showcase for innovative gardens commissioned for the villas of the rich. Responsibility for the phenomenon was laid partly at the feet of British gardeners like Sir Thomas Hanbury, whose magnificent private botanic garden, La Mortola, lay just over the Italian border at Ventimiglia, and Ellen Willmott, who gardened some way north at Aix-les-Bains. On the Riviera, British designers such as Harold Peto and Russell Page created gardens full of parterres, terraces, balustrades and fountains borrowed from the southern European tradition but rendered raffish, relaxed through exuberantly exotic planting and hard materials made to look soft in shades of honey and rose.

These garden makers, and the British preference for plants over formality, influenced French gardeners like Charles de Noailles whose villa at Hyères married modernism with plantsmanship worthy of any botanic garden. The terraces below it present a glorious prospect of olives and maritime pines mingling with the exotics de Noailles loved to collect. But Charles de Noailles was also behind another truly formal garden of startling originality. In 1925 he and his wife Marie-Laure were much taken by an exhibit staged by Armenian designer Gabriel Guevrekian at the Paris Exhibition of Decorative Arts. They asked Guevrekian to create a garden for them at Hyères, which is seen here restored exactly to his original plan.

The result, commonly called The Cubist Garden, owes more to De Stijl or Bauhaus than Cubism. Its grid of colour, water and lawn resembles a mosaic of enamels or a box of watercolours. Planting is radically simplified, the lines are sharp and straight. Through its intimacy and its use of colour, The Cubist Garden nonetheless conveys a playfulness and charm belied only by the fact that what appears to be a garden path is not and that it 'leads' to a blank-eyed Buster Keaton-type façade.

In its day the garden left many bemused, but by the end of the century elements – if not wholesale copies – of its gaudy geometry could be spotted at the major flower shows and in the backyards of the urban ultrachic.

Also this year...

Plant collector Harold Comber returns from the Chilean Andes and Argentine with many plants new to or rare in cultivation including Asterantha ovata, Berberis congestiflora, B. comberi, Desfontainia spinosa, Fabiana *and* Nothofagus *species*

Publication of Garden Craftsmanship in Yew and Box *by Nathaniel Lloyd, the first practical topiary manual*

Marion Cran, the first person to broadcast gardening talks on the radio, publishes her broadcasts under the title Garden Talks

William Robinson leases land at Gravetye to W.E. Th. Ingwersen to set up a nursery specializing in alpines

Death of Maria Theresa Earle (Mrs C.W. Earle) (b.1836), who wrote such works as Pot-pourri from a Surrey Garden *(1897, reprinted 11 times in its first year of publication, although her husband offered her £100 not to publish it), and* Gardening for the Ignorant *(1912)*

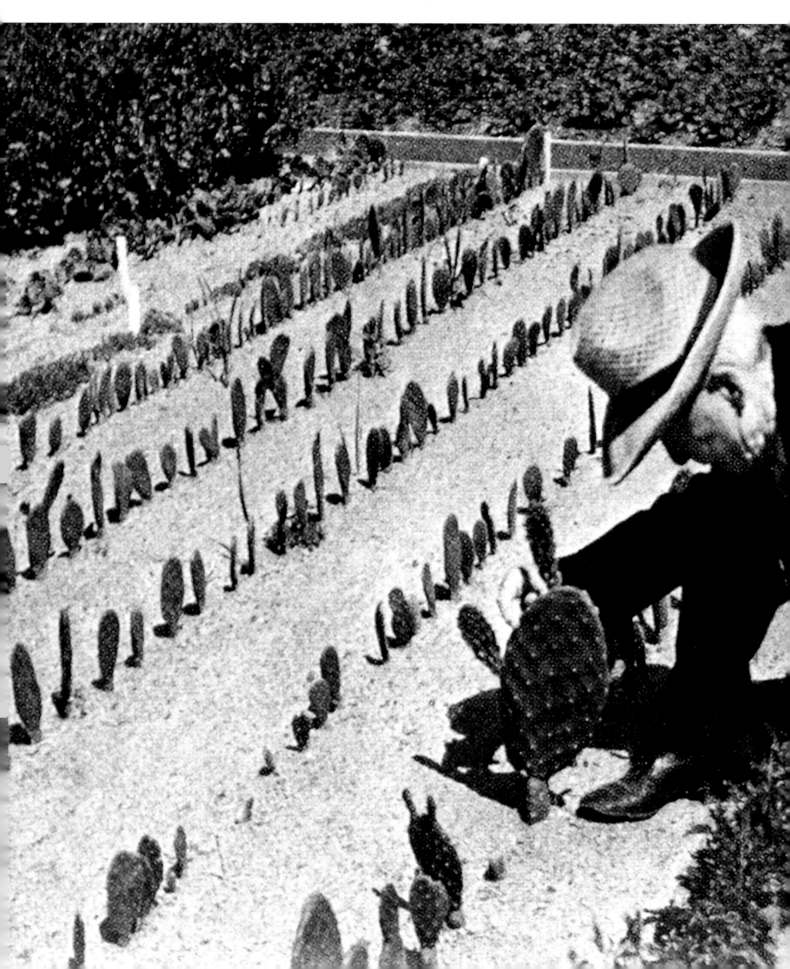

Luther Burbank

US plant breeder Luther Burbank dies, leaving a legacy of over eight hundred new varieties of fruits, vegetables, cereals and ornamentals. Born in Lancaster, Massachusetts in 1849, Burbank was educated at Lancaster Academy and, many years later in 1905, took a doctorate at Tufts. He began work at his uncle's plough factory, but turned to horticulture in 1870 when he bought a plot of land at Lunenburg, Massachusetts. Soon after, he developed the Burbank potato, a cultivar that showed considerable resistance to potato blight. He sold the rights to his potato in 1875 and moved on the strength of his $150 profit to California where he established a nursery at Santa Rosa. Here Burbank went to work developing a fast-growing, edible and thornless selection of the cactus *Opuntia*. Among the dozens of plum cultivars to originate from Santa Rosa were 'Gold', 'Wickson', 'Eldorado', and 'Climax'. Burbank prunes included 'Giant Splendor', 'Sugar', 'Standard' and 'Stoneless'. There was also a new hybrid fruit, the plumcot.

Santa Rosa soon became a cornucopia of new breeds – cherries, apples, peaches, nuts, edible berries and cereals. Burbank could also number such well-known ornamentals among his achievements as the fire poppy, the Burbank rose, the shasta daisy and the ostrich plume clematis. As is plain from the titles of his publications – *Training the Human Plant: Methods and Discoveries*, and *How Plants are Trained to Work for Man* – Burbank's approach to plant breeding was a unique mix of scientific innovation (techniques for mass pollination, for example), extravagant flair and earthy mysticism. He was a true American pioneer.

Also this year...

Vita Sackville-West publishes her poem The Land

T.R. Hayes of Ambleside, a nursery firm, designs the rock garden at Sizergh Castle

The Institute of Park Administration is founded

Euan Cox publishes Farrer's Last Journey

Death of Thomas William Sanders (b.1855), author of the classic Sanders' Encyclopaedia of Gardening *and editor of* Amateur Gardening *since 1887*

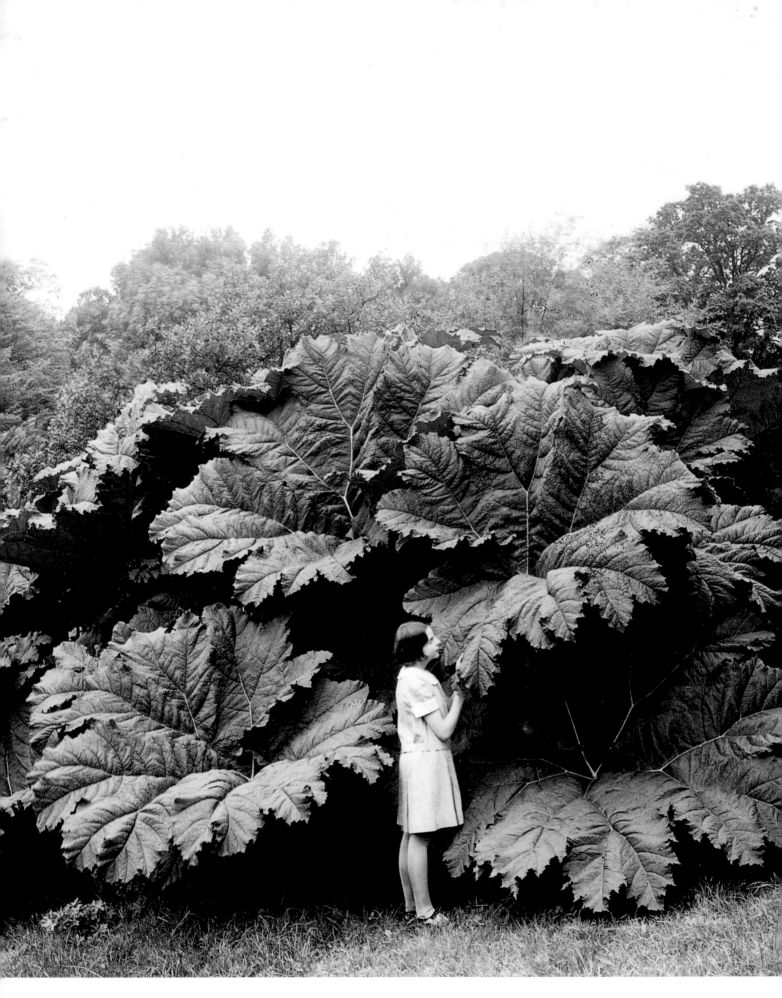

Miss Malby and the Gunnera

A snapshot culled from the albums of the great plantsman E.A. Bowles shows little Miss Malby beside the leaves of *Gunnera manicata*. The giant rhubarb (in fact no relation of rhubarb but a member of its own family, Gunneraceae) was introduced from southern Brazil in 1867, and took British gardens by storm. Here was a perennial that outdid the most gargantuan exotics in cultivation but could be grown outdoors with minimal winter protection.

Travelling in Chile in 1834, Charles Darwin measured a leaf of *Gunnera tinctoria*, 'which was nearly eight feet in diameter, and therefore no less than twenty-four in circumference! The stalk is rather more than a yard high, and each plant sends out four or five of these enormous leaves presenting together a very noble appearance'. The species Darwin encountered is somewhat smaller than Miss Malby's.

Gunnera manicata did particularly well in the damp, mild gardens of Devon and Cornwall. In *The English Flower Garden*, William Robinson relates the comments of a Truro gardener: 'It never attains the extraordinary dimensions it is capable of unless planted in a deep, rich soil with its roots in the water by the side of a pond or stream. Our plant covers a space fully 30 feet across and consists of from 25 to 30 leaves, some of them over 9 feet in diameter, upon clear stems 8 feet high.'

Robinson himself was unconvinced, 'These plants have attraction, but I never planted them, as they did not seem to be quite at home in an English garden.' The problem for Robinson, who remained our most fearsome arbiter of horticultural fashion up until his death in 1935, was not so much the *Gunnera*'s well-being as its incongruity. E.A. Bowles had no such scruples. His specimen thrived at Myddelton House, much to the delight of the children who flocked to his garden to play. Not that it should have done – the soil was basically dry and gravelly and the ground water viciously hard; but as Bowles himself remarked, 'I believe the great secret for ensuring its reaching gigantic proportions...is to feed the brute.'

Also this year...

British plant hunter and hybridist Collingwood Ingram collects ornamental cherries in Japan and introduces Gladiolus species and Kniphofia galpinii *from South Africa*

Foundation of the Rhododendron Association, which absorbs the Rhododendron Society four years later

D. Fyfe Maxwell publishes The Low Road, *the first of his books promoting the planting of heather gardens*

Plant collector Euan Cox publishes The Modern English Garden

Mrs C.F. Leyel founds the Society of Herbalists (later renamed The Herb Society)

First report of Dutch Elm Disease in Britain

Elsie Wagg and Lady Georgina Mure of Queen Victoria's Jubilee Institute for Nurses found the National Gardens Scheme as a memorial to Queen Alexandra

Villa Savoye

Le Corbusier has been described as dominating modern architecture in much the same way that Picasso dominated painting. Architectural historian Charles Jencks describes him as 'arguably the greatest architect of the 20th century... Why? Because of Le Corbusier's undeniable creative potency: he left us a mass of technical-aesthetic inventions which have had a widespread influence on world architecture probably comparable only with Palladio's influence in the past. He changed, or was instrumental in changing, the aesthetic direction of modern architecture twice: once in the1920s with his philosophy of 'Purism' and once in the 1950s with his sculptural form of 'Brutalism'.' Le Corbusier's Purist period culminated in two 'ideal villas': the Villa Stein at Garches and the Villa Savoye at Poissy, both near Paris.

The villa at Garches was lived in by Gertrude Stein's brother while the villa at Poissy was built between 1928–31 as a luxurious weekend retreat for clients who, Le Corbusier said, had no preconceptions as to what new architecture could be. Both villas incorporated the principles of what Le Corbusier called the 'Five points of a New Architecture'; these included the garden which was made possible by the flat roof, and the idea of the house being on stilts or *pilotis*, which lifted the building from the earth and freed the ground beneath.

The roof gardens reflect the architecture of the interior of the house, with purity and simplicity being paramount. Wide, open walkways and areas on several levels are connected by dynamic ramps rather than traditional steps. The pure white walls of the house add to the sense of space in the roof garden, which is starkly ornamented with plantings and sculptural shapes integral to the architecture. The sparse grounds surrounding the Villa Savoye serve to heighten the startling effect of Le Corbusier's white cube of a building, poised, seemingly hovering, above the flat green field – an effect which was criticized by many architects for looking like an alien space capsule that had just touched down on a Virgilian landscape.

Also this year...

A small aircraft crashes and burns at the western end of Kew's Syon Vista

The British Delphinium Society is founded

Euan Cox founds the magazine New Flora and Sylva

The RHS gives an Award of Merit to Rolcut Ltd for their secateurs

A partnership is formed between Russell Page and Geoffrey Jellicoe, founder-members of the Institute of Landscape Architects. They are soon working on such projects as the Royal Lodge, Windsor, and the grounds of Charterhouse School

E.A. Bunyard of Maidstone introduces the 'Golden Delicious' apple into England

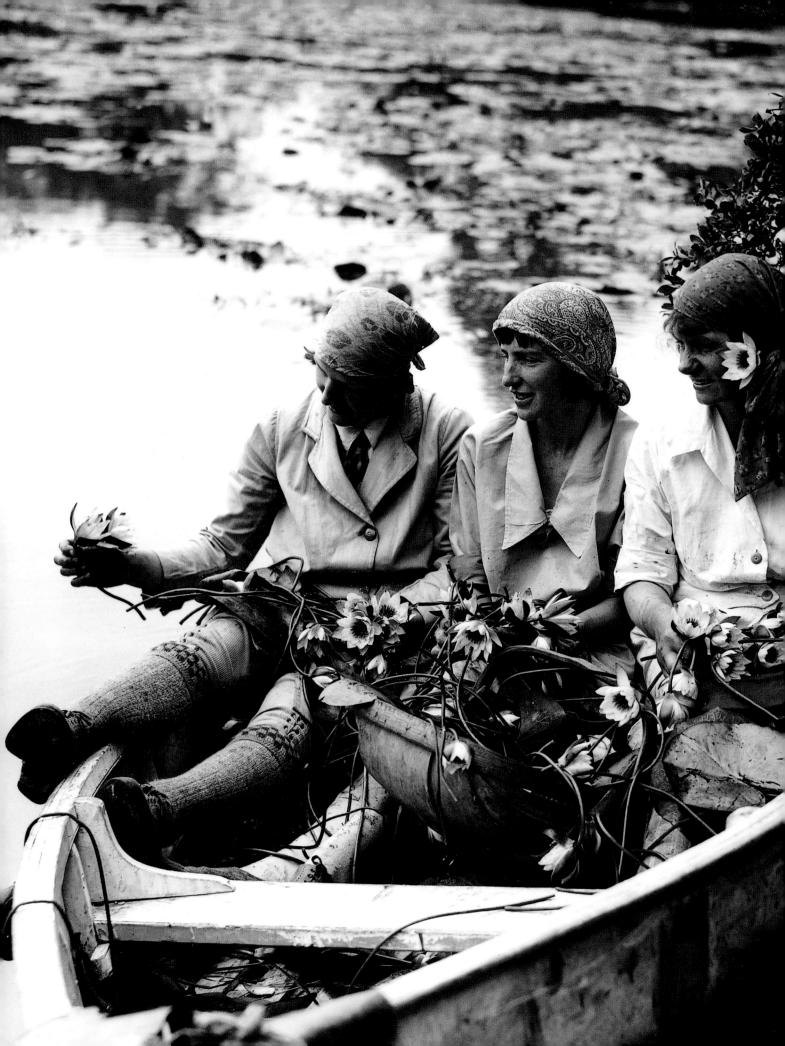

The lotus gatherers

Women land with a boat full of freshly gathered waterlilies. One of the more unlikely florist's flowers, waterlilies had been farmed in lakes on a limited scale since the second half of the 19th century. The species involved is not our native *Nymphaea alba*, but the fragrant waterlily, *N. odorata*, which was introduced to British gardens from North America in 1786. It differs from the European waterlily in having larger flowers which are often held clear of the water and exude an intoxicating perfume. The blooms are typically white, although cultivars and hybrids can range from ivory with a basal blush of wine red through pale rose to orange-pink and magenta. In this species the blooms can last several days even once cut. Like most waterlilies, however, its flowers close tightly at dusk – the very time when they would have been expected to be gracing dinner tables and corsages. Florists solved the problem by dabbing the base of each outer petal with wax to hold it in place.

As cut flowers, waterlilies were already falling from favour when this photograph was taken – partly due to their expense, but largely because of changing fashions. As ornamentals, they had not long arrived in many British gardens, which is surprising given that several gardening cultures had long before been aware of their value. For the ancient Egyptians, the Nile lotus (*Nymphaea caerulea* and *N. lotus*) was sacred and appeared in wall decorations, as an architectural motif and preserved in the bindings of mummies. The Chinese grew them in pools and large containers at least as early as the 10th century AD, as did the Japanese from the 17th century onwards.

Our own attitude to water gardening – and waterlilies – took a while to catch up. Francis Bacon declared that pools 'mar all and make the garden unwholesome and full of flies and frogs'. In 1731, Philip Miller allowed that aquatics did very well in large troughs, but quibbled over the expense of having to line such containers with lead. It was not until the mid-19th century that the waterlily became a desirable garden plant, and then it enjoyed, for a while at least, something like cult status. The French nursery-man Marliac-Latour gave impetus to the craze by breeding a range of beautiful and hardy hybrids in the 1860s and 1870s. In the 20th century, hybridization continued under George Pring at the Missouri Botanical Garden in St Louis.

But it was the small pond that did most to boost waterlilies in gardens. With water gardening attracting more and more followers (a new magazine devoted to it has per-fomed buoyantly this year), what was once an ephemeral cut flower for the rich has become one of our most enduring perennials.

Also this year...

Plant collector Harold Comber journeys to Tasmania for a syndicate headed by Lionel de Rothschild. He collects Eucryphia x hybrida *and* E. milliganii

Sir William Lawrence founds the Alpine Garden Society

The Institute of Landscape Architects is founded

Architect and landscape architect Sir Reginald Blomfield is appointed adviser on landscape to the Central Electricity Generating Board, for whom he has already designed the electrical pylon

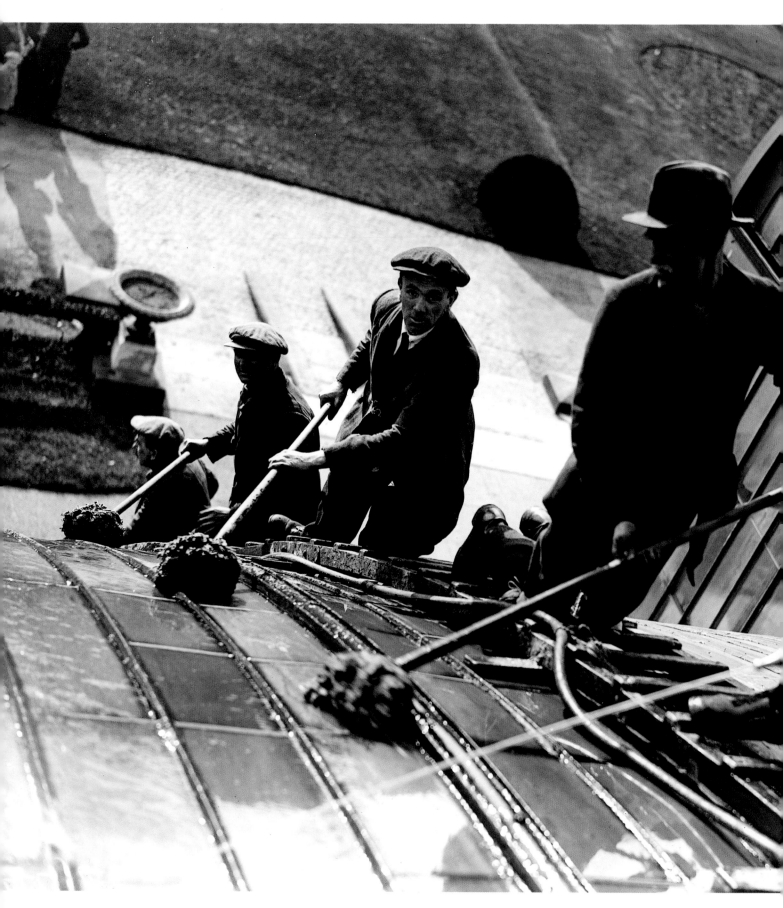

Walking on wet glass

When Kew's Palm House was completed in 1848, it was, as its builder Richard Turner had promised, 'unequalled as yet, by very far and not likely to be surpassed'. With 60 wrought iron half arches and 16 cast iron pillars, it was over 360 feet long, 100 feet wide and 63 feet high. Heat came from 12 boilers which led to a nearby chimney, 107 feet tall and designed to resemble a Romanesque campanile. Kew's Director, William Hooker, was delighted and Queen Victoria declared herself 'enchanted' with the new glasshouse; but Kew's Curator, John Smith, had misgivings. He felt the Palm House was little better than a railway station or 'some dockyard smithy'. Sure enough, six years later, Richard Turner did in fact put a glass roof on Liverpool's Lime Street Station. The Curator's objections notwithstanding, the Palm House soon became an iconic building for Kew and for botany worldwide.

For all the Palm House's pre-eminence as an example of 19th-century functionalism, John Smith's problems with it were partly to do with its functioning. The Great Stove which the Palm House superseded had been a fairly straightforward rectangular structure with a pitched roof. The Palm House is all curves. Maintenance becomes peculiarly difficult, and especially for those like the gardeners shown here, who are charged with cleaning the glasswork.

The operation was sometimes repeated throughout the year, whether to remove grime, moss and algae, or to apply and wash off coats of whitewash shading. A matter of clambering on ladders and inching over the glazing bars on crawling boards, cleaning the exteriors of glasshouses is never a pleasure, hence the 'mustn't grumble' expressions worn by these gardeners. No matter how many times one has done it before, walking on wet glass high above the ground is a job to be undertaken lightly only in the most literal sense.

Also this year...

The RHS establishes an Associateship of Honour, to recognize people who have contributed significantly to horticulture in the course of their employment

Harold Nicolson and Vita Sackville-West acquire Sissinghurst Castle and begin making a famous garden

Lord Fairhaven begins making a garden at Anglesey Abbey

At Blenheim Palace, Achille Duchêne completes a baroque revival water garden for the Duke of Marlborough

Publication of The Species of Rhododendron, *edited by John Barr Stevenson, for nearly half a century the guide to their classification*

Irish physician, plant hunter and arboriculturist Augustine Henry (b.1857) dies in Dublin

Death of Samuel Arnott (b.1852), Provost of Dumfries, horticulturist and author who specialized in colchicums and snowdrops (e.g. Galanthus 'S. Arnott')

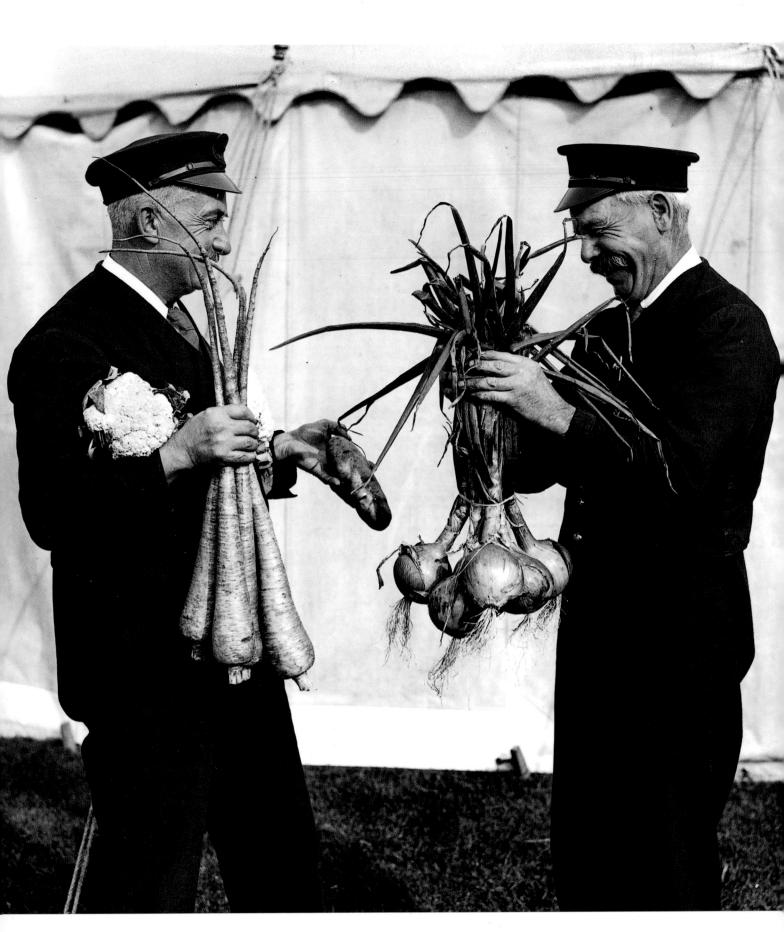

Transports of delight

A friendly stand-off between competitors at the Southern Railways Fruit and Vegetable Show in Raynes Park, London. The public transport network had developed a gardening tradition entirely of its own over the preceding 80 years, one which peaked in the 1930s. Station masters took an intense pride in cultivating small gardens on platforms and decorating station buildings with window boxes and hanging baskets. Even in the heart of London, train stations came to resemble pocket paradises. At Farringdon, for example, commuters were welcomed by platforms lined with herbaceous borders. The railwaymen probably took their cue from lock keepers who had been transforming stopping points along the canal system with beds of annuals and flowering shrubs since the early 19th century.

Station and lock gardens both were objects of fierce but friendly rivalry. Competitions sprang up across the country not only to find the best gardens but also to encourage workers to grow and show their own produce. Astonishingly, given the present governance of our public transport systems, these activities were encouraged and to some extent funded by the railway and canal management who could see only benefits accruing from them to staff and passengers (or must one call them 'customers'?) alike. The railway garden was a wholly benign and very British phenomenon of a type that seems to have been forgotten – an attempt to brighten the working lives of railwaymen and relieve the travails of travellers.

Railway gardens suffered, quite understandably, during the Second World War, and entered a terminal decline with the rise of the motor car and the savage line closures of the 1960s. A few survive, but in sadly reduced circumstances, and the modern-day equivalents of station masters certainly receive little incentive from their employers to revive the art.

Also this year...

Frank Kingdon-Ward publishes Plant Hunting in the Wilds

Le Corbusier's Villa Savoye is completed

The National Trust for Scotland is founded

Maud Grieve publishes A Modern Herbal

Gertrude Jekyll

For many the most important English garden designer of the century, Gertrude Jekyll dies in her 89th year. Born in London in 1843, she moved to Munstead in rural Surrey following the death of her father. It was here as an infant that she developed a passion for plants. She studied at the Kensington School of Art and in the early 1880s bought 15 acres of woodland at Munstead, where she practised painting, photography, carving and silver work in 'The Hut', her workshop among the trees.

As her eyesight deteriorated, Jekyll turned away from arts and crafts and towards gardening. In 1882 she contributed the first of many articles to William Robinson's magazine *The Garden*. This piece was on colour schemes, an old subject to which Jekyll brought new eyes, the eyes of a painter and designer with a love of natural abundance over tight formality. For all that, she was attacked for 'attempting in another way, and with greater variety of materials, what the bedding man has been aiming at all along'. In 1889 she met the architect Edwin Lutyens and commissioned him to build a house to stand in her garden at Munstead Wood. It was the beginning of a fruitful partnership – by the time the house was finished in 1897, they were at work on other commissions. Lutyens would draw out the bare bones of the garden, the layouts and hard landscape, while Jekyll created planting plans. These maps of shrubs, perennials and annuals would translate from the inky outlines and scrawl of Jekyll's hand to exquisite, live compositions.

Covering such subjects as lilies, wall and water gardening, roses and colour in the garden, Jekyll's many books began with *Wood and Garden* in 1899. Several collections of her articles exist, the best of which is *A Gardener's Testament*, published posthumously in 1937.

Ever practical, Jekyll wore hobnail boots and bottle-glass spectacles. Although she designed for a new generation of country house owners, she never forgot her early love of wild places and cottage gardens. This was reflected in some of the plants she favoured – lavender, honesty, primroses, love-in-a-mist (including *Nigella* 'Miss Jekyll', right), and columbines. Having abandoned fine art and taken up the arts of the garden, Jekyll's mission was to make 'pictures of living plants'. Artfully naturalistic and subtle as it was colourful, her style set the tone for some of the century's greatest gardens. She was as English as Elgar.

Also this year...

British plant collector Edward Kent Balls returns from the first of several expeditions to the Near East that will yield new species of Dionysia, Cyclamen, Geranium *and* Campanula

Theo Stephens founds the magazine My Garden, which runs until 1951

Beatrix Havergal moves her gardening school for women to Waterperry in Oxfordshire

Sir David Bowes Lyon acquires St Paul's Waldenbury, Herts, and begins to restore the garden

Scots plant hunter George Forrest (b.1873) dies of a heart attack at Tengyueh, Western Yunnan. He had spent much of his 28 years as a collector in the mountains of north-west China, surviving murderous monks, famine and civil war. He sent over 30,000 parcels of specimens and seeds back to his sponsors, and discovered some 1,200 plant species new to science

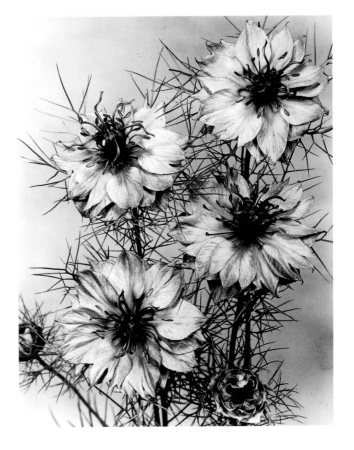

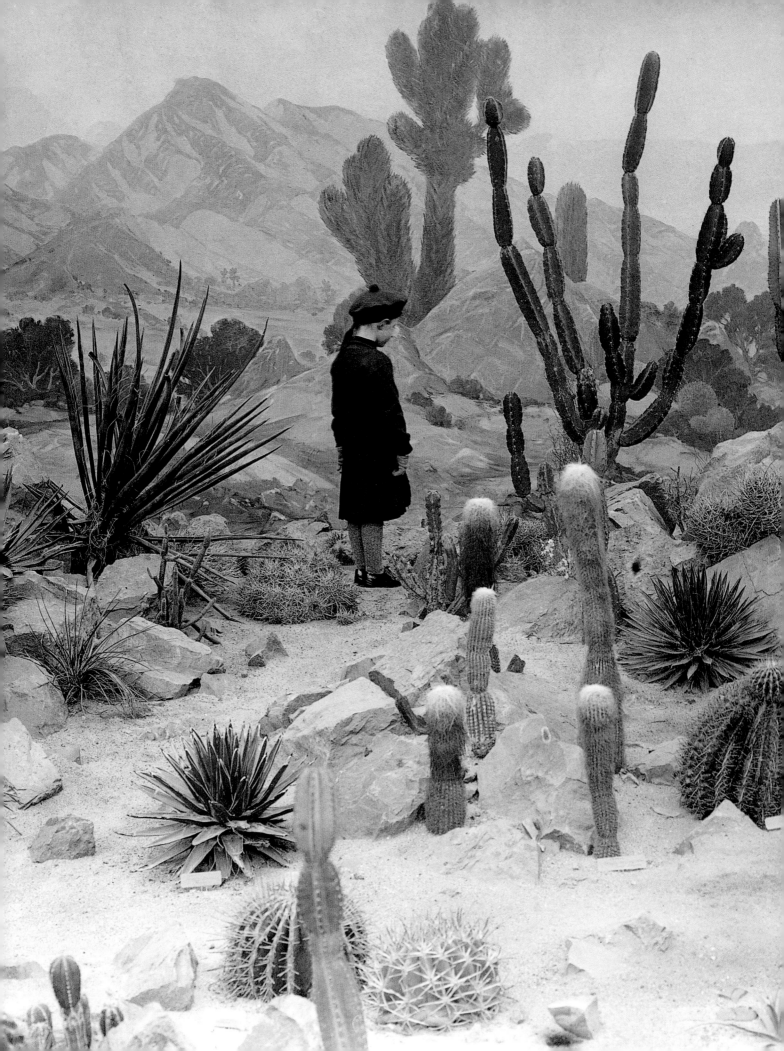

Sweetness in the desert air

In 1929 Mrs Sherman Hoyt of Pasadena exhibited a display of southern Californian desert flora at the Chelsea Flower Show. Behind them was a backdrop painted by Perry McNeedy – a panorama of giant saguaros, hazy mountains and purple sage. Having triumphed at Chelsea, Mrs Hoyt decided to donate the plants and painting to the Royal Botanic Gardens, Kew, and to provide funds for housing them.

Designed by J.H. Markham of the Ministry of Works, the Sherman Hoyt House opened in 1932. Early the following year this small visitor in gloves, woolly socks and tam-o'-shanter, stepped from an icy London January into the dry heat of a Sonoran summer. The house provided a bright and arid annexe to Kew's T-Range, a warren of equatorially wet and luxuriant hothouses which had been completed in 1869 and would survive until 1983. The new display included cacti like the barrel-shaped *Echinocactus*, white-wigged *Cephalocereus* and prickly-padded *Opuntia*; sword-leaved sisals and sotols, *Agave* and *Dasylirion*; and the spectacular boojum tree (*Fouquieria*) with savagely spiny, whip-like branches belied by honey-sweet primrose flowers.

Although cacti and succulents had been found in British gardens since the 17th century (William and Mary grew them at Hampton Court Palace), the Sherman Hoyt House was unusual in presenting a sample of the unique desert flora of the Southwestern States: several of these plants were new to European gardens, and several have since become endangered in the wild because of their very attractiveness to gardeners. The display was also pioneering in its use of landscaping: the plants were shown as if in nature and grown in an environment that attempted to recreate their native climate. This was part of a trend – horticulture's equivalent of the shift in zoos from caged menagerie to landscaped enclosure and wildlife park – that peaked in 1987 when Kew opened the Princess of Wales Conservatory. Built on the site of the T-Range, the Conservatory is divided into a series of areas each simulating a habitat and with its own controlled environment. One of the most successful of these is the section devoted to cacti and succulents, where some of Mrs Hoyt's plants, and her Californian panorama, can still be seen.

Also this year...

The third volume (a supplement) of W.J. Bean's Trees and Shrubs Hardy in the British Isles *is published*

Fifteenth and final edition of William Robinson's The English Flower Garden *is published. It first appeared in 1883*

The inaugural meeting of the RHS Lily Group is held

Phyllis Reiss begins replanning the gardens at Tintinhull, Somerset

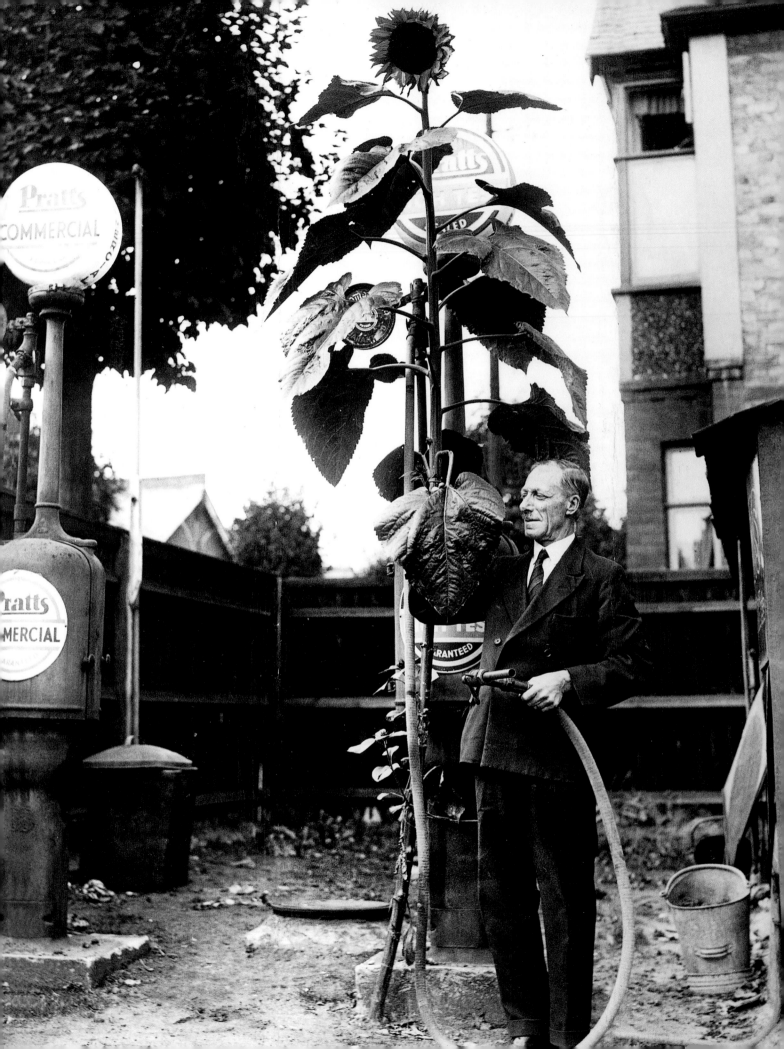

'High Test'

A sunflower seed dropped by a bird onto a garage in Teddington, Middlesex, germinated on nothing more than fuel-soaked concrete at the foot of a petrol pump. In less than ten weeks, it had reached a height of 12 feet 2 inches. The brand of petrol involved was 'High Test'. Images of giant sunflowers in odd places were fairly common either side of the Second World War: the sunflower was a cheery, proletarian monster, cheap to buy, easy to grow and gloriously out of tune with the 'good' manners and manicure preached to gardeners at the time.

Earlier in the century, sunflowers had enjoyed rather more cachet. For the rump of the aesthetic movement, the flower of choice after the Madonna lily was not a green-dyed carnation but a sunflower. They were held in equally high esteem by plant connoisseurs like the great William Robinson: 'Although often regarded only as a cottager's flower, the Annual Sunflower is one of the noblest plants we have and one of the most effective for various positions.' Robinson was also aware of a number of varieties of annual sunflower (*Helianthus annuus*) other than the typical golden giant; these included smaller plants, some of them extensively branching and others with pale yellow or coppery red flower heads. The red sunflowers were derived from a wild specimen discovered in 1910 by a Mrs Cockerell in Boulder, Colorado. Hybrids between it and the typical sunflower produced variations ranging from solid deep chestnut through streaks and stripes to glowing amber. In the years before the First World War, the English seed firm Suttons crossed the giant annual sunflower with the smaller *H. debilis* to produce bushy plants that bear a number of flowerheads in shades of pale yellow, deep gold and mahogany.

In the 1960s and 1970s the sunflower, like many flamboyant annuals, was eclipsed by the rise of perennials and plants that were thought to conduct themselves with a little more class and restraint. Sunflowers became instead a staple of children's gardens, food for the birds, and the world's second largest source of vegetable oil after soyabean. This continued until the mid-1990s, when, 400 years after its introduction to British gardens, the sunflower shone again. A revival of interest in annuals coincided with a fashion for plants with flowers in shades of yellow, orange and red, and especially for late-flowering members of the daisy family. The hybrids made and forgotten earlier in the century were remade, resulting in cultivars like 'Moulin Rouge' with deep burgundy, velvety flower heads, and the multi-flowered, primrose and chocolate-centred 'Moonwalker'. By the end of the century, the sunflower had passed the highest test of all and was outpricing orchids and lilies as a cutflower.

Also this year...

Plant collectors Frank Ludlow and George Sherriff begin collecting in Bhutan

Eric Savill begins work on the Savill

Garden in Windsor Great Park

Ellen Willmott (b.1858), English plantswoman and author, dies

High-rise gardening

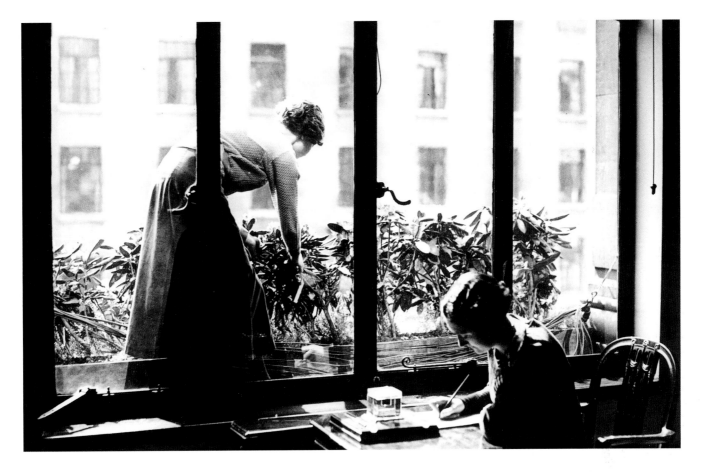

The window box has a venerable pedigree. The Ancient Greeks grew short-lived cereals, herbs and brightly coloured flowers in urns and bowls on their rooftops and windowsills. This was a quasi-religious practice that began as part of the cult of Adonis but whose decorative side-benefits soon became apparent. Next, the Romans took up the idea of adorning windowsills and, with characteristic pragmatism, constructed rectangular planters similar to those we know today. Window boxes that appear in paintings and horticultural texts from the Middle Ages onwards show a gradual evolution from the miniature coffin filled with wet earth and liable to plummet at any moment onto passers-by, to a thoughfully designed and permanent container complete with drainage and secured with hefty fixtures. For the Victorians, always pushing at the limits of the decorative arts, the window box presented all manner of opportunities. Mass-produced in metal or china, theirs were available in a staggering range of styles from the neo-classical to arts and crafts by way of putti-infested mock rococo and rustic die-cast branches.

In the 20th century, the window box increased in popularity as cities became denser, buildings taller and the prospect of 'real' gardening more remote. In 1935, this courageous woman (above) waters a high-rise window box as part of her daily office duties. Oddly, the plants involved are rhododendrons, and, to judge by their curling leaves, none too fond of life at the top. Annuals, bulbs and other replaceable plants of short duration are altogether better-suited to the task of brightening façades and surrounding an urban view with a green frame. But even they need regular maintenance, a job which the gardener (left), armed with only a three-gallon can and a head-spinning ladder, must surely have dreaded.

Also this year...

In Les Jardins de l'Avenir, French designer Achille Duchêne heralds a democratic era of gardening, 'an art of great power put in the service of the community'

Death of gardener, author and editor William Robinson (b.1838)

Gardens in the sky

In a leap that spans millennia, the cultivation of plants on rooftops, balconies and terraces links the gardens of the 20th century with those of antiquity. The ziggurats of Mesopotamia were festooned with vegetation. Built around 600BC, the Hanging Gardens of Babylon brought to early perfection the art of planting and maintaining lush borders and groves along the terraces of stepped pyramids – a tower of vegetation strikingly incongruous amid the dry, stony wastes. Potplants were a common sight on the rooftops of Athens and other ancient cities of the Mediterranean and Aegean; in Rome and Pompeii roof gardening attained a sophistication we might envy today, and balcony gardens were *de rigueur* in Constantinople. A little later and in another world entirely, the Aztecs grew ornamental and edible plants on the roofs of their homes. For much of the first 2,000 years of the Christian Era, however, the garden was removed from its celestial pedestal and returned to the earth, where it was thought it belonged. Balconies and terraces aside, the challenge and pleasures of making gardens in the sky were for the most part ignored until 1867 when the builder Carl Rabbitz presented a model of his Berlin house, complete with roof garden, at the Paris World Exhibition. The garden stimulated enormous interest – and much frustration. Prevailing architectural fashions hardly favoured rooftop plantings, while the building materials and practices of the time meant that any gardener brave enough to take to the skies risked burial in his own bed, or at best a deluged drawing room. With the coming of the 20th century all changed. Architects like Frank Lloyd Wright and Le Corbusier were fascinated by the horticultural possibilities presented by the summits and faces of their own buildings. Modernist design echoed the rectilinear, flat-roofed or stepped structures of ancient civilisations. Most importantly, materials had improved and technology advanced.

Between 1932 and 1940, the century's defining architectural form reached new heights with the construction of New York's Rockefeller Center, built on the site of Manhattan's old Elgin Botanical Garden and conceived as a clump of skyscrapers. Cyril Connolly may have dismissed it as 'that sinister Stonehenge of Economic Man', but the Rockefeller Center provided a unique opportunity for the creation of the largest and – at the time – highest hanging gardens in the world. As early as 1936 the gardens were already looking remarkably mature. Designed by Ralph Hancock, their centrepiece was the Garden of the Nations 11 storeys above 50th Street. Bravely taken from the 35th floor of the RCA Building, this dizzying shot shows the garden's 12 areas. Most were designed to recreate great national gardening traditions – English, French, Dutch, Japanese, Spanish and Italian. Others embraced horticultural ideas that even today seem innovative. These included a starkly modern garden, bird sanctuaries and schemes devoted to American native plants.

Also this year...

Crystal Palace is destroyed by fire

G.C. Taylor publishes The Modern Garden

Death of the Reverend George Herbert

Engleheart (b.1851), cleric, classicist and poet, who bred daffodils with extraordinary success, producing such cultivars as the orange-cupped 'Will Scarlett' and the pure white 'Beersheba'

Shaping up nicely

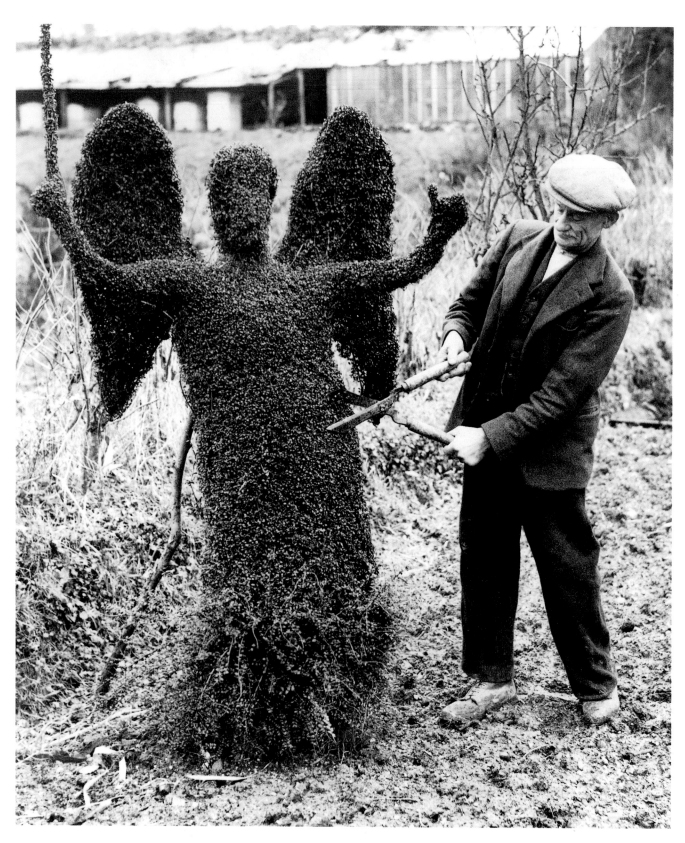

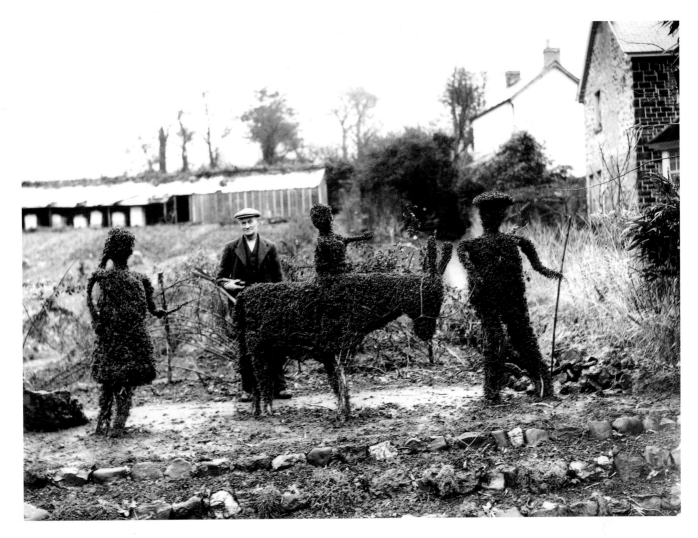

'Topiary' comes to us from the Latin *topiaria*, meaning, quite simply, ornamental gardening. The word became attached and then restricted to the art of sculpting trees and shrubs largely as a result of a passage in Pliny where he uses it to describe hunting scenes and ships shaped from trees. According to Pliny, the art had been pioneered by Gaius Martius around the end of the 1st century BC. In his *Letters*, Pliny's nephew also refers to hedges clipped into the forms of initials. During the Renaissance, the revival of interest in classical gardening led to a topiary craze and Florentine gardens became populated with verdant figures of giants, warriors, philosophers and even the occasional cardinal.

Inanimate subjects were also sculpted – vases, obelisks, triumphal arches and spheres. It was these architectural motifs that found most favour among gardening pundits of the English Renaissance; Francis Bacon, for example, was fond of topiary columns and pyramids but decidedly snooty about the human form, 'Images cut out in juniper or other garden stuff: they be for children.'

Three centuries after Bacon wrote his essay *Of Gardens*, David Davies of Carmarthen would certainly have disagreed with him. The Welsh topiarist had been painstakingly sculpting this scene of Mary and Joseph with the infant Jesus on a donkey (above) over a period of years. They were the centrepiece of his topiary 'Garden of Eden', a living tableau of Bible stories fashioned from the bushy evergreen honeysuckle *Lonicera nitida*.

Also this year…

Publication of Gertrude Jekyll's collected articles, A Gardener's Testament

Russell lupins, which gardener George Russell had been secretly breeding for years, are first exhibited at a Westminster Flower Show and cause a sensation

W.W. Pettigrew, Superintendent of Parks for Manchester, publishes Municipal Parks, *still the only British textbook on the subject*

Birth of plantsman Roy Lancaster

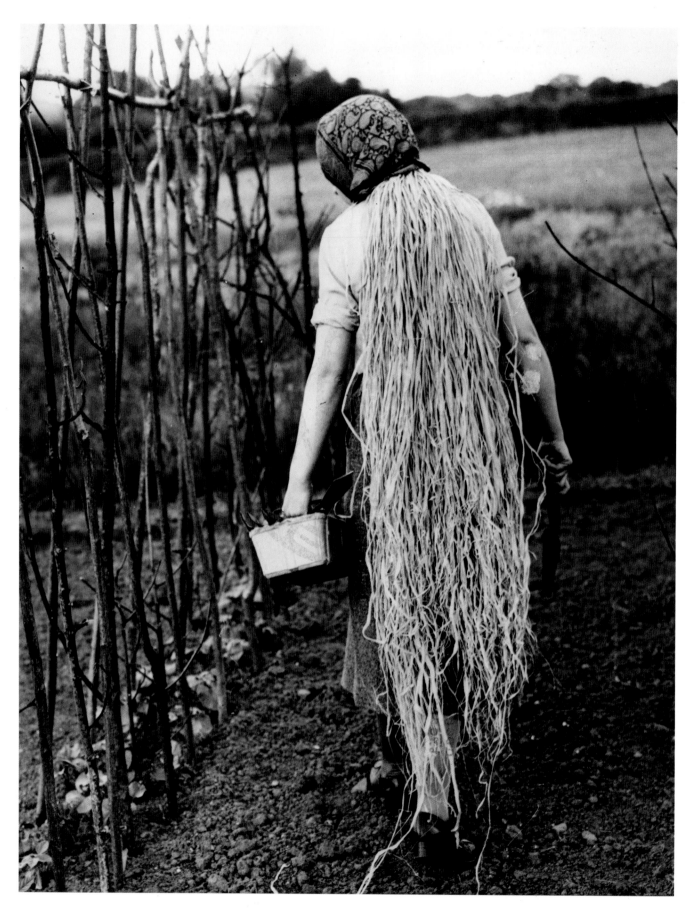

Intermediate technology

The century was one of huge technological advances in horticulture, but some problems remained insoluble and some of the oldest methods were unimprovable.

Scorching tender new shoots, late frosts present a grave threat to plant life stirred into growth with the onset of spring. In the early hours of the morning, when the thermometer registered six degrees of frost, one nurseryman lit 20,000 fires at Potton, in Bedfordshire, to protect his crops (below). The results were far from satisfactory, although this field of fire, which looks more like a upside-down planetarium or the world's worst runway than sound horticultural practice, is one of the most striking gardening images of the century and a testament to one grower's determination not to be beaten by the elements.

A few months later, with the last frosts passed, this Newport market gardener (left) sports a mane of raffia as she squares up to her runner beans. Originally grown as an ornamental for its scarlet flowers, the runner bean, *Phaseolus coccineus,* was introduced in the late 16th century. Its culinary value was soon discovered and the bean became so fixed a summer feature of English gardens and allotments that it is difficult to imagine it in its place of origin, the tropical uplands of Central America. Her raffia wig likewise is a long way from home. For so long the main tying material of British gardeners, the tough papery strands of raffia are stripped from the young leaflets of *Raphia farinifera,* a palm tree native to Tropical Africa and Madagascar.

Also this year...

Publication of Historic Gardens of England *by Alicia Amherst (Lady Rockley)*

In London's Kensington High Street, the department store Derry and Toms opens a roof garden designed by Ralph Hancock. A blend of oriental lyricism and luxuriant foliage, the garden was immensely popular and survives today

Publication of The Water Garden *by Frances Perry*

Publication of The Flowering Shrub Garden *by Michael Haworth-Booth*

Christopher Tunnard publishes Gardens in the Modern Landscape

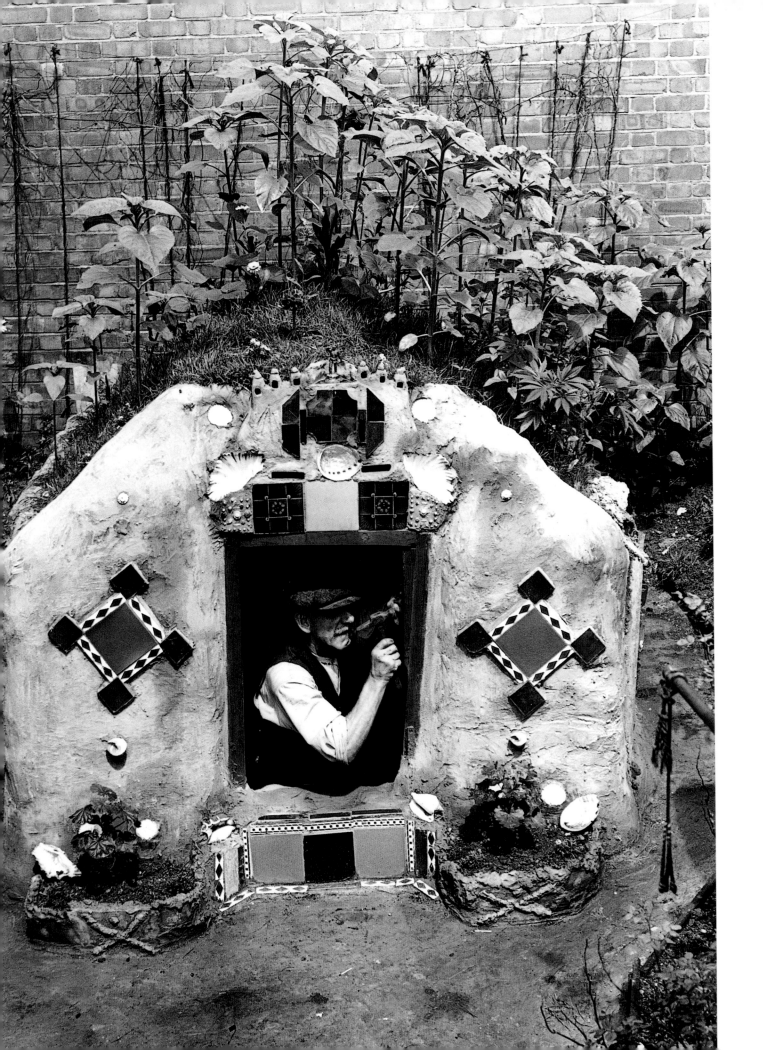

A sensible folly

Prime Minister Neville Chamberlain studies an exhibit at the Chelsea Flower Show (right) in May 1939. Within five months, Britain would be at war and the flower show – for so long a staple of London society and the British at leisure – would vanish for a while along with so much else, beneath a pall of darkness and austerity. Like his father Joseph, Chamberlain was fond of plants and gardens and seems to have taken particular pleasure in this display of what *Picture Post* informs us were dwarf shrubs. With the Munich Agreement in tatters and preparations for war already in hand, whiling away a few hours in the grounds of the Royal Hospital clearly came as light and very welcome relief for the Prime Minister. This was Chamberlain's last Chelsea visit. He resigned a little under a year later and died the following November.

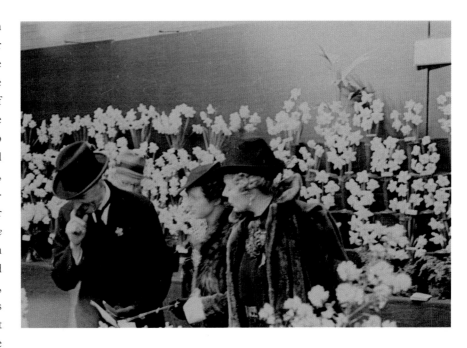

One of the most common domestic preparations for war was the construction of an air raid shelter. Most householders with gardens but without basements and in areas exposed to the threat of air raids began to make Anderson shelters. Basically deep pits lined with corrugated steel, the shelters were covered with a mound of the excavated soil. The mounds gave extra protection from bomb blast and provided camouflage – but not enough, it would seem. The magazine *Garden Work* began to campaign for the planting up of Anderson shelter roofs, many of which, it complained, were beacons to bombers – 'closely resembling an Eskimo's igloo...left nakedly standing in full view of the houses'. The answer was to garden the shelter. Vegetables tended to be the first and most obvious choice of green cover, although some of the more usual crops underperformed in the overheated shallow soil (there are, however, reports of blanched rhubarb being sprouted *inside* shelters). Members of the cucumber family fared better, as did many ornamentals. Even before war had been offically declared, the ARP shelter was viewed as a challenge to the indomitable and opportunistic spirit of the British gardener – as in the case of Mr Barlow (left), a marine store dealer, who decorated his in July 1939 with shells, mosaic and tiles.

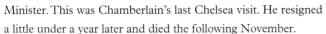

Also this year...

Kew's Alpine House is rebuilt

W.J.C. Lawrence and J. Newell publish Seed and Potting Composts, *which describes their development*

of the John Innes (JI) composts

The partnership of landscape architects Russell Page and Geoffrey Jellicoe is dissolved

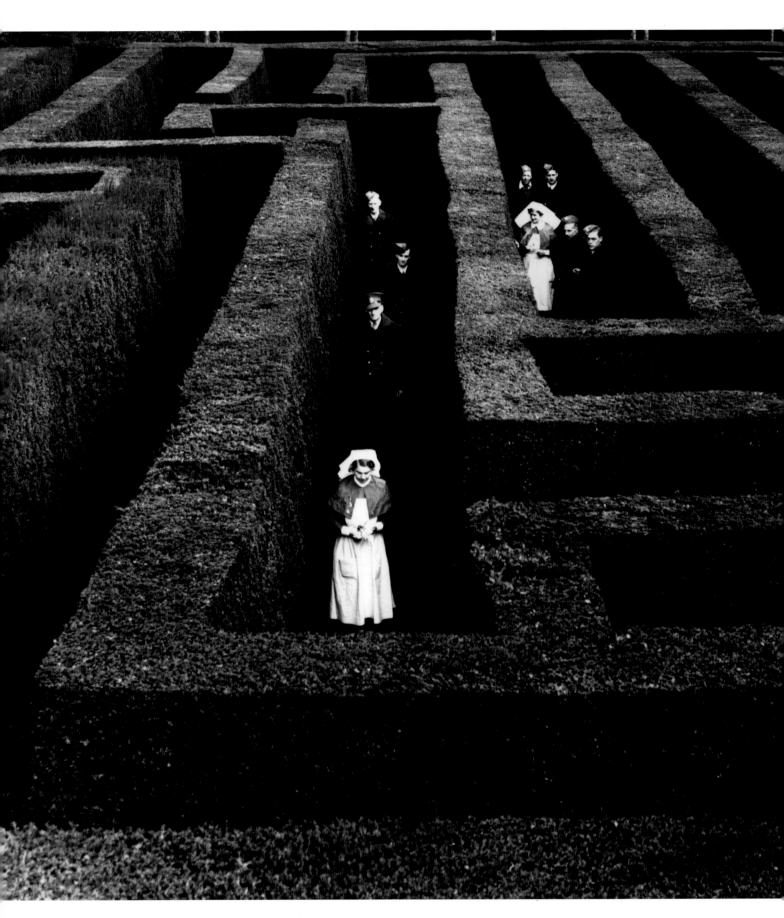

Turning the corner

In the late 1930s Britain imported 80 per cent of its fruit and 90 per cent of its cereals. Home food production had never been so low – a fact that threatened disastrous consequences following the outbreak of war and the curtailment, by the summer of 1940, of trade with much of Continental Europe. To switch the nation from major importer to virtual self-sufficiency was no easy task. Each county set up its own War Agricultural Committee mandated to enforce the 1939 Cultivation of Lands Order. The order provided for the ploughing of pasture (by far the most common form of English farmland), and its replacement with cereal and vegetable crops.

In February 1940, the campaign was given a boost in the form of an oratorical flourish from the Welsh Wizard himself. Speaking at a City lunch, David Lloyd George insisted, 'We can double the yield of our soil, and no submarine or magnetic mine or aeroplane can get at it.' His remarks were heard across the country. Within three months nearly two million acres of land had been ploughed and were ready for planting.

Existing farmland was not the only soil to be turned as part of the war effort. Commons and parks were given over to vegetables; the growing of ornamentals on allotments was at first disparaged and then banned; private gardens became providers not paradises. One of the most striking examples of this change of use could be found in the moat at the Tower of London, where lawns were dug and a series of allotment-type plots were made by Tower workers and local residents. The result was a garden as beautiful as it was useful, one that harked back to the high-walled *potager*s of the Middle Ages and early Renaissance while feeding the victims of a very modern conflict.

Other great buildings were experiencing wartime transformations. At Hatfield House in Hertfordshire, nurses guide recuperating soldiers around the great maze (left). The maze lies to the east side of the mansion built by Robert Cecil between 1609 and 1611 when no less a plantsman than John Tradescant the Elder had charge of the gardens. In his time at Hatfield, Tradescant travelled throughout Europe acquiring unusual trees, shrubs and perennials. Notably fruitful were Tradescant's forays to the Low Countries – nations that have long enjoyed a special horticultural relationship with Britain, but which had just a month left of freedom in April 1940, when this photograph was taken.

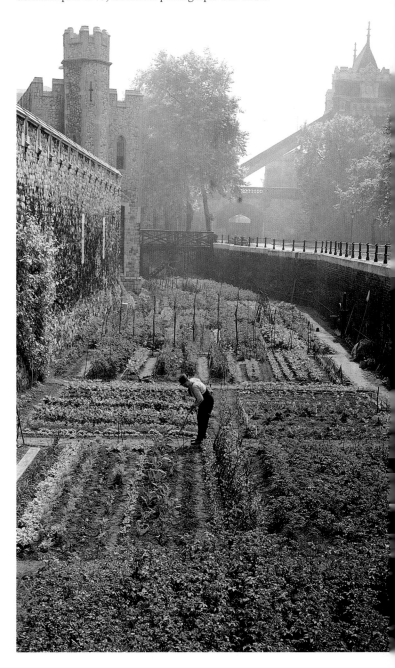

Also this year...

Garden historian and author Eleanour Sinclair Rohde writes The Wartime Vegetable Garden

Park gates are ordered to be left unlocked at night: after a wave of vandalism, locking is resumed

Sir Alfred Daniel Hall publishes his great work The Genus Tulipa *with plates by Osterstock*

Death of Walter P. Wright (b.1864), founder-editor of Popular Gardening

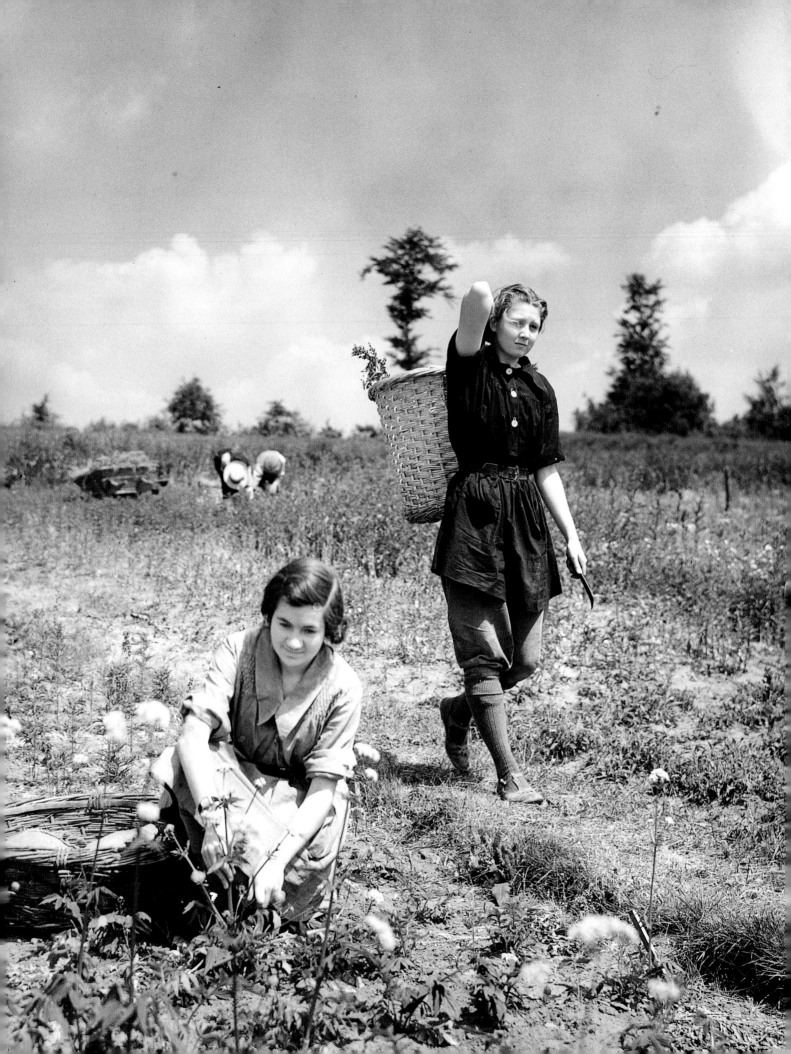

Herbal remedies

Despite its wealth of native herbs and long history of using them, by the late 1930s the UK was importing the bulk of its medicinal and culinary herbs (even dandelions) from Continental Europe. Following the wartime breakdown of trade with mainland Europe, the Vegetable Drugs Committee was set up to counter the acute lack of herbs. Valerian (*Valeriana officinalis*) was one of a number of plants promoted by the committee, and here we see Kentish land girls gathering this herb, valued since ancient times as a sedative. By 1940, it was in full-scale production as a source of nerve tonics and topical ointments for the domestic and US markets. It was also widely used in military hospitals. Other farmed herbs included the narcotic, diuretic, sedative and potentially lethal *Atropa belladonna*, foxglove – a cardiac stimulant, anti-asthmatic stinging nettles, and sphagnum moss, which had proved useful as an absorbent wound dressing in the First World War.

Private individuals were asked to gather wild herbs or to grow them on any available land. They were then collected and dried at centres organized chiefly by the Women's Institute. During one harvest, the tonic and diuretic dandelion seems to have caused particular problems – not only did the roots lose some 90% of their weight on drying but when fresh they could stain a much-prized frock beyond repair.

Intensive herb farming answered the needs of the food industry as well as medicine, and so it came about that companies such as Heinz and Crosse and Blackwell found themselves using only the finest, fresh-grown British herbs. The Ministry of Food encouraged gardeners to grow a range of herbs for their own kitchens and prevailed on herb farm owner Miss D. Hewer to write a book on their culture and cuisine. The result, coming at a time when one might have imagined all to be flavourless austerity, includes recipes coupling lemon thyme with veal, fennel with fish, and chopped chives with omelettes, and makes one wonder what Elizabeth David had to complain about.

Also this year...

The RHS publishes The Vegetable Garden Displayed *as a contribution to the newly launched Dig for Victory Campaign. The book will later be translated into German to help with building up domestic production in the postwar shambles*

A deciduous conifer, Metasequoia glyptostroboides, *the dawn redwood, is discovered alive and well in Southeast China. A 'living fossil', it matches conifers that were abundant nearly 200 million years ago. It had already been named* Taxites *in 1828 on the basis of fossil evidence by the botanist Brongniart. No-one then imagined it was still extant*

Death of Alicia Amherst (Lady Rockley, b.1865), garden writer and historian

The Director of Kew, Sir Arthur Hill, is killed in a riding accident

Dig for Victory

As the Dig for Victory campaign entered its second year, London began to resemble a giant allotment. In Kensington Gardens, the lawns around the Albert Memorial proved unexpectedly fertile, while at the Quality Inn Restaurant in Regent Street, waitresses took to growing tomatoes in boxes.

In the late 1930s Britain imported an astonishing three million hundredweight of tomatoes from the Channel Islands, the Low Countries and the Canaries annually – all sources that had dried up within a year of the outbreak of war. Government was particularly concerned about losing the vitamin-rich tomato, and ordered market gardeners to devote at least 90 per cent of glasshouse space to their production for half of each year. On the Isle of Wight, Ryde Council adopted a policy of 'Tomatoes not Tourists' after the mayor had a friendly chat with a man from the Ministry. By 1943, they were harvesting over ninety tons of tomatoes from a mere seven and a half acres and such were the profits from sales to the mainland that islanders were rewarded with a modest cut in their rates. Amateur gardeners were also encouraged to grow tomatoes and soon realized that they performed perfectly well outdoors on a sunny wall (or, indeed, a West End pavement).

As the war continued, seed merchants began to exhaust their fund of tomato seeds. The US came to the aid of British gardeners, donating, for example, 90 tons of seed of assorted crops to the National Allotment Society in 1943 alone. But gardeners had already learnt to save their own seed for sowing the following year and there was another, entirely accidental method of disseminating tomato seeds. They are very good at escaping the human digestive system unharmed, and when town corporations began selling sewage sludge as fertilizer, wartime gardeners found to their surprise that they were growing tomatoes where they had not planted them – not, of course, that this could ever have happened at the spotlessly run Quality Inn.

Also this year...

Death of horticulturist and businessman Arthur Kilpin Bulley (b.1861). He created a great garden at Ness on the Wirral Peninsula in Cheshire, founded the nursery firm of Bees Ltd during a slow time for his cotton-broking business and sponsored plant-collecting expeditions by George Forrest (to Yunnan, 1904), Frank Kingdon-Ward (to Southwest China, 1911) and R.E. Cooper (to Sikkim and Bhutan, 1911–13)

Death of Marion Cran (b.1879), gardener, pioneer broadcaster, poet, journalist and author of some 12 books on gardens and gardening

Peace in a soldier's garden

A cedar of Lebanon casts long shadows on the lawn at Hidcote Manor in Gloucestershire. When American Major Lawrence Johnston began to create his garden in the Cotswolds in 1905, this cedar, five beech trees, a farmhouse and a clutch of old walls were all he had. Within two decades Hidcote had become one of the most famous gardens in England. It remains the most influential English garden of the century and one of the most visited.

In terms of colour and intensity of planting, Hidcote owed much to Gertrude Jekyll. It was in overall design that Johnston departed from her style. Hidcote is famously a collection of garden 'rooms' – small spaces bounded by walls or high hedges, cunningly juxtaposed and entered via a series of pathways fed by a single central alley. This alley has been likened to the long gallery of a country house; leading away from the cedar, it passes between a series of herbaceous borders. The first is planted with grey foliage and pastel flowers. The second section is aflame with scarlet dahlias, billowing smoke bush and smouldering purple-leaved *Berberis*. Next comes a flight of stone steps flanked by a pair of charming, Delft-tiled belvederes. There follow two rows of tall, closely trimmed hornbeam hedge with bare trunks (hence this area's name, 'The Stilt Garden'). The central alley ends in wrought iron gates through which one perceives a few trees and turf, picturesquely semi-tended as if in a Poussin landscape, and a sudden and staggering sweep of the Cotswolds whose windy western slopes can probably be blamed – or thanked – for having compelled the Major to invent his high-walled garden rooms and secluded walkways.

The result has been described as a village of cottage gardens, but this does no justice to Johnston. He was a pioneering plantsman with, *inter alia, Mahonia lomariifolia, Verbena* 'Lawrence Johnston', *Hypericum* 'Hidcote', *Lavandula* 'Hidcote', Rose 'Lawrence Johnston', Rose 'Hidcote Gold', *Penstemon* 'Hidcote', *Fuchsia* 'Hidcote' and *Campanula latiloba* 'Hidcote Amethyst' directly or indirectly to his credit. His use of colour and eclectic approach to garden design and ornament achieved degrees of elegance and sophistication unmatched by Gertrude Jekyll and emulated by Vita Sackville-West.

Before the Second World War, eight men were employed at Hidcote. The conflict reduced their number and stalled Johnston's plans. Death and disruption found out Hidcote's hidden spaces. Unless its sense of desertion points to the departure, not far away, of Hidcote's *genius loci*, Lawrence Johnston, the serenity of this 1943 photograph is illusory. Five years later the National Trust took over the garden leaving the execution of Johnston's plans to Walter Bennett, one of his original gardeners.

Also this year...

Edward Salisbury is appointed Director of Kew

There is widespread removal of iron railings for the war effort; vandalism becomes an entrenched phenomenon in urban parks, causing park superintendents to ask whether ornamental horticulture will be possible in parks in future

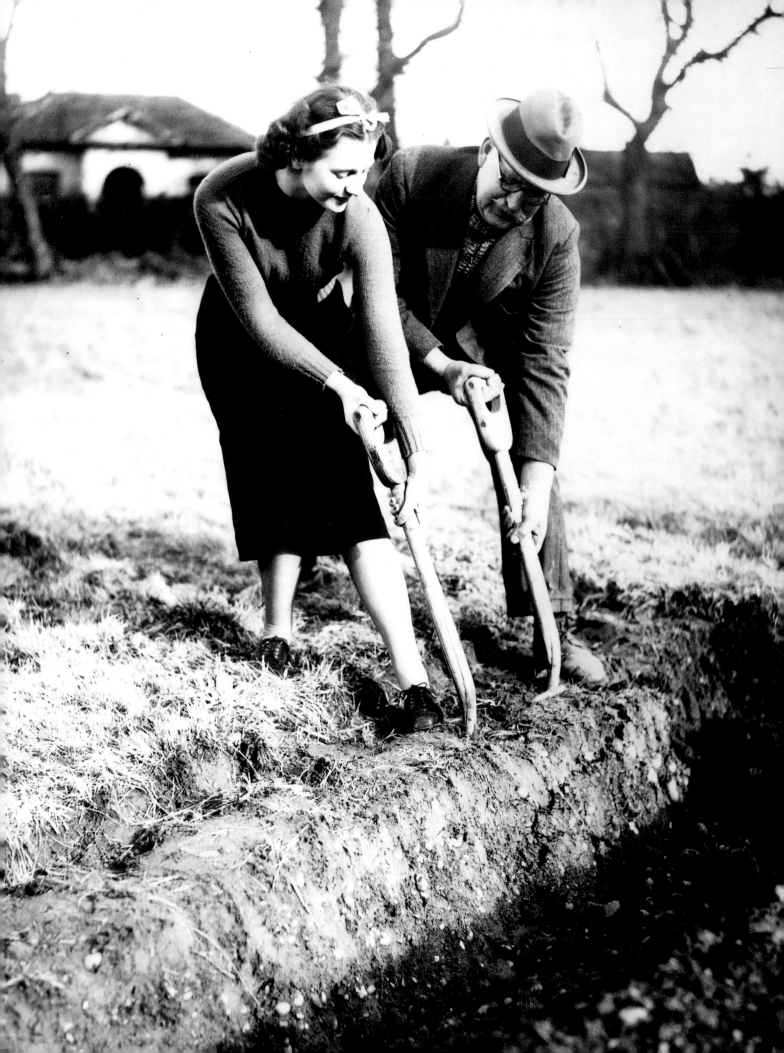

The wrong way to dig

On the home front, digging was almost equivalent to fighting. In the summer of 1939, with war in the wings, the Government had joined forces with the Royal Horticultural Society to produce a pamphlet advising gardeners on how best to turn their plots over to vegetable production. Catchily titled *Growmore Bulletin No. 1*, the pamphlet fared badly. It was attacked by experienced gardeners, who found its cropping schemes muddled and the sowing times unclear. There was also a bias in favour of greens (especially spinach), while potatoes were given short shrift. Some northern sons of toil suspected that effete southern ways were being forced upon them. The proof readers of *Growmore Bulletin No. 1* had hardly helped its cause: three feet is the correct planting distance for marrows, not three inches.

A corrected and revised version appeared in January 1941. The following month the Government had the good sense to tie the campaign to a slogan borrowed from a London evening newspaper article of the previous year. The slogan was 'Dig for Victory', a phrase that had been in the air for a while. In 1940, for example, the Home Service broadcast a play, *Digging for Victory*, about the conversion of one Christopher Grigg from gardening tyro to self-sufficient expert. It ends with the doggerel:

> *There's an obvious moral in Christopher Grigg*
> *If he can grow turnips, we also can dig*
> *So back to the land – and if you are able*
> *Contribute a sprout to the national table.*

Christine Grigg might have been more appropriate. Much of the digging for victory was undertaken by women gardeners whose number grew steadily as men were taken away to other forms of production and the battlefield. The Dig for Victory campaign for 1942 addressed itself to women especially. Women's gardening associations began to form that year and in some towns over half of all available allotments were rented by women.

Despite their evident enthusiasm and proficiency, it was still felt that some women needed a word to the wise on the difficult matter of digging. In 1944, propaganda photographs were published on how and how not to dig. Here the girl is holding a fork the wrong way (her hand is too far up the handle to do anything but sprain her wrist), while her tutor would like it to be thought that he is doing things properly – in fact, most gardeners would not find his positioning much better.

Also this year...

Due to a labour shortage, much of the commercial potato crop cannot be harvested – strict rationing follows

The onion, which had become a pearl beyond price as a result of wartime shortages, is at last grown in sufficient quantity thanks to the Dig for Victory campaign

A radical solution

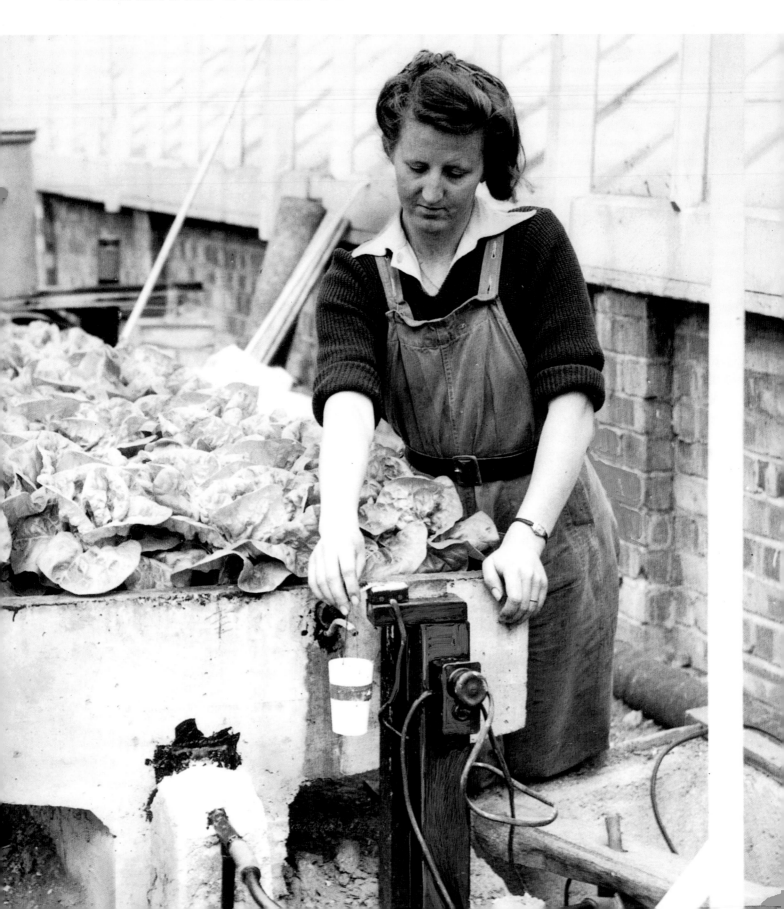

In Egham, Surrey, nurserywomen tend crops of lettuce and carnations grown by the hydroponic method. Hydroponics, or hydroculture, is the cultivation of plants in nutrient-enriched water. The principle involved – that plants absorb food in a water suspension and not directly from the soil – was demonstrated by the 19th-century French agricultural chemist Jean-Baptiste Boussaingault, who grew crops in sand and charcoal flushed with nutrient solutions. Boussaingault's system was adopted in the first two decades of the 20th century as an experimental method for observing the process of plant nutrition.

It was not until 1929, however, that W.F. Gericke, an American searching for an economical means of growing tomatoes, took the hydroponic technique out of the laboratory and into commercial crop production. It soon became widespread practice wherever fertile soils or organic manures were in short supply. Hydroponics have proved especially useful in arid and built-up regions.

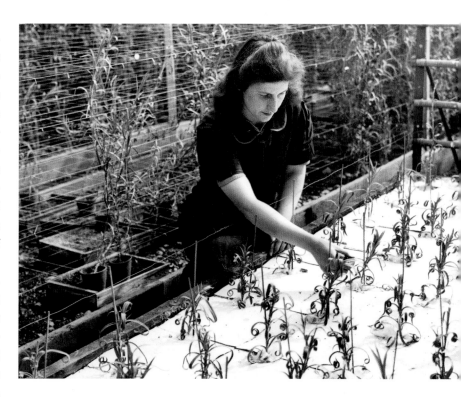

The first generation of commercial hydroponics entailed suspending the crops in nothing more than the food solution. Plants grown on this model were difficult to support physically and tended to produce poor or abnormal root systems. The introduction of inert growing materials (sand, shingle, vermiculite, clay granules, rock wool, glass fibre) allowed crops to develop as if they were rooted in soil while giving the grower maximum control over feed and water. As the technique advanced, automatic devices were introduced to regulate the food–water ratio and supply.

In 1945, hydroponics was very much at the cutting edge of commercial crop production. Within a few decades most growers were showing a preference for soilless media (peat, polystyrene granules and, latterly, coir) which combined the virtues of conventional, soil-based cultivation with the basic principle of hydroponics in a more moderate and manageable form.

Hydroponics remained popular in the home and public buildings, however, and planters filled with clay granules and houseplants (usually in various stages of decline) can still be seen in airport lounges and offices.

Also this year...

Rose 'Peace' is named at a ceremony under the aegis of the American Rose Society. Raised by the French Meilland Nurseries, the rose had flowered in 1936 and propagating material was sent to the US, Germany and Italy. During the war years each country claimed the rose as its own and named it ('Mme A. Meilland', France; 'Gloria Dei', Germany; 'Giola', Italy; 'Peace', US). For many years and worldwide, the name 'Peace' stuck. Under the law of priority, however, a plant must keep the earliest legitimate name it receives, and Rose 'Peace' is properly and once more Rose 'Mme A. Meilland'

The Rhododendron Association is absorbed into the RHS

At the Garden House, Buckland Monachorum, Lionel Fortescue plants the Leyland cypress, x Cupressocyparis leylandii as a windbreak – the first major use of this tree since its discovery in the grounds of Leighton Hall, Welshpool in 1888

Chemists Diels and Alder publish their discovery of the pesticidal properties of chlordane: this soon leads to the introduction of Dieldrin and Aldrin as pesticides

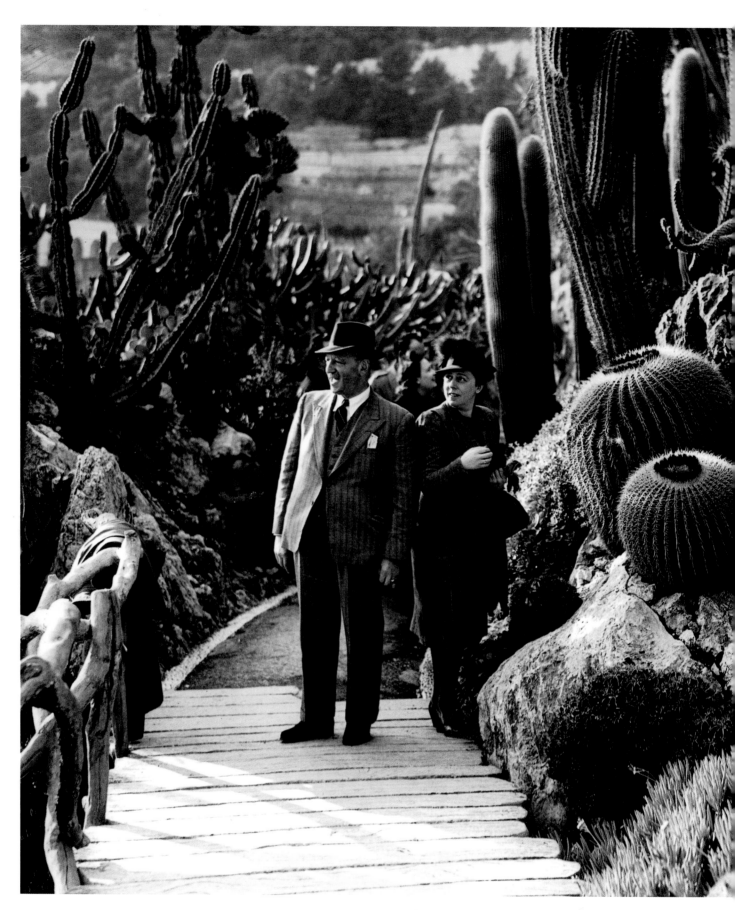

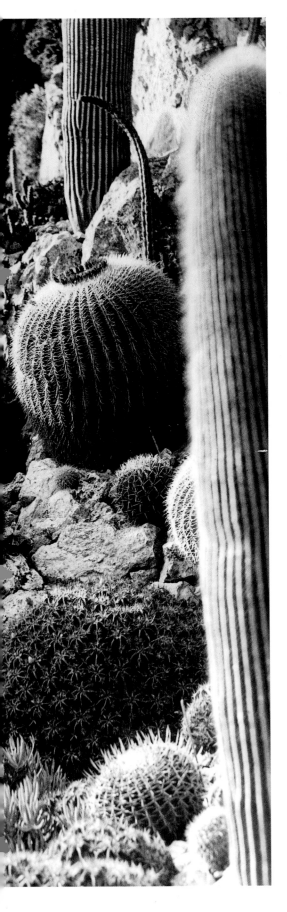

Prickly pairs

Visitors find themselves transported to another climate and landscape entirely when they visit Monaco's Jardin Exotique. The garden consists of a series of cliffs and chasms spanned by rustic bridges. The plants it contains are cacti and succulents and represent the apogee of the subtropical style of gardening that was pioneered on the Côte d'Azur by expat British horticulturists like Sir Thomas Hanbury toward the end of the 19th century. The Jardin Exotique, however, was a truly Monegasque undertaking, the dream-come-true of avid cactus collector Prince Albert I of Monaco.

When he started buying cacti and succulents in 1899, the Prince decided quite simply to acquire the best available specimens of as many species as possible. Since there are something like 10,000 species of succulents found in over forty different plant families, he had ample scope to indulge his fancy before even coming to the 1,650 species-strong Cactaceae itself. The result was one of the largest collections in the world, boasting plants of great rarity, size and antiquity (some are well into their second century), all them lovingly labelled and curated. As was true of Sir Thomas Hanbury along the coast at La Mortola, Prince Albert's primary objective was botanical. He wanted to use Monaco's favoured climate and terrain to grow succulents more or less as they would grow in nature and for the purpose of study. But, again like Hanbury, he could not resist the opportunity to make a garden of outstanding drama and beauty. He set to work in 1914.

For its site the Prince chose a dry precipice in full view of the royal palace. Ravines were made or enlarged and their channels colonized with sweeps of icy blue mesembranths. Along their sides, narrow paths still wind among the cumbrous boughs of *Opuntia* and lead away to groves of saguaros and *Cereus*. Succulent pelargoniums and aloes from the Cape spill over stony bluffs and here and there the spectacularly swollen and corky trunks of *Nolina*, the elephant foot tree, soar to summits of sword-like leaves.

The initial impact of the Jardin Exotique comes from the sheer variety and abundance of plant forms it contains. Seen in the landscape, succulents turn a garden into a living sculpture gallery. These are plants with personality, consorting with each other in a kind of vegetable phantasmagoria. But they offer more than form alone. Many of them, the cacti especially, bear brilliantly colourful flowers, and at Prince Albert's Riviera desert they bloom most profusely in the dead of winter – as these refugees from an English January discovered to their delight.

Also this year...

Roy Hay publishes Gardener's Chance, *a plea for allotment cultivation*

Alan Bloom moves his nursery to Bressingham, Norfolk, where he promotes the concept of island beds for growing perennials

At Tilgate Horticultural Research Station, Crawley, Sussex, Frank Wyatt

invents the ring culture method of growing tomatoes, after soil supplies had run short

The Northern Horticultural Society is formed

The Soil Association is founded

Orchids for all

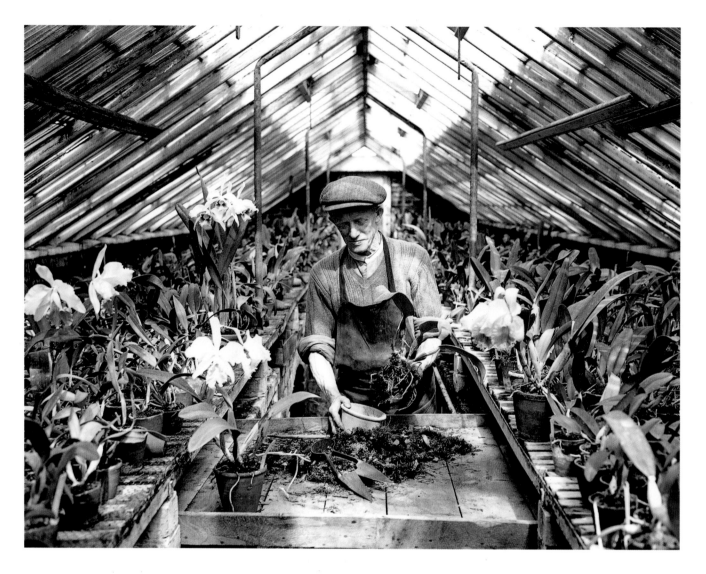

At the St Albans firm of Sander and Sons, nurseryman Bill Faulkner repots *Cattleya* orchids (above). Founded in 1876 by the German-born Henry Frederick Conrad Sander, the company specialized in exotic plants and orchids especially, sending plant hunters throughout the Tropics and achieving dominance of the world market. Unlike so many of its competitors, Sanders survived the collapse of the great hothouse era that came with the First World War. In 1947, the nursery was still growing upwards of 300,000 orchids for export at any one time. Here, Faulkner, who had been with the firm for 44 years, repots mature plants, some of which would still have been collected from the wild. The future for orchids did not lie in this direction – wild plants were becoming difficult and costly to obtain. At the same time botanists and gardeners were newly aware of the con-

servation issues that surrounded the plundering of plants from nature. To survive as a hobbyist's flower in the wake of the Second World War, the orchid needed to be within reach of growers with limited resources *and* an ethical purchase.

Technology provided an answer. Dust-fine and dependent on symbiotic fungi, orchid seeds had always proved difficult to germinate. By 1947, Sanders was using a new technique for germinating orchid seeds reliably and in quantity. This entailed sowing them in aseptic flasks on nutrient-rich agar jelly. As a result, Sanders and other nurserymen were able to meet the demands of a new orchid-growing public. Having been the world's leading importer of orchids, the UK became the major exporter.

Exhibiting for the first time at the Chelsea Flower Show, King George VI won great acclaim for a display of *Schizanthus*

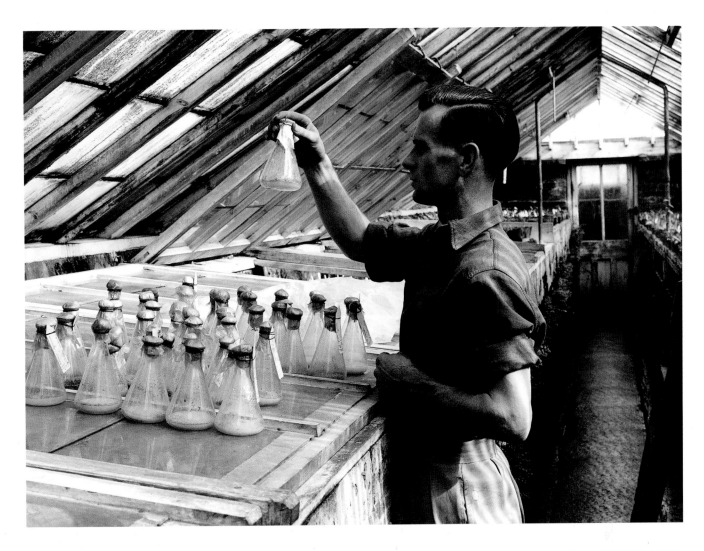

(below) grown in the Royal Gardens at Windsor. Scarcely reminiscent of their true relations (the potatoes and nightshades), these flamboyant annuals were popularly known as poor man's orchids. The real thing may have ceased to be a rich man's fancy, but the poor man's orchid had become the sport of kings.

Also this year...

Landscape architect Brenda Colvin publishes Trees for Town and Country

Rhododendron yakusimanum *causes a sensation when it is exhibited for the first time at the Chelsea Flower Show*

Geoffrey Jellicoe is invited to plan Hemel Hempstead New Town. In the event, only his water garden design is executed

The radio programme 'Gardener's Question Time' is broadcast for the first time

Death of William Jackson Bean (b.1863), sometime

Curator of Kew and author of Trees and Shrubs Hardy in the British Isles

Death of French garden designer Achille Duchêne (b.1866) who, with his father Henri, restored many great 17th-century French gardens and adopted the formal style himself for such projects as the gardens at Blenheim Palace (1902–30). He later rejected patron and parterre for 'democratic' community gardens, although his public projects were still formal in approach

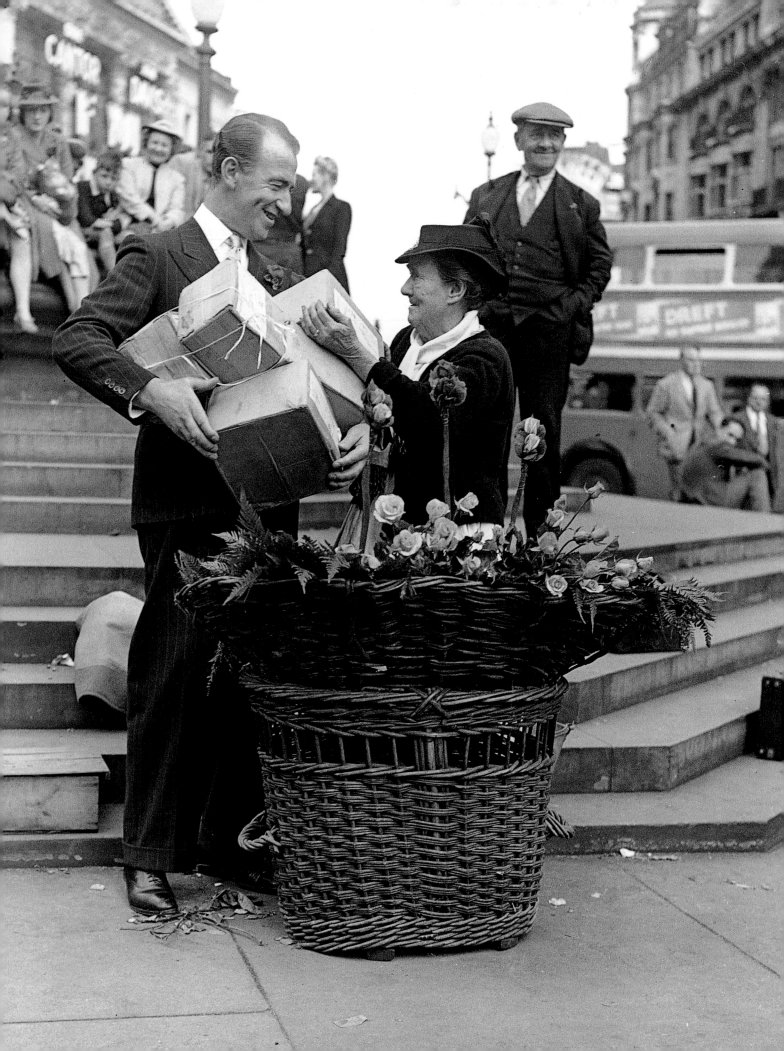

Who'll buy my roses?

Dick Bentley, Australian star of the BBC programme 'Show Time', presents flower-seller 'Old Polly' (Polly Beecham) with food parcels. Polly had been sent gifts 'care of the BBC' ever since she made a wartime broadcast to Australia, and a decision was finally taken to get the goods to her – although what condition the provisions would have been in is anyone's guess. At first the Corporation's efforts to deliver were foiled when Polly could not be found at her usual pitch under the statue of Eros, in London's Piccadilly Circus. Uncharacteristically for someone who had been a permanent London fixture since before Shaw even thought of *Pygmalion*, the flower seller had decided to take a break in Ramsgate. Polly reappeared to general relief and Bentley was despatched to Piccadilly with parcels and press photographers.

Polly was among the last of her kind. Flower girls, for so long a charming, if somewhat raucous feature of London's street life, were growing old. Few fresh Eliza Doolittles sprang up to replace them. Their extinction could be explained partly in terms that many small traders might find familiar – centralization supposedly meaning 'greater choice for all'. In 1886 Covent Garden Market opened a new Floral Hall to meet the growing demand for cut flowers. This side of the market's activities soon matched its dealing in fruit and vegetables. The market was supplied not only by commercial growers but also by the head gardeners of country houses eager to augment their income. Where once cut flowers had been a feature of grander homes, the new market's produce was destined for florists and thence to customers across the social spectrum.

In 1894 *The Gardener's Chronicle* rallied to the florists' cause, exhorting the new class of bourgeois flower buyers to look to Covent Garden for choice and value. The same journal snobbishly attacked as 'sentimental' customers who continued to buy inferior flowers (often English wild flowers or traditional 'fancies' like violets or pinks) from grubby street girls or 'rough-looking chaps'. A half century later 'the chaps' were still in evidence and there to stay, but Polly was an endangered species. Professor Higgins would have wept.

Also this year...

Ness, the Cheshire home and garden of A.K. Bulley, is endowed by his daughter to Liverpool University; it is now the University of Liverpool Botanic Garden (see 1942)

British plantsman Collingwood 'Cherry' Ingram publishes Ornamental Cherries

The dawn redwood, Metasequoia glyptostroboides, is introduced to British gardens via the Arnold

Arboretum of Harvard University

Swiss chemist Paul Muller is awarded the Nobel Prize for Medicine for his invention of DDT

Lawrence Johnston bequeathes Hidcote to the National Trust, which sets up a joint committee with the RHS to advise on garden acquisition and maintenance

Sylvia Crowe prepares landscape master plans for Harlow and Basildon New Towns

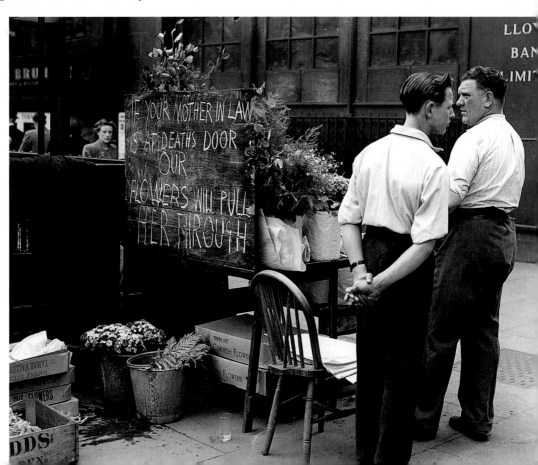

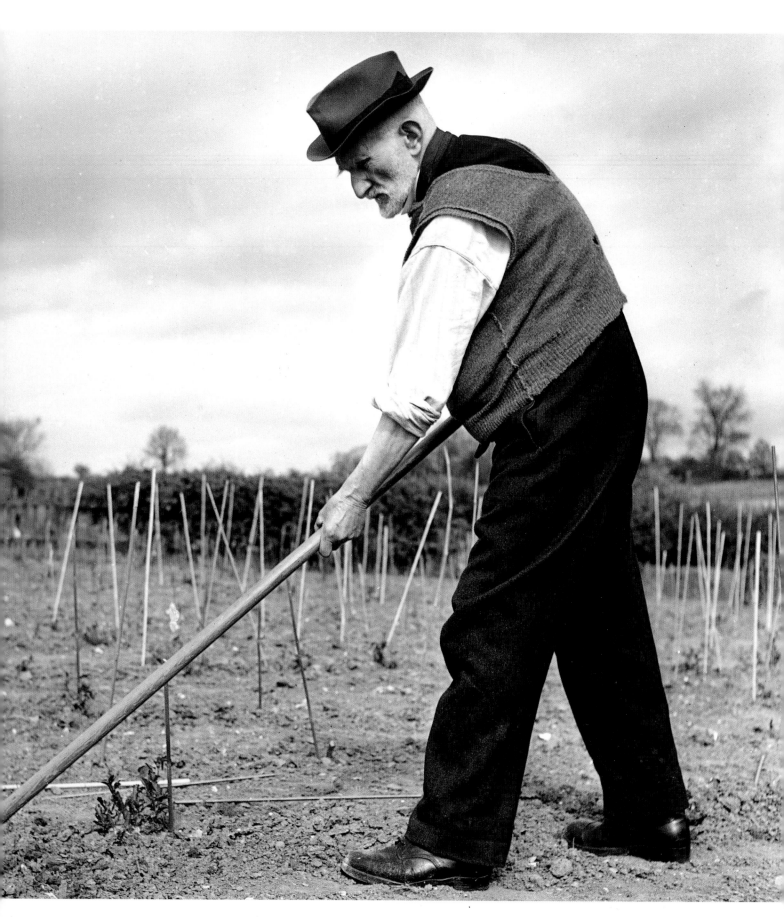

Gulliver's travails

Busy hoeing in his trademark hat and distinctive white beard, Gulliver Speight does not look like an old school studio photographer, but in his professional life he was just that – a well respected portraitist. He also took many documentary pictures including a photograph of 'E' Company Territorials mobilizing at Market Harborough on 6 August, 1914 in preparation for the First World War – this famous photograph was taken from the upstairs window of his premises overlooking the town's main square. By 1949, when he turned 85, Gulliver Speight spent far more time in his garden than in his studio and had become firmly established as one of the Grand Old Men of British Gardening, standing alongside George 'Lupin' Russell, Watkin Samuel, the Allwood brothers, Alec 'Narcissus' Gray, and G.P. Baker of the irises.

Although Speight looks very sturdy in this photograph, he was described as a frail, nervous, and shy man. He was most famous for his roses, not as a breeder but as a great and highly successful exhibitor who was still showing blooms at the age of 85. The roses that he exhibited were the 'spoiled darlings' from among the 2,000 rose bushes in his fragrant garden at Market Harborough in Leicestershire. His blooms won him the respect of discerning rose lovers everywhere, and would bring him admiring visitors every season. As well as showing off his roses to visitors, he would often turn out the old toffee tins in which he kept the gold and silver medals won by his blooms at the many flower shows he attended during his long and productive years as an exhibitor.

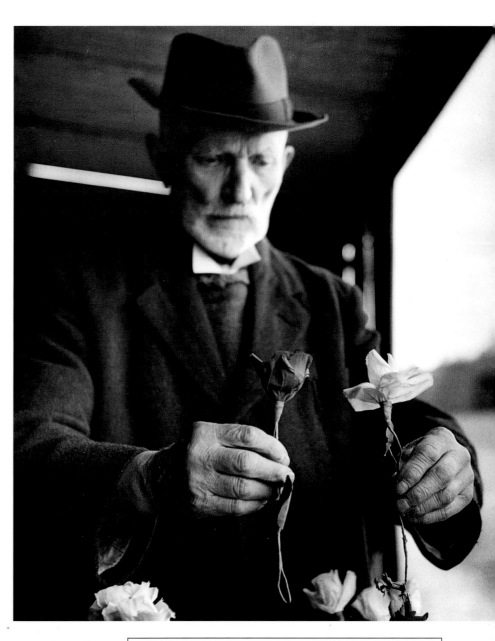

Also this year...

Bodnant Gardens in Denbighshire are endowed to the National Trust

Landscape architect Brenda Colvin publishes Land and Landscape

The National Carnation and Picotee Society and the British Carnation Society merge as the British National Carnation Society

The National Vegetable Research Station at Wellesbourne, Warwickshire, is founded

An official English rose

In 1946 Albert Norman, of Normandy, Surrey, a diamond-setter, entomologist and passionate rose lover, crossed Rose 'Crimson Glory' with Rose 'Southport'; the result, Rose 'Ena Harkness' was a vigorous hybrid tea with fully double flowers in dark crimson-scarlet and with a sweet perfume.

At the National Rose Society's St Albans trial grounds in July 1950, the high, solid centre characteristic of 'Ena Harkness' is held together with a length of string in readiness for the show bench. The treatment was successful – the Society's panel of 33 experts judged Norman the raiser of the finest new rose suitable for 'Mr Everyman' to grow in the average garden. Seven years later he was elected president of the Society.

Also in July 1950 a new American rose, the single, snowy 'White Wings' (right) made its English debut at the Society's trial grounds; while at the National Rose Society's Summer Show in June, a gold medal had been awarded to 'Show Girl' (below), a new pink hybrid tea raised by Armstrong Nurseries.

Also this year...

Dorothy Stroud publishes her biography of 'Capability' Brown

The Kurume Punch Bowl in the Valley Gardens, Windsor Great Park, is completed

James Russell designs the parterre at Seaton Delaval, Northumberland: his first garden design commission

The American Cyanamid Company introduces the organophosphorous compound malathion as an insecticide

Death of John Barr Stevenson (b.1882), whose rhododendron collection at Tower Court is transplanted to the Valley Gardens, Windsor

Death of Frederick Chittenden (b.1873), horticulturist. A lifelong servant of the Royal Horticultural Society, from 1939 he devoted himself to production of the RHS Dictionary of Gardening, a work hampered by the war and left unfinished at his death

Rose terraces and laburnum arches

One of the greatest British gardens of the century, Bodnant, near Colwyn Bay in Gwynedd, began its transformation around 1900 when the 2nd Baron Aberconway was given control of the gardens by his mother. Within five years, Aberconway had begun to terrace the slopes that ran down from the blue granite, yellow-mullioned house. As at Powis Castle, the terraces were Italianate in style. Each differed in its dimensions and contents: the third terrace accommodates two blue Atlas cedars which were planted around 1875 when the McClaren family (Lords Aberconway) first bought Bodnant; the Rose Terrace (pictured below in 1951) offers a commanding prospect of Snowdonia through writhing fox-red Arbutus trunks; and on the Croquet Terrace, a wall fountain takes a veil of bridal white Wistaria each spring. At one end of the Canal Terrace stands a small building moved stone-by-stone from Gloucestershire in 1938: built in 1730, the 'Pin Mill' was at first a summerhouse and then became a pin factory before reverting to garden house on its arrival in Wales.

Bodnant's climate is mild and damp, its soil leafy and acid – ideal conditions for rhododendrons. Following his own maxim, 'Find out which plants grow well for you and grow a lot of them', the 2nd Lord Aberconway sponsored plant collecting trips which yielded numerous *Rhododendron* species, *R. aberconwayi* among them. Seeds sent to Bodnant from the Himalayas and elsewhere came into the care of Aberconway's celebrated head gardener F.C. Puddle. The two men also worked together to develop hybrids like the scarlet *Rhododendron* 'Elizabeth'.

Bodnant's finest plants are not all exotic, rare or recent introductions, however. One of the garden's earliest and most spectacular features is a laburnum walk some 180 feet long (above). To wander through its gentle curve in mid-spring is to step from a great garden into a gilded grove.

Also this year...

Publication of the Royal Horticultural Society Dictionary of Gardening. *Its Editor, Frederick Chittenden, had died the previous year leaving the work unfinished. It was completed by Patrick Synge and W.T. Stearn*

Vermiculite is introduced as a potting compost

David and Rosemary Verey move to Barnsley House, Gloucestershire

J.R.B. Evison succeeds Bertram MacLaren as Supervisor of Parks for Brighton

Sybil Spencer moves to York Gate near Leeds

Polyvinyl chloride film (PVC) is introduced for use in greenhouses, an invention that leads to the development of the polytunnel

Picking the habit

A few leaves at a time, a woman gathers home-grown tobacco. Growing 'the weed' was still a common practice in the early 1950s, having become a matter of necessity during the Second World War. The 'Sacrifices for Victory' budget of April 1942 increased the price of 20 cigarettes from 1s.6d (7½p) to 2s (10p). Encouraged by a pamphlet, *How to Grow and Cure your own Tobacco at 2d a lb* (available from WH Smith for the princely sum of 6d, free seeds included), smokers reacted to the price hike by turning to home production.

In the early years of the war, the law required domestic tobacco growers to obtain a license. Those without were fined as much as £2. As home tobacco-growing became more widespread, its regulation became unworkable – the sanctions were relaxed and finally dropped. Excise officers continued to take an interest in the plantations that had sprung up in backyards countrywide, however, and liked to be assured that the produce was strictly for the owner's own enjoyment.

Tobacco seed was sown in a glasshouse or, more often, on a windowsill in spring. Seedlings were grown on in pots prior to planting out in the open garden after the last frosts. Set at two foot intervals in rows three feet apart, the plants were grown in full sun on a well-watered and heavily manured soil. Sources ranging from government handouts to newspaper articles offered tips on how to achieve the largest and most aromatic leaves. Plants should not be allowed to flower (advice often ignored, for gardeners found tobacco flowers exotically attractive and were cheered by their delicious evening perfume). Any branches should be pinched out. No more than 10 leaves should be encouraged per plant (again advice likely to be scoffed at by growers with large habits to service).

While growing the tobacco came relatively easily, curing the leaves did not. They needed to be dried slowly in consistently moderate humidity. Heatwaves and rainy cold spells were equally disastrous, and the British climate can always be relied upon to provide both. Nonetheless, many gardeners succeeded in producing a useful crop and sheds throughout the land filled with drying leaves hung from washing lines. With this first stage of curing complete, the leaves were tied in bundles and exposed to full sunlight. Next they were hung in a cool, dark cupboard for at least three months. Various embellishments to the process were attempted. In one case, a grower coated the ripened leaves with molasses – the result was a richly satisfying smoke which rendered pipes unusable in no time. The last stage in this most unwholesome of cottage industries was a trip to the tobacconist who, for a small consideration, would cut the weed for pipes or hand rolling.

Also this year...

Declared unsafe, Kew's Palm House is closed to the public. Kew's Australian House opens, designed by S.L. Rothwell of the Ministry of Works and constructed in aluminium sections by Crittall

The National Trust for Scotland acquires Pitmedden, and commissions a revivalist garden design from James Richardson

Creators Ltd of Weybridge introduces plastic garden hose

C.E. Lucas Phillips publishes The Small Garden

After the Thirteenth International Horticultural Congress, the first Code of Nomenclature (official rules of naming) for Cultivated Plants is produced

Russell Page designs the Festival Gardens in Battersea Park, London, as part of the Festival of Britain

Death of Albert James Macself (b.1879), prolific garden writer and editor of Amateur Gardening *from 1926 to 1946*

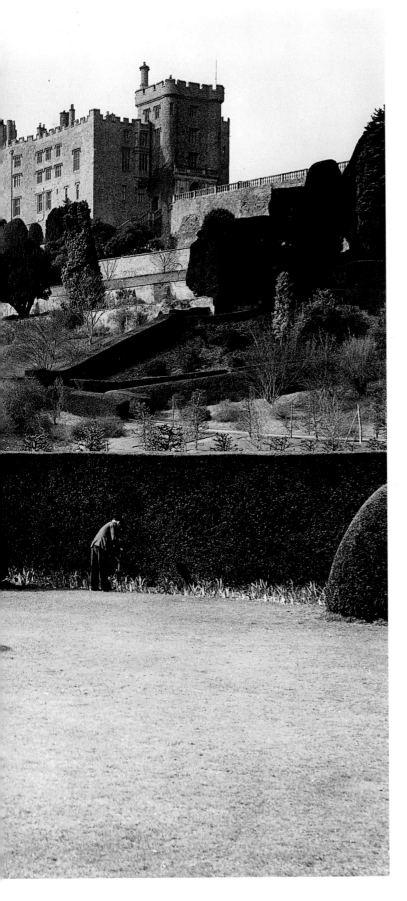

A pleasant seat

Soon after the 4th Earl of Powis endowed it to the National Trust, gardeners were photographed working in the lee of the terraces at Powis Castle in Welshpool. The Princes of Powis built the castle and lived there until William III gave away their seat to court favourite the Earl of Rochford. It was during Rochford's tenure that the terraces were constructed. Made between 1690 and 1722 and the work of an unknown British designer, they are 500 feet long and sculpt the crag of pink limy rock from which the castle commands the Severn Valley. The terraces are Italianate, ornamented with balustrades and urns and peopled with leaden emperors, shepherds and shepherdesses. Later embellishments include a lead peacock on the Orangery Terrace which came from Claremont in Surrey when Lord Clive married into the Herbert family (they had by then resumed their seat as Earls of Powis). A remarkable structure cut into the terrace wall, the orangery itself received a new portico which was moved from the castle entrance early in the 20th century. Above the orangery stands a brick-faced loggia once used as an aviary.

The terraces are home to a range of warmth-loving plants, including the silver filigree *Artemisia* 'Powis Castle'. Their sunny, exuberant plantings contrast vividly with the looming yew trees that guard the battlements, and the wooded wilderness that rolls down to them. Powis is famous for its trees – in the 18th century Admiral Rodney would have his ships built only from oaks found in the region of the castle. Nearby, Gwen Morgan's Wood contains a majestic specimen of *Pinus ponderosa* and the tallest Douglas fir (*Pseudotsuga menziesii*) in the British Isles.

Visiting the castle, 'Capability' Brown is said to have suggested that the terraces should be broken up, the plants discarded and the slope laid bare to the rock. As gardener to George III, Brown seems to have adopted a similarly Philistine attitude to several gardening ventures that had enjoyed the patronage of William of Orange. Happily for Powis and garden-lovers, the great 'improver' was ignored on this occasion.

Also this year...

The Glasshouse Crops Research Institute is founded

The felling of trees in Kensington Gardens leads to the formation of a Standing

Advisory Committee to monitor the treatment of trees in the Royal Parks

The magician of Myddelton

Edward Augustus ('Gus') Bowles dies at his Enfield home, Myddelton House. Born in 1865, Bowles enjoyed a cosseted upbringing, the son of Middlesex gentry that had made its money from the New River, an aqueduct built to carry water from Hertfordshire springs to London some two centuries earlier. Too delicate for public school, he spent much of his childhood in the garden at Myddelton before going up to Jesus College, Cambridge to read Divinity. The Church was spared his services, however, when, having lost a brother and sister to tuberculosis, Bowles resolved to stay at Myddelton to look after his ageing parents. At first his interests ranged widely in natural history; then, in the early 1890s and at the urging of the great Gloucestershire gardener Canon Henry Nicholson Ellacombe (1822–1916), Bowles turned increasingly to horticulture. He disposed of the gloomy evergreen vegetation around his parents' estate and began transforming Myddelton into one of England's most beautiful and innovative gardens – hardly an easy task for a man afflicted with acute hay fever, dry gravelly soil and water (from the New River) 'so hard one feels it would be scarcely a miracle to walk on it'.

Hay fever accounts in part for the character of Myddelton's transformation. In late spring and early summer each year, Bowles would leave England, taking refuge from his allergies in the Alps, the Dolomites and other mountainous or dry European destinations. These journeys furnished him with many of his favourite plants – among them colchicums and crocuses (left), of which he was growing over one hundred and thirty species as early as 1901. His travels also shaped his ideas on landscape and plant association: before long Myddelton had acquired rock gardens, terraces and an alpine meadow.

These developments bore fruit during the Great War, when Bowles published three works, *My Garden in Spring*, *My Garden in Summer* and *My Garden in Autumn and Winter*. Charmingly written, they are nonetheless the productions of a practical plantsman, full of insights ('patience seems to be the only manure [*Iris unguicularis*] needs') and peppered with prejudices that it is only too easy to share ('spotty, marbled double balsams I should like to smash up with a hammer'). Bowles' approach was less informal in his *Handbook of Crocus and Colchicum for Gardeners* (1924) and *Handbook of Narcissus* (1934). These were effectively monographs full of descriptions that reflect Bowles' gifts as a botanist, and paintings that illustrate his talent for botanical art.

Bowles was left a sizeable inheritance and the gardens at Myddelton House prospered, assisted by teams of gardeners and swarms of local children for whom the most celebrated English amateur gardener of the 20th century seems to have been a magical figure. Bowles' greatest bequest to horticulture takes the form of the plants he introduced to gardens. For him plants were personalities: 'So long as plants flourish I cannot bring myself to destroy their happiness.' Bowles developed a keen sympathy for the more extrovert or eccentric of these personalities, growing monstrous forms like the corkscrew hazel *Corylus avellana* 'Contorta' in a border he termed The Lunatic Asylum. Some of Bowles' discoveries proved to be outstanding garden plants – the golden grass *Millium effusum* 'Aureum', golden sedge *Carex elata* 'Aurea', a pale primrose hellebore and the raven *Viola* 'Bowles' Black' are among the lasting joys that we owe to the magician of Myddelton.

Also this year...

Lawrence Hills founds the Henry Doubleday Research Association to carry out research into organic gardening methods

A whirlwind at Leighton Hall, Welshpool, destroys one of the original seedlings of x Cupressocyparis leylandii. *The ravaged plant – a*

distinctive, smoky-grey specimen – is cloned and named x Cupressocyparis leylandii *'Naylor's Blue' after its raiser*

The American rose breeder W.E. Lammerts introduces 'Queen Elizabeth', the first Grandiflora rose

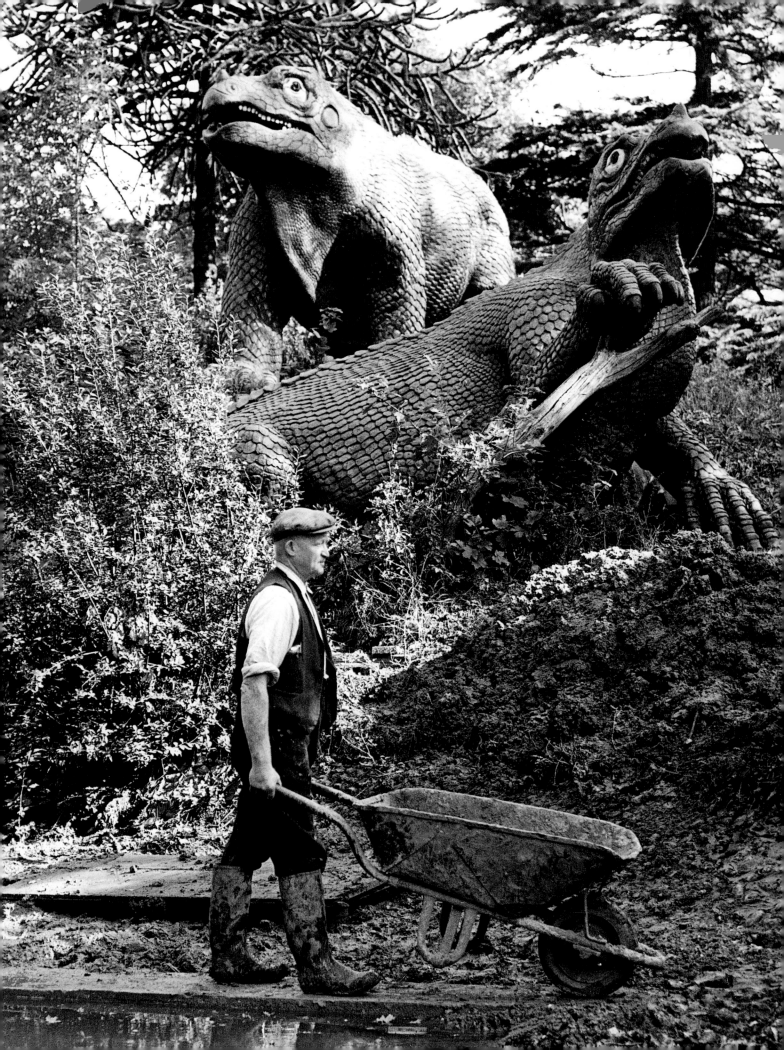

Jurassic park

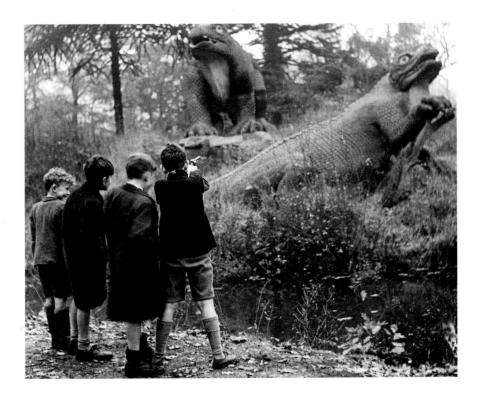

A gardener walks the plank as he cleans the lake in the grounds of the Crystal Palace at Sydenham, south London, watched over by a pair of giant stucco dinosaurs. There are 29 of these massive creatures lurking around the lake; they were built in 1854, the year that the Crystal Palace was re-opened by Queen Victoria, having been moved from Hyde Park to Sydenham after the Great Exhibition of 1851. The technical adviser for the dinosaur models was no less a biologist than Richard Owen, but the evidence on these creatures available to him was limited and his own interpretation of it idiosyncratic to say the least. As a result, many modern schoolchildren could point out that these monsters are anatomically flawed.

Although the Crystal Palace was originally constructed as an exhibition centre it has a long association with gardens, having been designed by Joseph Paxton, Superintendent of the Duke of Devonshire's gardens at Chatsworth House. The palace – a huge structure of iron and glass – was erected in Hyde Park amid much controversy; residents feared that if the park became a 'bivouac of all vagabonds', Kensington would become uninhabitable. Their fears were unfounded: the exhibition was a great success. The following year the Crystal Palace was dismantled and was later re-erected at Sydenham, where it formed the centrepiece of a new park and gardens.

Charles Dickens described the grounds as 'tastefully laid out with flowers, cascades and fountains', and noted that 'concerts, dramatic entertainments, flower shows... etc., are held annually, the charge for admission being usually one shilling, or by guinea season ticket... Illuminated Garden Fêtes on a grand scale and with novel effects, will be given every evening during the summer.'

The Palace itself burned to the ground on the night of 30 November, 1936 despite the combined efforts of 90 fire appliances. Crystal Palace Park today comprises 200 acres and includes formal gardens, a large circular tea maze, boating lakes, a zoo, sports facilities and, of course, the dinosaurs, which have been granted the same status as listed buildings.

Also this year...

Graham Stuart Thomas becomes garden adviser to the National Trust and publishes Old Shrub Roses

S. Miller Gault becomes Superintendent of Regent's Park

Frances Perry publishes The Woman Gardener

Gardens Illustrated, *founded by William Robinson in 1883, is absorbed by* The Gardener's Chronicle

King-size beds

'Only three crowns, Madam' replied Prime Minister Robert Walpole when Queen Caroline asked him what it would cost to make St James's Park a private garden for the royal family once more. Having been shared with the people, sometimes willingly, sometimes grudgingly, The Royal Parks were given to the nation in 1851. St James's had long been the favourite. When Charles II was restored, he began almost at once to lavish his attentions on it, employing the landscaper André Mollet as early as September 1660 to design a canal aligned with the steps of Whitehall Palace. Charles also built up a botanical collection in this park and a royal menagerie where pelicans appalled visitors as they still do by gulping down newly fledged ducklings.

A succession of leading British gardeners contributed to the park, among them Thomas Greening, an 'improver' who created Arcadian landscapes in the 1750s, John Nash, the genius behind The Regent's Park and Regent Street, and a variety of 19th-century horticulturists. Today St James's Park is a palimpsest, bearing the marks of centuries of garden history and somehow managing never to be anything but elegant, Elysian even when the hot dog stands outnumber the squirrels.

The park is rightly proud of its summer bedding. Here no fewer than eight gardeners plant up a border with hydrangeas in early May. When compulsory competitive tendering was introduced at The Royal Parks in 1992, it was feared that sights such as this one (in terms of both the number and cheeriness of the staff and the quantity and healthiness of the plants) would vanish. Those fears were misplaced. The standard of St James's summer bedding has, if anything, improved over the past eight years. Efforts have also been made to restore features from previous centuries. By recreating, for example, 'gardenesque' plantings from the mid-19th century, which bring together small trees, shrubs and perennials in carefully wrought associations, St James's Park is not just one of London's 'green lungs', but its living history.

Also this year...

George Taylor succeeds Sir Edward Salisbury as Director of Kew

The long-standing bulb firms of Peter Barr & Sons and Robert Wallace & Co. of Colchester amalgamate to form Wallace & Barr

Fireblight, Erwinia amylovora, *a disease affecting such woody members of the rose family as apple, pear, cotoneaster and hawthorn, is first reported in the UK*

One small step

In 1930 landscape architect Marjory Allen was shopping at Selfridges, in London's Oxford Street, when the lift she was riding overshot its stop and she found herself on the store's roof. Inspired by this sky-high urban wilderness, she set about persuading Gordon Selfridge that the roof was an ideal spot for a garden. Six months later the Selfridges roof garden was nearing completion – a series of design essays on such themes as scent, roses, the cottage garden, water features and winter-flowering plants. Not to be outdone, another department store, Derry and Toms in Kensington High Street, went to work on its own roof garden the following year. The Selfridges garden scarcely survived the decade, while the exotic orientalism of the Derry and Toms garden can still be enjoyed.

This episode of rivalry between two West End shops sparked a minor but spectacular trend in 20th-century English gardening: the department store roof garden. The most adventurous example was begun in 1956 at Harvey's store in Guildford High Street. Landscape architect Geoffrey Jellicoe took his inspiration for it from the first images of Earth seen from space. He covered the store's roof with a mirror of water which represents the skies. Across it spread constellations of stepping stones. Fountains arc like shooting stars and islands of vegetation simulate the smooth, amoeba-like outlines of nebulae.

In 1957 Harvey's roof garden was a resounding success. Customers enjoyed travelling its stepping stone galaxies or surveying its unearthly outlines from a nearby balcony. Eventually, overly fussy safety regulations forced the garden's closure. It survives but is out of bounds for visitors, the last word in a short-lived but fascinating fashion, and proof that commerce can sponsor visionary design that neither patronizes nor repulses the public.

Also this year...

Alan Bloom founds the Hardy Plant Society

Margaret Brownlow publishes Herbs and the Fragrant Garden

Christopher Lloyd publishes The Mixed Border

Lanning Roper publishes Successful Town Gardening

The education of a gardener

Horticultural students at the Royal Horticultural Society's Wisley garden cultivate vegetable plots – and enjoy a brief interlude in their labours beneath the blossom on The Old Cherry Field.

Education has always played an important part in the activities of the Royal Horticultural Society. Examinations set by the Society span the range of levels of horticultural expertise: the RHS General Examination is the first step in many budding horticultural careers and one of the most popular non-voca-tional qualifications, while the Master of Horticulture qualification is awarded to those who have attained the peak of professional excellence and is recognized as being the equivalent to a university degree.

At the end of the century, the Society reassessed its educational role in a bid to attract more candidates for these examinations and keep pace with the dynamic nature of horitculture and the shifting culture of the gardening profession. The two-year

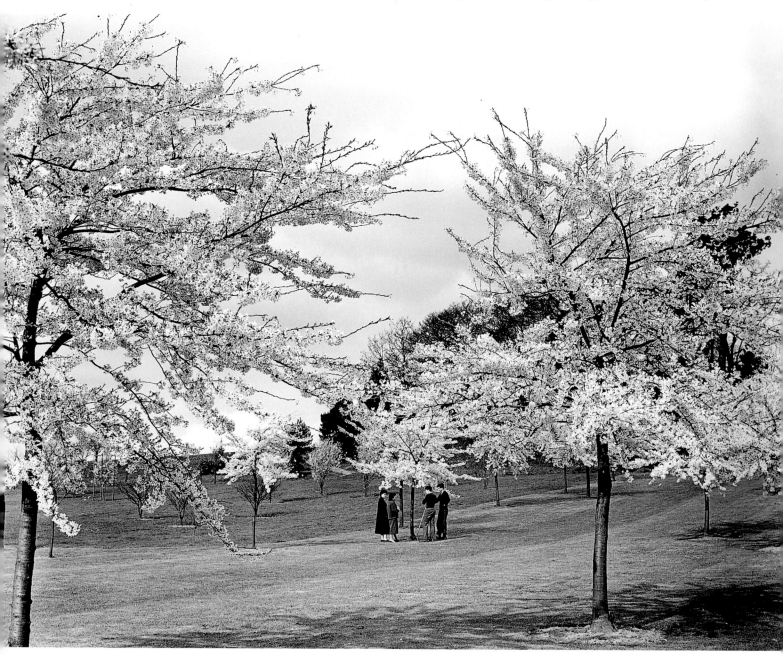

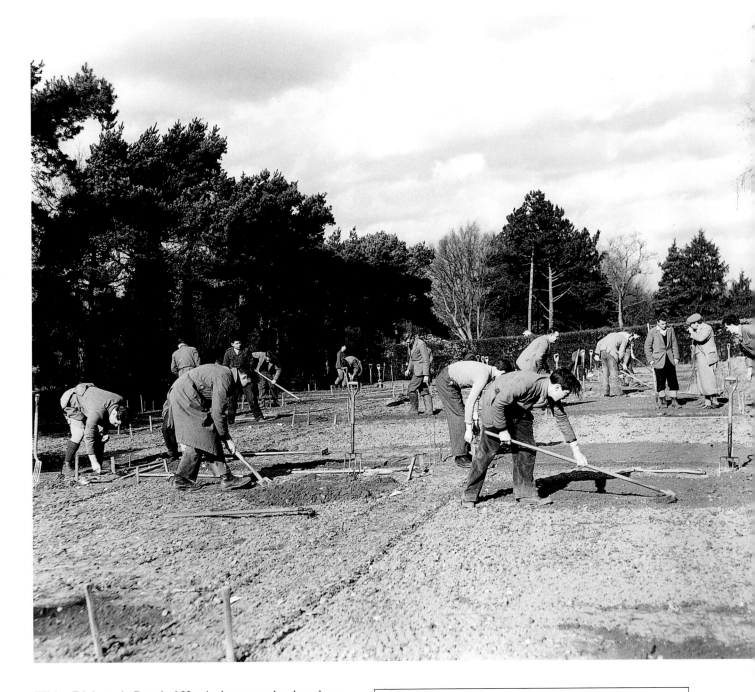

Wisley Diploma in Practical Horticulture was developed to set a benchmark by which future leaders in horticulture could be selected. It recognizes that career gardeners need scientific and technical knowledge to an ever-higher degree. Yet the value of the apprenticeship element of horticultural training – practical experience – cannot be overstated. When designing courses for future generations of horticultural professionals, the RHS has resolved to continue to strike a balance between these two vital forces in a gardener's development. Scenes like these at Wisley can still be seen 42 years later – and probably for many years to come.

Also this year...

Paraquat and Diquat are introduced as herbicides

Willhelm Kordes introduces a new rose, 'Schneewittehen', marketed in England as 'Iceberg'

The weekly magazine Garden News *is founded*

The Gardener's Chronicle *welcomes plastic pots as better for plants than clay, but regrets their costliness*

At Covent Garden in July Lilium regale *costs 3s–6s per dozen, as do cauliflowers*

Death of carnation breeder and nurseryman Montagu Allwood (b.1879)

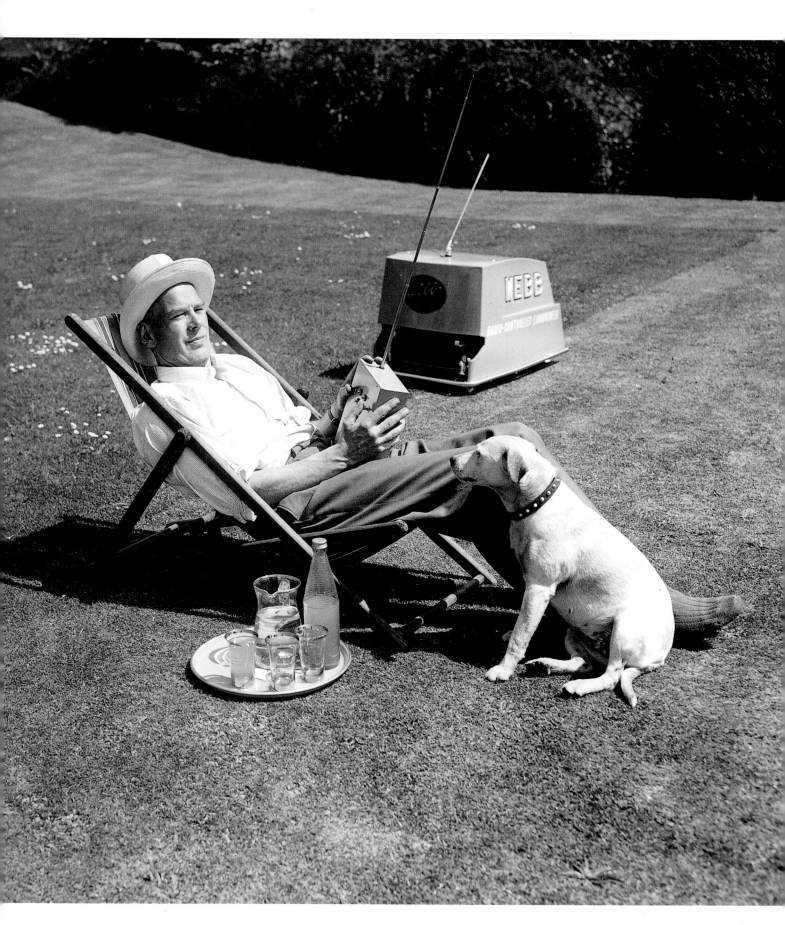

Giant hedges and remote-controlled mowers

Writing in 1662, John Evelyn took credit for having popularized yew as a substitute for the more tender Italian cypress 'whether in hedges, or pyramids, conic-spires, bowls or what other shapes, adorning the parks and other avenues with their lofty tops thirty foot high, and braving all the efforts of the most rigid weather, which cypress cannot weather'. Certainly between the 17th and 19th centuries, yew, one of the most ancient features of the cultivated English landscape, took on a new role, far from the whispering graveyard shade tree and ideal for mazes, topiary and giant-baffling hedges.

By the mid-20th century, the fashion for tall, sharp-edged and clean-sided hedges and ingenious topiary was in decline. Electric hedge trimmers had not quite arrived. The shortage – or expense – of manual labour meant that hedges everywhere were grubbed out or allowed to revert to unruly thickets, while some of the most celebrated examples of the topiarist's art turned from figurative to abstract within a matter of years. Unabashed, gardeners continued to trim the world's tallest yew hedge in Cirencester (right). Standing over 40 feet tall (very much the maximum Evelyn had suggested), it required regular shearing and replanting wherever bald patches appeared. The great trim came in early autumn each year and lasted several days.

Not only was there a shortage of labour around this time, but the majority of small garden owners had also decided that gardening ought to involve as little labour as possible. Nearly 90

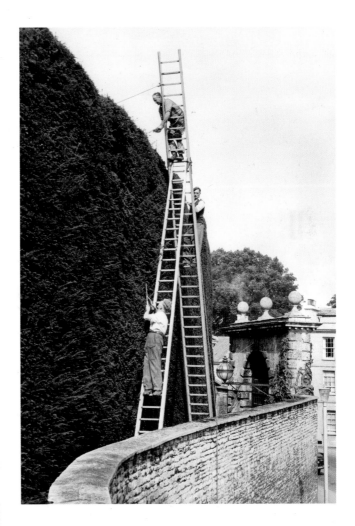

per cent of British gardens still had a lawn, presenting a chore that was as inescapable as it was boring. Other domestic activities were fast becoming automated – why not lawn mowing? In June 1959 Philip Southall of Rednal, Birmingham spent an exhausting afternoon putting a new remote-controlled mower through its paces. The brain-child of Woking research engineer Alfred Atton, the remote-controlled mower enjoyed a brief vogue, primarily in the US, but was soon supplanted by rotary and sit-on models. Even in an age of automation, it seemed that many gardeners could still agree – however grudgingly – with Edwin Budding who patented the first cylinder mower in 1830: 'Gentlemen may find, in using the machine themselves, an amusing, useful and healthful exercise.'

Also this year...

Gardener George Burrows is given responsibility for carrying forward Lawrence Johnston's vision for Hidcote, the Gloucestershire garden left to the National Trust on Johnston's death two years earlier

Bicentenary of the Royal Botanic Gardens, Kew – the foundation dating from the creation of the Physic or Exotic Garden in 1759

David Hessayon publishes Be Your Own Gardening Expert, *the first of the world's best-selling series of gardening books*

Death of Beatrix Farrand (b.1872), US landscape architect whose early works combined Italianate formality with English romanticism, most famously in her gardens at Dumbarton Oaks, Washington DC

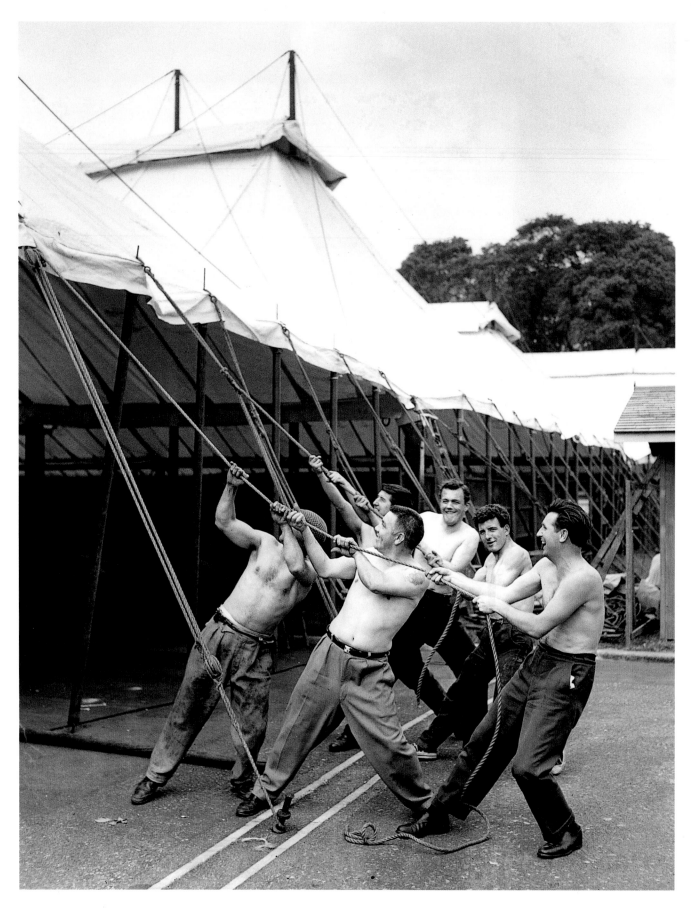

The largest tent on earth

A team of workmen erects the Great Marquee at the Chelsea Flower Show. This marquee was one of four to have been made to the same specification between 1951 when the first appeared, and the mid-1980s when the last was commissioned. It covered an area of 3.4 acres and was itself made of 6.8 acres of canvas. The structure was stitched together with 274 miles of yarn and weighed over 65 tons. Each year a team of 20 men took as many days to erect it, and at the end of Chelsea week, the marquee would be broken into 512 strips of material to be cleaned, checked and stored until the following May.

Chelsea Operations Manager Nick Yarsley described this annual ritual: 'The methods of erecting the Marquee's canvas hadn't changed much since the first one went up many decades ago. It was all a matter of ropes, posts, pulleys and sweat – a bit like being on a ship.' His maritime analogy is apt – the marquees were made and erected by Piggotts Brothers, an Essex firm which used to make sails for the Royal Navy.

In 1999 the marquee made its last appearance. Not only was its fabric deteriorating, but the world's largest tent could no longer cope with the rising number of visitors. In 2000 it was replaced by two shining white pavilions which can accommodate a flow of nearly two hundred thousand show-goers comfortably and allow the plants more air, light and space. This left the RHS with the problem of disposing of a mere 13.6 acres of used canvas (being the total area of the outgoing marquee plus its retired predecessor stored in Piggotts' Ongar warehouses). The Society, through the Old Chelsea Marquee Company, had the canvas made into bags and aprons that will ensure the Great Marquee continues to cover discerning gardeners for years to come.

Also this year...

Beth Chatto begins to plant her celebrated garden at White Barn House, Elmstead Market, near Colchester

Miles Hadfield publishes Gardening in Britain, *drawing much interest to garden history, a subject that will grow in stature over the following four decades*

Geoffrey Jellicoe begins publishing his Studies in Landscape Design *(the third*

and final volume appears in 1970)

The magazine Practical Gardening *is founded. It runs until 1996*

The Climatron at the Missouri Botanical Garden is opened

Death of nurseryman and alpine specialist Walter Ingwersen (b.1883) (x Halimiocistus *'Ingwersenii')*

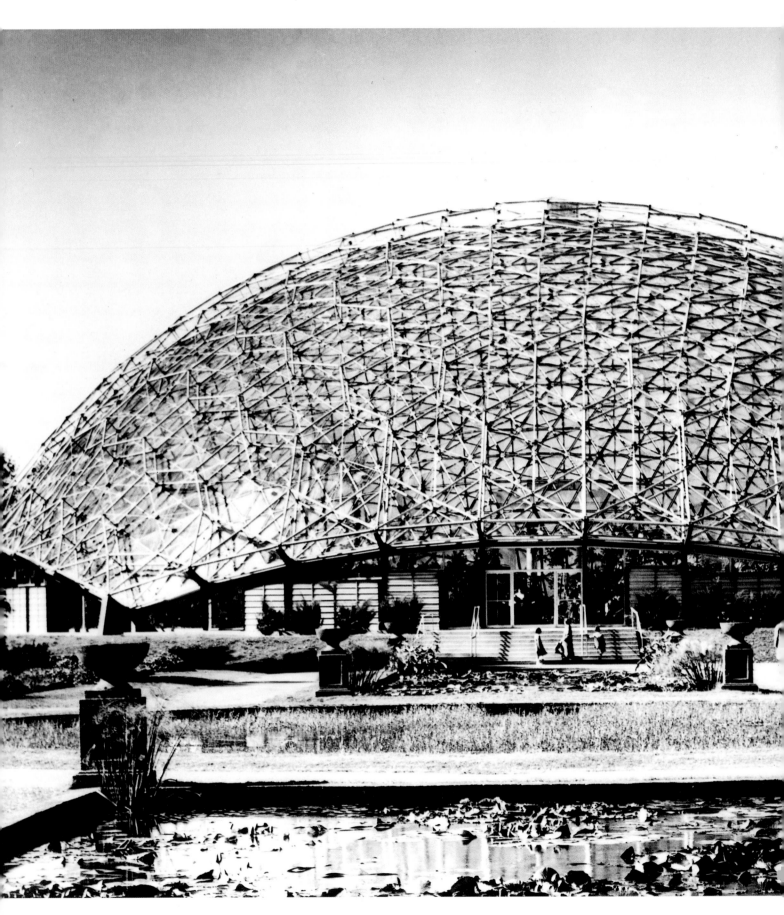

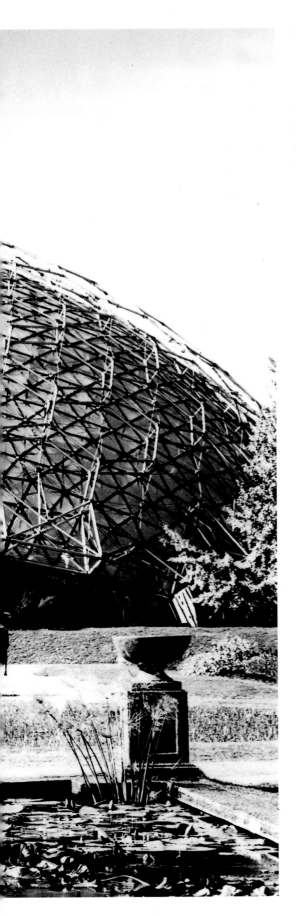
The Climatron

'The world's most unusual greehouse', the Climatron at the Missouri Botanical Garden in St Louis, received the Reynolds Award in 1961 for its originality and design. In 1976 it was named as one of the 100 most significant architectural achievements in US history.

The Missouri Botanical Garden is a 79-acre urban oasis, originally created by Henry Shaw, a prominent St Louis businessman, who opened his garden to the public in 1859. It is also known as Shaw's Garden and boasts outdoor display gardens, collections of orchids and tropical plants, beautifully laid out Chinese and Victorian themed gardens, the largest Japanese garden in North America, and the Climatron, one of the first geodesic domes to be built in the US and the first to be used as a greenhouse.

The Climatron opened to the public on 1 October, 1960. It has no interior support, allowing more light and space per square foot for plants than conventional designs. It rises 70 feet in the centre, enclosing an area of approximately 24,000 square feet (more than half an acre). The interior of the Climatron is designed on a tropical rainforest theme, recreating the diversity and ecology of the forests with more than 1,100 different species of tropical plants; these include banana, cacao, coffee, orchids, and rarities like the callipygian coco de mer, which produces the largest seed in the plant kingdom. This lush rainforest environment is maintained at a temperature between 64°–75° Fahrenheit by a computerized climate control system, humidity is kept at an average 85% and the plants are watered with de-ionized water.

After two years of extensive renovations, the Climatron re-opened in 1990. As well as the dense foliage of the rainforest, visitors can now see sparkling waterfalls, cliffs, and exotic fish, and view from a bridge the forest canopy. Dispensers allow visitors to sample edible plant products from some of the crop trees in the dome, and hundreds of colourful tropical butterflies fly freely within a specially designed habitat.

There are 2,425 panes of glass in the renovated Climatron. The old, deteriorated Plexiglas panes have been replaced with heat-strengthened glass, containing a Saflex plastic interlayer. The inner surface of this glass-and-plastic sandwich is coated with a low-emissivity film, which helps reduce heating costs by retaining the solar energy collected during the day for use at night.

Also this year...

An international scheme of plant registration authorities comes into effect, under the auspices of the International Commission on Botanical Nomenclature

Lorries and motor mowers finally oust horses from Kew Gardens – in 1948 only two remained

The 'Minibrite' greenhouse is launched, the first prefabricated, self-assembled aluminium glasshouse

Death of Sir David Bowes Lyon (b.1902), RHS President

Ars longa vita brevis

Gardener, poet and novelist Vita Sackville-West dies, aged 68. She was born at Knole, Kent. On her father's death in 1928, the estate passed to her uncle, the 4th Lord Sackville. By this time she had married, in 1913, Harold Nicolson, a diplomat, author and, later, Member of Parliament. Their first home and garden was in Constantinople, but from 1915 to 1930 they lived at Long Barn, near Sevenoaks. Here she began her long apprenticeship in gardening when they made a fine terraced garden on a steep difficult site. They moved to Sissinghurst Castle, Kent, in 1930.

Sackville-West's poetry, personal life, the love and loss of Knole, her gardening and the creation of Sissinghurst were intricately fused. Her long poem, *The Garden*, was published in 1946 and won the Heinemann Prize – the money went on azaleas. When on the outbreak of war in 1939, a German invasion force seemed likely to land in Kent, her response was to plant over 11,000 bulbs at Sissinghurst, as a lasting memorial should she have to flee.

When the Nicolsons bought Sissinghurst 1930, it was a ruin. There was an Elizabethan tower, some old cottages and farm buildings, a moat and old walls. Harold Nicolson planned the main architectural lines, sometimes by correspondance when serving overseas. It was Vita's task to plant the six-acre garden (opposite). She experimented with colour – grouping similar plants in enclosures, each a separate garden with its own character, 'like the rooms of an enormous house'. The White Garden is the best-known example. She was ruthless in removing any plant that was not exactly right; nonetheless she opposed excessive tidiness, encouraging wild flowers that met with her approval and self-seeded plants to grow where they fell naturally. In 1953 she described Sissinghurst's style as a fusion of 'the strictest formality of design with the maximum informality in planting'. She was indebted to Gertrude Jekyll for her theories of planting and to Lawrence Johnston for his 'garden room' design, which she borrowed from Hidcote Manor.

Vita Sackville-West was a prolific gardening writer with a weekly feature in *The Observer* newspaper from 1945 to 1961. Following her death, her recently appointed gardeners, Pamela Schwerdt and Sibyl Kreutzberger, continued to look after the gardens at Sissinghurst, which were taken over by the National Trust in 1967. Sissinghurst's gardens have since become so popular that visitors are sometimes allocated timed tickets.

Also this year...

Ending a 120-year tradition, Kew receives plants by Wardian case for the last time

Roy Hay publishes Gardening the Modern Way

Rachel Carson publishes Silent Spring, *drawing attention to the harmful effects on wildlife and the environment of DDT and other pesticides*

H.C.Webb introduces the 'Little Wonder', an electrically powered version of the traditional hedge clipper

The Flymo is patented in Sweden; it will be launched on the international market in 1964

Sir Frederick Gibberd redevelops Queen's Gardens, Hull

The purest of pleasures

In 1963 there seems to have been a bounty on gardening divines. At Minster Abbey at Thanet in Kent, Sister Florina, a Benedictine nun, was shot watering tomatoes in one of the abbey's glasshouses. Meanwhile in Nottinghamshire, photojournalist Eve Arnold captured Father Gregory Wilkins at work with a rotary mower. This was all good sport, but rather ignored the fact that horticulture and holy orders enjoy an ancient association without which the development of our own, secular gardens would have taken a very different course.

Within monastery walls, gardens were providers of food and medicinal herbs, while in the sacristan's garden ornamentals were grown for church decoration. Forbidden to eat meat, the Benedictines developed a deep and extensive knowledge of gardening and plant lore. The Carthusian monastery at Grande Chartreuse, near Grenoble, was likewise expert in horticulture and herbal medicine; the Carthusian Brothers developed flowers for cutting, most famously that delightful relation of the pink, *Dianthus carthusianorum* (also a great favourite of that well-known lover of all things monkish, Henry VIII).

The 9th-century monastery of St Gall in Switzerland has one of the oldest surviving gardens, a plan of which dates to 820AD. It shows a cemetery planted with fruit and nut trees and a vegetable garden where each crop is allocated one of 18 orderly beds. This adjoins a seed store, toolshed, work space and gardener's hovel. Surveyed by an apothecary's house and infirmary, the nearby physic garden produced herbs and a few ornamentals (lilies, roses). The St Gall scheme clearly shows the debt monastic gardeners owed to the ancient world and to the Roman *villa rustica* in particular.

Monks were the inheritors and guardians of Rome's extensive botanical and medicinal knowledge, as is amply demonstrated by another document asso-

ciated with St Gall, the poem *Hortulus* ('The Little Garden'). Written in 827AD on Reichenau (an island in Lake Constance), this delightful poem is the work of Walafrid Strabo (d.849) sometime abbot of the monastery there. *Hortulus* describes 23 plants in detail and some others in passing, praising not only their medicinal virtues but also their beauty and fragrance. Alongside its borrowings from Pliny and Dioscorides, the poem contains numerous direct observations made by the abbot himself.

What seemed bizarre in 1963 was merely the latest manifestation of the longest surviving gardening tradition in the western world.

Also this year…

The Kew Diploma, a highly regarded three-year course in horticulture, is instituted

Most nurseries have by now abandoned clay pots in favour of plastic – a growing trend since 1960

First sighting in the UK of New Zealand flatworms which spread throughout the country by the mid-1990s

The annual 'Britain in Bloom' competition is established

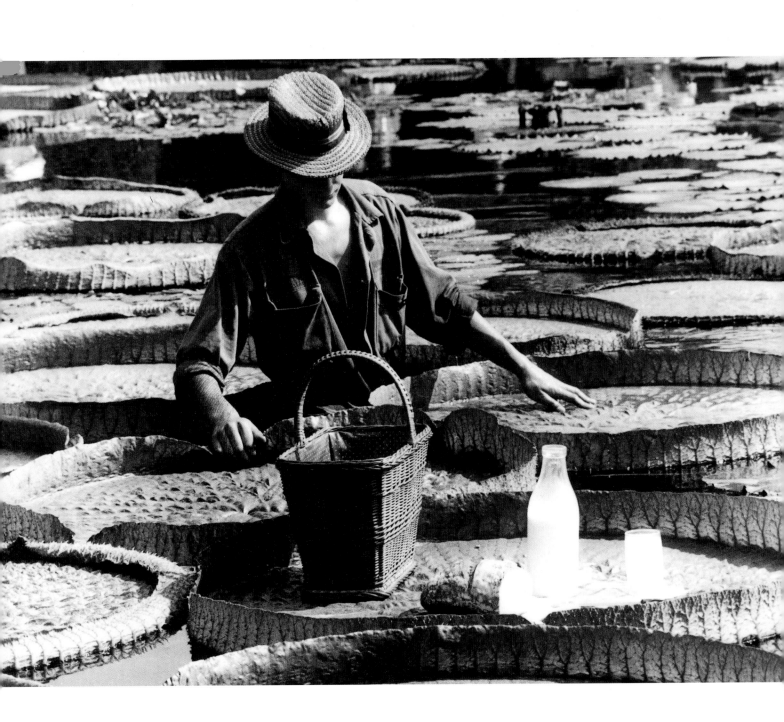

Feeding among the lilies

Waist-deep in water, a gardener breakfasts from a leaf of the giant waterlily *Victoria amazonica* at the Stuttgart Garden Show. The show was held at the Killesberg Park, which had been laid out by the great landscape designer Hermann Mattern for the Reichgartenschau of 1939. During the war years, the Killesberg, with its pools, fountains, dry stone walls and epic planting schemes, had fallen into disrepair. Mattern restored his creation as a home for the 1950 Garden Show, an event planned to stimulate competition among growers and reawaken German enthusiasm for horticulture – most pointedly among the planners of parks and other public spaces.

Few plants are more show-stealing than the giant Amazonian waterlily, which still grows in a 1,200-square-yard pool in the Moorish Garden of Stuttgart's Park Wilhelma. Appropriately enough, it was a German botanist, Thaddaeus Haenke, who first came upon its eight-foot-wide pads in a sluggish Amazon backwater in 1801, but Haenke's specimens went astray following his death in 1817. The giant waterlily remained a rumour until 1828 when the French botanist D'Orbigny rediscovered it in the Bolivian province of Corrientes. He confessed to having been 'dumbfounded with the deepest emotions' on first seeing the plant – but not too transported to send dried and pickled specimens of it back to Paris.

At the Muséum d'Histoire Naturelle, nobody seems particularly to have noticed the arrival of this aquatic monster, which was left to rot in a cupboard. Responsibility for the lily's debut would fall to Robert Schomburgk, an English-naturalized German naturalist. Exploring in British Guiana in 1831, Schomburgk came upon an inlet spread with the pads of giant waterlilies. Back in London, his specimens were described by the botanist John Lindley, and in 1838, the giant waterlily became *Victoria regia* (now *Victoria amazonica*) in tribute to the new Queen.

The giant waterlily's history in gardens is similarly fitful. Only 2 of 22 seeds sent to Kew from Bolivia by British explorer Thomas Bridges in 1845 germinated. These made sorry plants, with leaves smaller than the native British waterlily's and no hint of a flower. Nothing dismayed, Kew's Director, Sir William Hooker, welcomed *Victoria* to English gardens as a plant of 'preeminent beauty, rarity, and we may add celebrity... Seldom has any plant excited such attention in the botanical world.'

It was the Duke of Devonshire's gifted gardener, Joseph Paxton, who coaxed the giant waterlily into meriting Hooker's praises. In 1849 Paxton took one of the Kew seedlings north to the safety of his first glass masterpiece, Chatsworth's Great Stove. Here he berthed *Victoria* in a custom-built heated tank complete with waterwheel. Over the summer and autumn, the waterlily grew with astonishing speed: its leaves, less than six inches in diameter at Kew, were soon nearly six feet across. On the evening of 9 November, the first of its immense flowerbuds opened – pure white becoming suffused with wine red over its two-night lifespan and heavily scented of pineapple and custard apples.

Chatsworth was awash with visitors. The newspapers resounded with accounts of this marvellous plant whose leaves were large enough to support a child (Paxton's own daughter Annie, as it happened, dressed as a fairy for one of gardening's most famous engraving-opportunities). Before long, household goods – gas jet-holders, vases and baby's cradles – were on offer, fashioned after the world's most famous flower. By far the most spectacular example of the lily's impact, however, was on Joseph Paxton himself. He took his inspiration for such great glass structures as the Crystal Palace from the waterlily's giant pads whose delicate membranes stretch drum-like over networks of robust, spanning veins.

Also this year...

Geoffrey Jellicoe designs the John F. Kennedy Memorial at Runnymede

John Brookes begins his garden design practice

The Plant Varieties Rights Act is passed

The year of the garden centre, a phenomenon that is here to stay, as The Gardener's Chronicle *announces, reviewing Waterer's two centres at* Bagshot and Twyford, and Bygraves' at St Albans. *Europe's largest supermarket, Fine Fare, opens in Tolworth, Surrey, and incorporates a garden centre (Chelsea Choice) as part of its services*

Botanist and plant hunter Roy Lancaster moves to the Hillier Arboretum at Ampfield, near Romsey. Six years later he becomes the arboretum's first curator

The people's terrarium

In a 1993 tribute to author Anthony Huxley, Fred Whitsey described his publications, travels and service to horticulture. He also credited Huxley with having started a craze: 'The idea of growing houseplants in large, clear glass bottles', Fred Whitsey wrote, 'was his invention, and his carboy garden was one of the sensational surprises of a Chelsea Show of the early 1950s.' Anthony Huxley certainly promoted bottle gardens, 'the making of which', he remarked 'seems to the uninitiated to be as mysterious as the ship in the bottle (although it is in fact quite simple).' He saw them as a modern reworking of an old and originally technical device.

The idea of growing plants that were sensitive to dust, dry air, draughts and fumes in closed glass cases was developed in 1825 by the Scot Alan D. Maconochie, and in 1829 by the London physician Nathaniel Ward. At first Maconochie experimented with goldfish bowls; later he constructed miniature, wood-framed glasshouses for the home. Because Maconochie did little to publicize his inventions, it is to Ward that the growing case laurels must go. Ward's own approach was more scientific: he designed cases capable of sustaining plant life for years at a stretch. The Wardian case, as it became known, made a small but vital contribution to the expansion of Empire and the advancement of botany and horticulture. Previously, live plants had rarely survived long sea journeys. Sealed in Wardian cases, however, they needed next to no care on board ship, withstood gale and spume and made no demands on such precious resources as labour and water.

In 1842 the London nursery firm Loddiges reported that Wardian cases had increased survival rates in their plant shipments from 5 to 95 per cent. We have these containers to thank for the safe passage and introduction of many of the plants in our gardens and glasshouses. Of greater political and economic significance, Wardian cases carried tea to India from Shanghai, the Cavendish banana from Chatsworth to Fiji, and Brazilian rubber trees to Sri Lanka and Malaysia.

The Victorians soon saw possibilities in the Wardian case beyond the purely functional. Elaborate terraria began to adorn many homes, some of them, like 'The Crystal Palace Case', absurdly ambitious imitations of larger glass structures. The story of late 20th-century gardening is often one of reviving in simpler or more popular form fashions abandoned at the century's start. In the 1950s, the Wardian case was reborn in the shape of the modern terrarium, clean-lined, perhaps made from new plastics and filled with houseplants (which too were making a comeback).

The 'people's' terrarium was the bottle garden and the flower of the bottle gardener's art was the carboy, like this one proudly displayed by George Harrison. Emptied of acid, cider or whatever other hazardous liquid they were designed to contain, and painstakingly landscaped with cutlery tied to sticks and a primitive form of keyhole surgery, these vessels could be seen everywhere by 1965. Mr Harrison is not quite there, however. To achieve perfection, the carboy garden needed strictly to be crowned with a hessian lampshade and lit by a lightbulb of a suitably dingy tint.

Also this year...

The National Trust gives management of Wakehurst Place to Kew

Kew withdraws from the running of Bedgebury Pinetum

A new Jodrell Laboratory is built at Kew

The Garden History Society is formed

The century plant

Given the rarity of their flowering, their extraordinary appearance, allegedly wondrous properties and the superstition that they were used by Adam to stitch together his fig leaves, it is easy to see why century plants, members of the genus *Agave*, should have caused sporadic sensations in London ever since *A. americana* was introduced from the Americas by Raleigh. In 1730 London nurseryman John Cowell managed to flower a plant of 'the great American aloe' only to find his Hoxton gardens at the centre of a riot and himself the vicitim of a vicious attack by rivals determined to destroy what was by common assent the best show in town.

At Kew over two hundred years later, this specimen of *Agave atrovirens* var. *laussima* began to produce a flower spike in Christmas 1966. *The Times* reported the gardeners' 'ticklish problem' – moving a two-ton plant from glasshouse to glasshouse in hope of finding one that would finally accommodate its giant inflorescence. Pictured here in Kew's Orangery, the plant had already reached a height of 25 feet and was achieving nearly a foot of growth per week.

Itself standing between 35 and 40 feet high, the Orangery could scarcely be hoped to house the fully developed flowerspike, a massive, candelabra-like structure that can easily top 40 feet. The standard grower's solutions to the problem of rampaging agaves – either smash the roof panes or put the plant outdoors – were not available: one of Kew's most venerable buildings, the Orangery was not for smashing; nor was the season mild enough for this tender Mexican native to survive outdoors. In the event, the *Agave* managed to contain itself – just.

The name 'century plant' reflects the widely held belief that an *Agave* will not flower until it is at least 100 years old, a belief that is not quite accurate. Agaves rarely make their century, but they can certainly wait decades before blooming. Having performed this spectacular feat they die. The plant shown here is 40 years of age and has just one year ahead of it, a year in which to bask as one of the Royal Botanic Gardens' chief attractions.

Also this year...

The Mitchell Park Conservatory is opened in Milwaukee

Publication of The Education of a Gardener *by Russell Page*

Vancouver nurseryman H.M. Eddie launches the dogwood hybrid Cornus *'Eddie's White Wonder'*

Springfields Garden opens to the public in Spalding, Lincolnshire

As landscape consultant to the Forestry Commission, Sylvia Crowe publishes an influential pamphlet on the principles of forest landscape

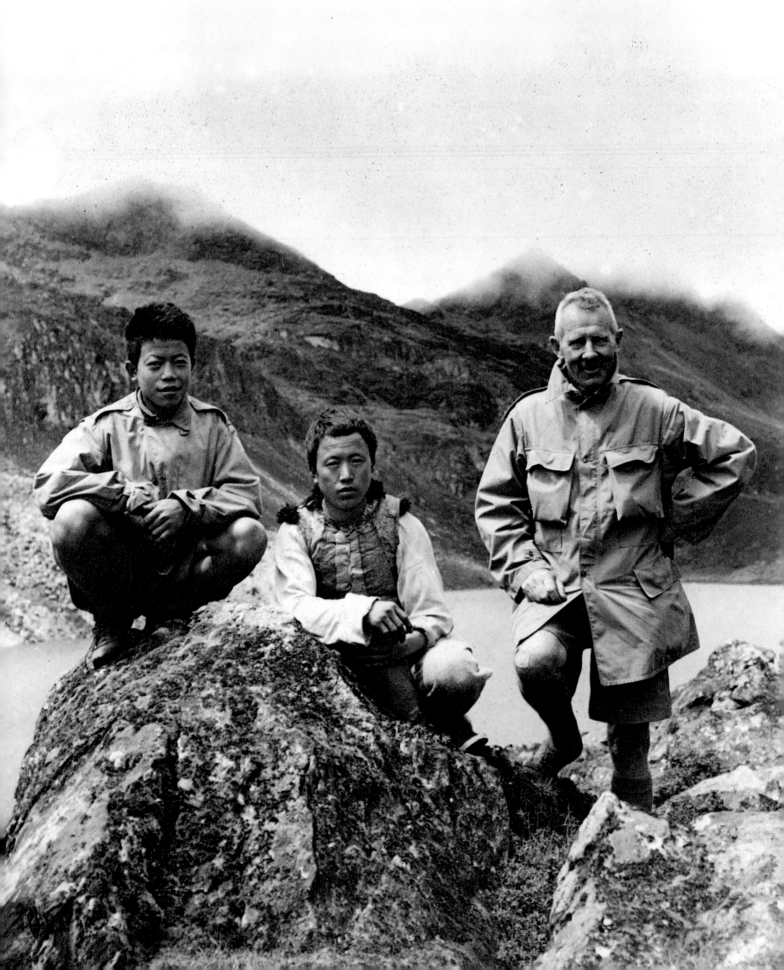

George Sherriff

Plant hunter Major George Sherriff, shown here on expedition in the eastern Himalayas, dies in Kirriemuir, Angus. Born in Stirlingshire in 1898 and educated at the Royal Military Academy, Woolwich, Sherriff went on to fight bravely during the First World War and, soon after, joined the mountain artillery on the Northwest Frontier. He then enlisted in the consular service, becoming British Consul in Kashgar in 1932. The seeds of his future career as a plant hunter had already been sown, however. On a 1929 shooting trip in Kashmir, Sherriff met the London-born Frank Ludlow (1885–1972), a natural scientist who had been working as an educationalist in India and Tibet. Together they planned the series of seven Himalayan expeditions for which they would become famous.

Between 1933 and 1950, Ludlow and Sherriff explored Bhutan, Tibet and the surrounding Himalayas. These were extraordinarily fruitful excursions. Travelling with future Kew Director George Taylor in 1938, for example, they collected 24,000 specimens, 5000 of which were either new to science or endemic to China and Sikkim. Among them were *Berberis sherriffii*, the magnificent yellow tree peony *Paeonia lutea* var. *ludlowii*, 27 new *Primula* species, 38 new saxifrages and 23 previously unseen gentians.

During the Second World War, Sherriff returned to soldiering until 1943 when he succeeded his plant-collecting colleague Ludlow as Assistant Political Officer with responsibility for the British Mission at Lhasa. Here the two of them found the lovely Lhasa poppy *Meconopsis torquata*, one of a number of Himalayan poppies to their credit that includes *Meconopsis superba* and *M. grandis*. When the war ended, the two partners began wholesale collecting again in 1946, discovering 23 species of *Rhododendron* in the small district of Pemakochung alone. The last of their wanderings in Bhutan (1949) yielded a total of 5,000 species and included the purple and gold-chequered *Lilium sherriffiae* and the glowing red *Euphorbia griffithii*. Both men returned to Britain a year later – Ludlow to work on his collections at the British Museum; Sherriff to live in Ascreavie in Kirriemuir where he created a famous garden landscaped in imitation of the Himalayas he loved so well, and stocked with the plants he had found there.

Also this year...

Beth Chatto opens her 'Unusual Plants' nursery in Essex

The National Trust embarks on its first garden restoration, at Westbury Court, Gloucestershire

Derek Lovejoy wins the first postwar competition for a town park with a plan for Everton Park, Liverpool; it is never realized

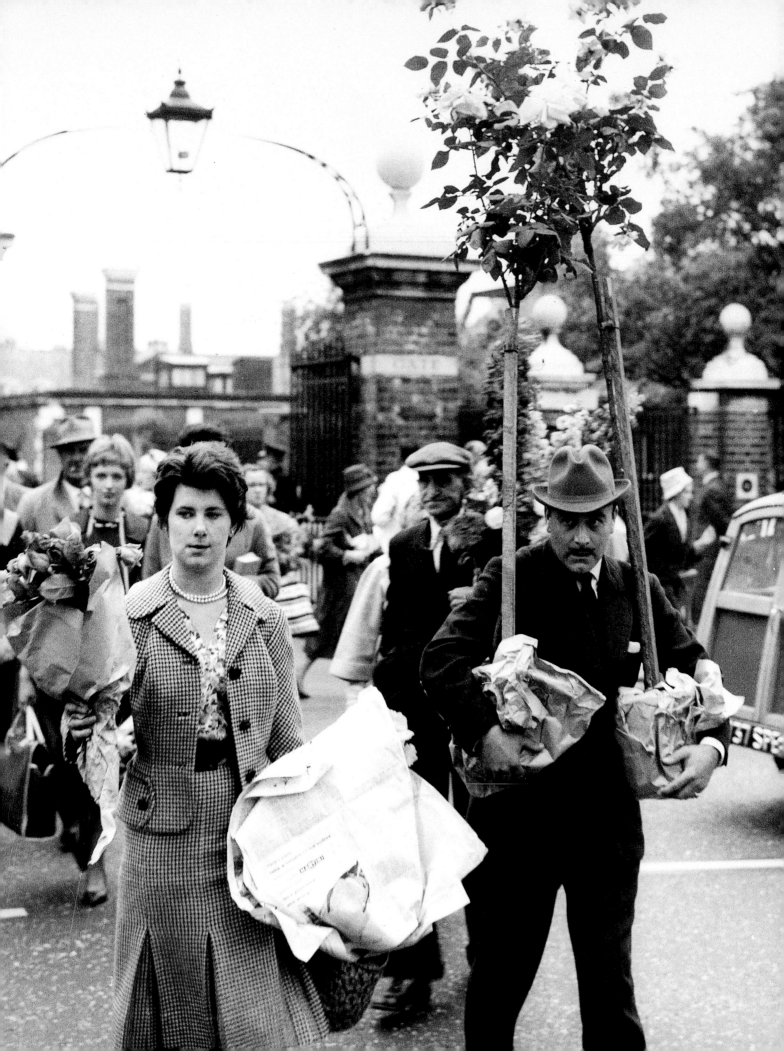

It's like a jungle out there

Warm Pimm's aside, the hardest aspect of the Chelsea Flower Show is the fact that for four days one has to endure the greatest horticultural temptation since Eve picked the apple – and resist it. The show abounds with plants one simply must have. Rarities, novelties, the commonplace, even things already in the garden at home, all become transformed by a species of Chelsea magic. For four long days, visitors (in 2000, 157,000 of them) must look without touching or buying. There are survival strategies, of course. We pick up catalogues, take notes and place orders; but none really answers the basic need, felt by so many gardeners, to have it *now*.

Then Friday comes and the afternoon of the final day. What ensues might justifiably be called the horticultural sale of the century if it did not happen every May. Stands are disbanded, whole gardens spirited away by gardeners who have perfectly good gardens of their own, and plants that have been eyed-up all week change hands for a fraction of their market value. Outside the show ground, the Chelsea Embankment briefly resembles Birnam Wood and press photographers loiter in the Royal Hospital Road in the certainty of snapping something that can be captioned 'Heavy Plant Crossing'.

This locust-like defoliation of Chelsea's brimming marquee and spectacular show gardens can induce personality changes and extremes of behaviour. Under such conditions it pays to be on guard – and this was certainly as true in 1968 as it is in 2000. This gentleman, bearing aloft not one but two standards, is ready to see off anyone who would commit the mortal sin of coveting thy neighbour's wife's aster or his ox-eye daisy.

Also this year...

James Russell begins planting Ray Wood at Castle Howard

The gardening supplies company Gardena introduces snap-on couplings for garden hose into the UK

On 14 January, a hurricane in Scotland fells thousands of trees

Syon Park opens its garden centre in west London

Some 14,000 container-grown trees and shrubs are planted at Thamesmead new town, the first large-scale use of containerized plants

Death of Vera Higgins (b.1892), botanical artist, editor of the Journal of the RHS, *President of the National Cactus Society and author of works on cacti and succulents*

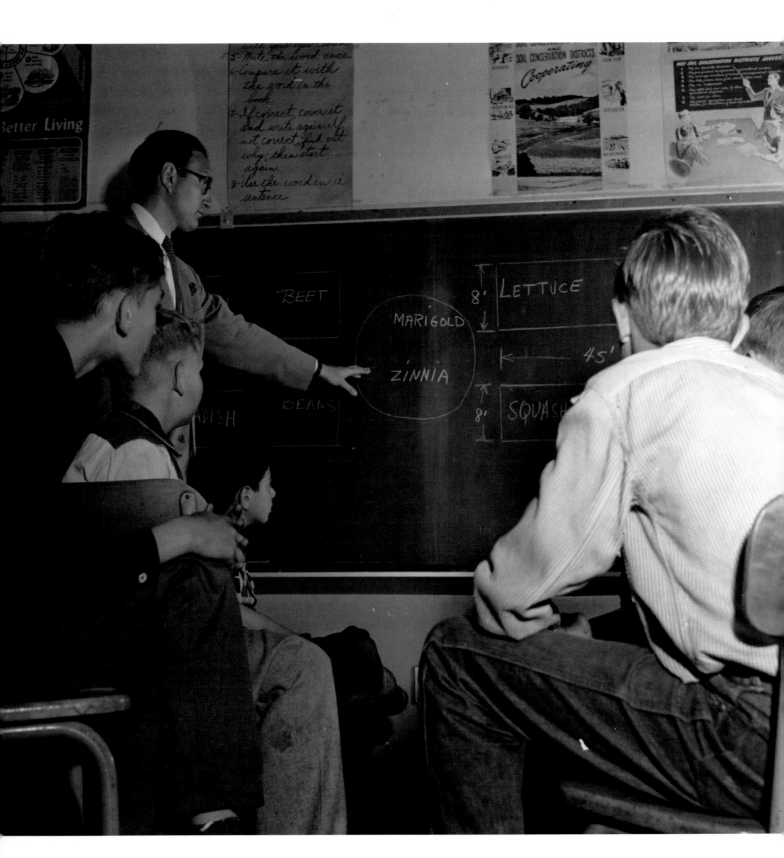

Happy days

On the eve of the 20th century, the great rose grower and garden author Dean Samuel Reynolds Hole put what would probably now be termed a 'mixed age group' through a short horticultural inquisition:

> I asked a schoolboy, in the sweet summertide 'What he thought a garden was for?', and he said, Strawberries. His younger sister suggested Croquet, and the elder Garden-Parties. The brother from Oxford made a prompt declaration in favour of Lawn Tennis and Cigarettes, but he was rebuked by a solemn senior, who wore spectacles, and more black hair than is usual with males, and was told that 'a garden was designed for botanical research, and for the classification of plants'.

Of course, few gardens are strictly for botanical study, but fewer still are solely for strawberries and smoking. One suspects that the good dean had found himself a rather cross-eyed focus group.

Horticulturists and educationalists have made numerous attempts to capitalize on the facts that many children are instinctive gardeners, and that most good gardeners start young. In 1855 Jane Loudon published *My Own Garden* or *The Young Gardener's Yearbook*. This was followed by the Reverend Johns' magazine *Gardening for Children*. Another journal, *The Garden* ran a regular feature titled 'Gardening for Children'. In 1905 the subject began to take on a more concertedly educational approach when Watkin and Sowman published *School Gardening*. Three years later, Gertrude Jekyll added to the thousands of words of junior gardening advice already published with her *Children and Gardens*; and the following year Madeline Agar produced *A Primer of School Gardening*. So it went, through *A Textbook of Gardening for Schools* (Hardy and Foxman 1939) to the ambitious secondary school garden plans printed in *The Teaching of Rural Studies* (Carson and Cotton 1962).

It is a scheme of this last sort that we see being taught here. A group of schoolboys is shown a planting plan that involves hardy annuals and a few easy vegetables. They appear to be rapt, indeed the scene looks more like a briefing at Bomber Command than a gardening lesson. Yet gardening, which combines art with science, thinking with doing and patience with activity, has some-

how never established itself in the curriculum, at least not outside schools for the liberated rich or the tramlined poor.

In the last decade of the century, the Royal Horticultural Society set out to remedy this situation by sponsoring inter-school competitions for young gardeners. Happily many of them have less in common with Dean Hole's brats than they do with US garden writer Allen Lacy, who remembers his first plant purchase (aged eight) in this way:

> It was named 'Happy Days', and it cost 25 cents, a week's allowance. 'Happy Days', the first plant that was all my own, came home with me that afternoon...An iris so-named was a perfect choice for a child who would grow up to find that most of his days in a garden were full of pleasure.

Also this year...

Modernist US landscape architect Garrett Eckbo publishes The Landscape We See

Garden historian Alice Coats publishes The Quest for Plants, *stimulating interest in the story of plant exploration*

The Queen's Garden at Kew is opened; commissioned by Sir George Taylor, it is an attempt to replicate a garden of the 17th century

A large-scale outbreak of Dutch Elm Disease affects southern England – over the next few years it will spread, virtually eliminating the elm from the English landscape

The Thorpe Report on allotments is published

Geoffrey Jellicoe is commissioned to design the water garden at Shute

Publication of Room Outside *by John Brookes*

Publication of The Design of Small Gardens *by C.E. Lucas Phillips*

Death of Harold Comber (b.1897), plant collector and botanist. He had left England and full-time plant hunting in 1952 to work with Jan de Graff, breeding lilies in the US. His last seven years were spent studying the flora of Oregon

Death of plantswoman and author Margery Fish (b.1892); a former journalist, she began gardening late in life when she and her husband, sometime editor of the Daily Mail, *moved to East Lambrook Manor in Somerset. Her most famous book,* We Made a Garden, *was published in 1956*

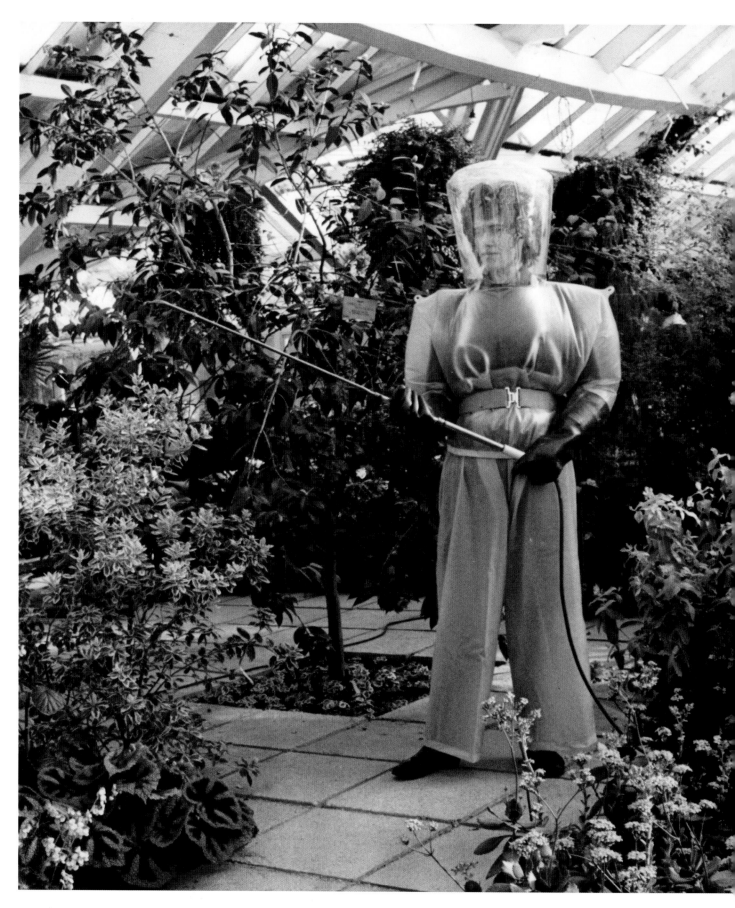

Breathe easy

At the Royal Botanic Gardens, Kew, Sophia Pienkos wears a PVC protective suit that seems to owe more to science fiction than horticultural science. By the early 1970s, gardeners were becoming more and more aware of the dangers of pesticides and herbicides. Fears were being expressed about the harmful effects of chemicals like DDT and Paraquat not only on the environment but on the user. Previously there had been a widespread tendency among gardeners to use such compounds with something approaching foolhardiness; now the consequences were beginning to tell. Protection became a matter of deadly seriousness.

Kew was a pioneer in these matters, taking steps to safeguard employees and public and developing codes of good practice that would not be adopted by many other horticultural operations for nearly ten years. By that time gardeners had already absorbed more than their fair share of organophosphates.

In the mid-1980s garden chemicals were receiving a well-deserved bad press. As an institution consecrated to the study and protection of biodiversity, the Royal Botanic Gardens could hardly condone poisoning environment and workforce as well as pests. Programmes of biological control were implemented in the glasshouses. These work on the principle of 'dog eat dog'. A natural predator, harmless to everything but the offending bug, is introduced to the glasshouse and attacks the pest. For example, two of the most common pests under glass, white fly and red spider mite, can be dispatched by a small wasp (*Encarsia formosa*) and a cannibalistic mite (*Phytoseiulus persimilis*) respectively. Meanwhile gardeners can breathe easy and space suits like this one can be left to gather dust in the potting shed.

Also this year...

Kew's Temperate House is declared dangerous and closed to the public

Publication of The Well-Tempered Garden *by Christopher Lloyd*

Armillatox is introduced to combat honey fungus

The five-year-old firm of Davies

Enterprises moves to Nantwich, Cheshire, and changes its name to Stapeley Water Gardens

The Sand and Gravel Association institutes its Restoration Award for projects that turn gravelpits and quarries into amenity landscapes

Patient pumpkin

Prize-winning vegetable grower Charles Roberts gives intensive care to a pumpkin which he hopes will sweep the board at an autumn show. The pumpkin, *Cucurbita pepo*, was first introduced to British gardens in 1570 and was originally native to Mexico. It soon became a common sight in kitchen gardens, although the British have never found it quite so palatable as do North Americans, for whom it has a special place on porches and the dining table at Thanksgiving. In the early 1970s, pumpkins, gourds and squashes were in something of a slump. More recently, they have enjoyed a revival as tastes diversify and more growers look to suppliers of unusual or heritage vegetable seeds. Not only do we enjoy growing these outlandish cousins of cucumbers and marrows, but we are learning how to use them.

There are now over one hundred pumpkin cultivars, ranging from 'Munchkin', with fruits only three or four inches in diameter, to 'Prizewinner' which weighs in at around 200lbs. At 60lbs, Mr Roberts' 'patient' still has some way to go. In the continental climate of the US, a pumpkin can safely be expected to produce a fruit weighing over 100lbs in something like 120 days from germination and with no special attention. Our own climate is less pumpkin-friendly and the challenge here has always been to maximize the amount of water and feed available to the developing crop. In the 17th century this was a matter of growing pumpkins on dung heaps, which not only nourished the plant but also generated heat to compensate for disappointing summers.

Latterly, pumpkin growers have resorted to a variety of strategies to bulk up their precious babies. One is to swell the fruit using a hypodermic and drip feed. Although the technique works and is more or less undetectable, among those who judge such things, it is not quite considered sportsmanlike. Mr Roberts' bedside manner might just cost him the cup.

Also this year...

With decimalization, Kew's visitor entrance fee soars from 3d to 1p

John Heslop-Harrison follows George Taylor as Director of Kew

James Hancock becomes head gardener at Powis Castle, and begins to restore the gardens for the National Trust

Mrs Desmond Underwood publishes Grey and Silver Plants

DDT is banned in the United States

Hillier's Manual of Trees and Shrubs *is first published*

Roy Lancaster joins a University College, Bangor, expedition to Eastern Nepal where he spends three months studying Himalayan plants

A lethal stroke

A horticultural researcher puts on the gauntlet to deal with weed grasses in a patch of brassicas. One square metre of farm or garden topsoil can contain upwards of 20,000 seeds buried in readiness for germination. Of these, the great majority will be weeds (plants that grow where they are not wanted). Of those, grasses will be among the most frequent and the most pernicious. Their seeds are small enough to be carried widely by a variety of vectors from small mammals to a strong breeze. Once established, they are difficult to eradicate – showing a high degree of resistance to selective weedkillers.

In 1972, the best available chemicals for dealing with unwanted grasses were still of the blanket bombing type, as likely to kill the crop as the weed itself. The usual solution to the problem – applying the herbicide directly to the weed with a fine nozzle – still presented a threat to the crop: spray drifts, and no operator is so careful that none of the solution will touch the plants one actually wants to keep alive. This glove was designed to allow growers to attack weeds directly and with greater precision. The glove has a porous, spongy palm which releases a powerful herbicide (probably Paraquat, used with reckless abandon in the 1970s) delivered by a tube from a chest-held reservoir. The operator merely gives his target a gentle handshake and the game is up. In this case he is attacking the inflorescence just as it sets seed, thereby despatching a generation of unborn weedy grasses.

The glove was not an entirely happy innovation. As the decade advanced, so did public awareness of the terrible consequences of over-using garden chemicals, and not just to the environment. Virtually unprotected, this researcher was in high risk of poisoning himself – weeds are by nature more unkillable than gardeners.

Also this year...

Kew concludes that its Orangery is unsuited to citrus cultivation and converts it to a bookshop and gallery

The National Trust creates a knot garden at Little Moreton Hall, Cheshire

Lord and Lady Salisbury move from Cranborne

Manor to Hatfield House, Hertfordshire, where they begin to create new gardens

Death of Sir John Heathcoat-Amory, who with his wife Joyce had created new gardens at Knightshayes, Devon, since the Second World War

CITES

Consignments of illegally imported orchids and succulents are seized by UK Customs officers. Gardens have long been enriched by exotic (non-native) species and a fascinating chapter in the story of gardening and botany concerns the activities of plant hunters. We have them to thank for the dazzling diversity of our garden flora, and the influx of new plants that continues even today.

That said, taking plants from the wild became less and less acceptable as the century progressed. Populations of some species became threatened by over-collecting. The Chilean blue crocus *Tecophilaea cyanocrocus*, for example, was gathered in such numbers that it became extinct in the wild and now survives only in gardens. The English native slipper orchid, *Cypripedium calceolus*, was reduced to a single wild specimen by the 1970s thanks to the demands of gardeners and florists. In 1986 a newly discovered Chinese slipper orchid, *Paphiopedilum micranthum*, was so hot a horticultural property that its native habitat was quite simply stripped as some 36,000 plants were sold into western cultivation.

In 1973 an international meeting was convened in Washington DC to discuss the regulation of traffic in threatened wildlife. The Convention on International Trade in Endangered Species (CITES) came into force in 1975 and was ratified by the UK in 1976. Within 10 years nearly one hundred countries had become party to it. In respect of plants, the convention concentrates on groups put at risk by their horticultural or economic desirability – cacti and succulents, orchids, cycads, carnivorous plants, bulbs like snowdrops and cyclamen.

The species controlled by the Convention are listed in two appendices. Those listed on Appendix I cannot be imported or

exported unless there is firm evidence that the plants have been artficially propagated. Appendix II plants can only be transported and sold under license from the CITES authorities for their countries of origin and destination.

CITES has done much to conserve the world's most vulnerable – and covetable – flora: a measure that had to be taken if we were to avoid stocking our gardens at the expense of nature's own. Not that the flow of new plant introductions from the wild has decreased. There are still unscrupulous dealers who will flout CITES. Equally there is a new generation of plant hunters prepared to collect responsibly and in association with growers and institutions. The growers then bulk up what the collectors find for large-scale, legal sale. CITES was a major factor in the 'greening' of gardens that began in the 1970s and peaked toward the end of the century. Alongside peat substitutes,

organic cultivation methods, ecological gardening and other green issues, the conservation of rare, choice plants in the wild and in cultivation has helped gardening's growing identification with environmentalism. It has become possible to garden for the planet as a whole.

Also this year...

Somerset County Council begins restoring the Gertrude Jekyll garden at Hestercombe

At the Royal Botanic Garden, Edinburgh, James Cullen and David

Chamberlain initiate a major reclassification of Rhododendron

Allen Cooper announces his development of Nutrient Film Technique

The curtain falls at Covent Garden

Covent Garden was originally just that – a garden belonging to a convent. The convent in question was part of the Abbey of St Peter at Westminster, now Westminster Abbey. Long Acre, Covent Garden's most famous street, was a long, narrow acre of market gardens which belonged to the Abbey. After the Dissolution of the Monasteries the land was granted to the 1st Earl of Bedford, and Covent Garden slowly began to take on the shape we see today. The 4th Earl commissioned architect Inigo

Jones to design the piazza and to build a number of up-market houses 'fitt for the habitacions of Gentlemen'; Jones took the Piazza d'Arme in Livorno, as his inspiration, where he had helped to build the cathedral.

In 1670 the 5th Earl and his heirs were granted a royal charter to hold a market for flowers, fruit, roots and herbs. The market gradually expanded and led to the establishment of coffee houses, Turkish baths, gambling dens and brothels. This change in the character of the neighbourhood led to new regulations governing the market and to the building of the market hall, which *The Gardener's Magazine* described as 'a structure at once perfectly fitted for its various uses; of great architectural beauty and elegance; and so expressive of the purposes for which it was erected, that it cannot by any possibility be mistaken for anything else than what it is'. Other market buildings followed, including the Floral Hall in 1860, the Flower Market in 1870–71 (now the London Transport Museum), and the Jubilee Market in 1904.

At its peak the market employed 1,000 porters, and was supervised by 12 officials of the Bedford Estates and 7 policemen hired from the Metropolitan Police. Charles Dickens wrote that, 'no visitor to London should miss paying at least two visits to Covent Garden: one, say at 6a.m., to see the vegetable market; the other, later on, to see the fruits and the flowers... the wall-like regularity with which cabbages, cauliflowers, and turnips are built up to a height of some 12 feet is nothing short of marvellous.'

Control of the market changed hands several times until, in 1961, it was bought by the Covent Garden Market Authority, who in 1974 moved the entire venture to a new site on land formerly owned by British Rail at Nine Elms in Vauxhall. The New Covent Garden Market is the most important fruit, flower and vegetable market in the United Kingdom, dealing with an estimated one million tons of goods annually.

Also this year...

Fisons launches its 'Gro-Bag', the most famous, though not the first, of the peat bag systems for growing plants

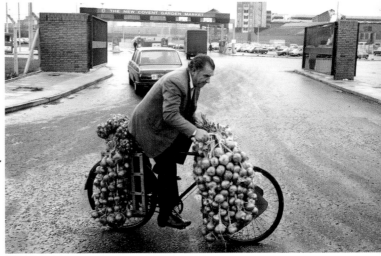

Condemned

In London's Richmond Park the death cross condemns victims of Dutch Elm Disease to felling. The disease is caused by a fungus, *Ceratocystis ulmi*, which blocks the tree's water vessels, killing it through thirst and starvation. The fungus is transmitted by elm bark beetles which breed in the decaying bark of affected elms and then carry the fungal spores to healthy trees where the adult beetles feed. The first signs of infection are wilting and shoot death. As the disease progresses the inner bark becomes brown-stained, and even large trees may succumb in as little as one or two months.

Dutch Elm Disease originated in East Asia (where elms are resistant) and was first observed and studied in the Netherlands in the 1910s (hence its name). The earliest-known strains were comparatively benign, sometimes killing only the odd bough; but by the 1930s more virulent forms of the fungus were attacking Britain's elm population on a epidemic scale. It was in the 1960s, however, that a strain appeared that would transform the British landscape for ever and which reached the height of its contagion in 1975. In southern England a survey of the disease's grip on the elm population had begun in 1971. By 1980 more than twenty million trees had been lost – 90 per cent of the total elm population counted at the survey's start.

In practical terms, Dutch Elm Disease remains incurable. To eradicate the fungus-carrying beetles would require insecticidal spray in such quantities that the likely environmental damage would outweigh the value of any trees saved. A fungicide has proved effective against the disease itself, but the treatment is costly, lasts for one season only and the innoculation procedure, which involves drilling the trunk with numerous holes each year, can only be repeated so many times before the tree will bear no more. Over the century, various disease-resistant elm clones have emerged only to be carried off by ever-fiercer strains of the disease. The only practicable control for Dutch Elm Disease is the felling and destruction of all infected trees.

The English elm (*Ulmus procera*) was an ancient introduction from Southern Europe. There is a certain symmetry in the fact that it may be replaced in cultivation by a new wave of immigrants – American and Asian elm species and hybrids capable of withstanding the fungus. Whether these could ever match the stately profile, graceful branching and pale gold autumn tones of our 'native' tree is doubtful. Meanwhile, the English elm is not quite extinct: a very few specimens survive in something like their original splendour, and clumps of low, bushy elms persist which have suckered from the roots of felled trees. Having grown so high, these too fall prey to the disease. For the moment, the one-time giant of the English landscape is condemned to a life of arrested development.

Also this year...

Geoff Hamilton becomes Editor of Practical Gardening

Alan F. Simmons publishes Potted Orchards

The Journal of the RHS *becomes* The Garden

John Bond becomes Keeper of the Savill and Valley Gardens, Windsor

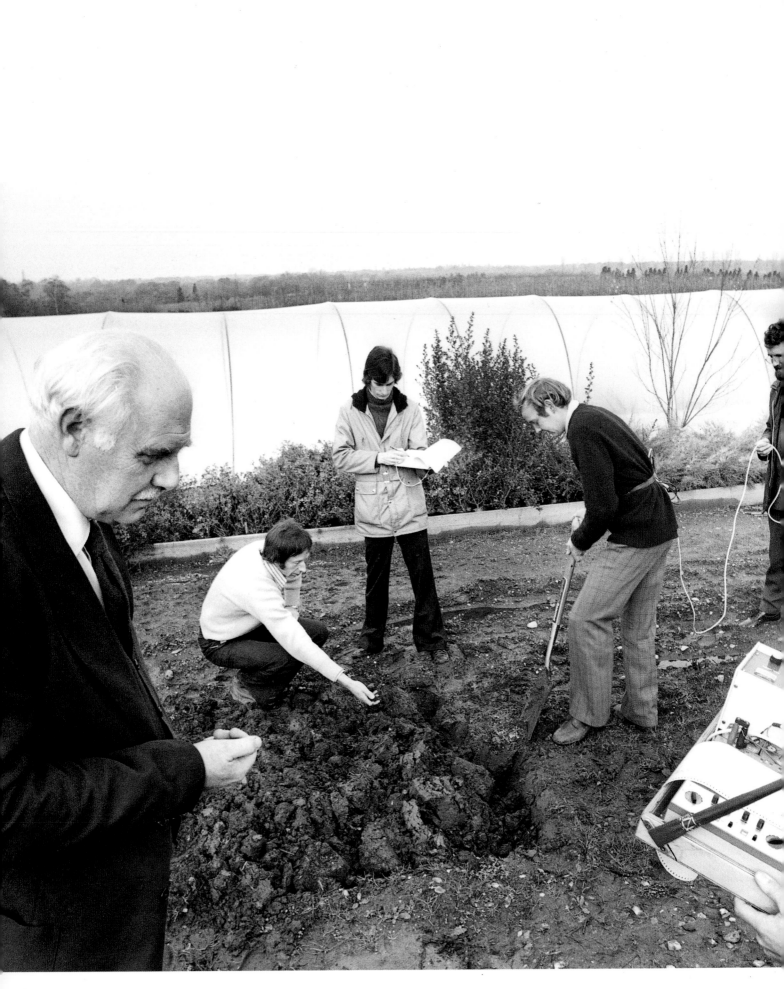

Trench warfare

Around 40,000 BC, a Paleolithic planter would have broken ground using a digging stick made from a mammoth rib. For more delicate operations, he (or, in all probability, she) might have resorted to a form of mattock made from the tusk of a mammoth attached to a branch. This early technology prevailed for a long time: ancient digging sticks have been unearthed in, among other places, Australia, Southern Asia and the Americas. The Incas made improvements of the sort we would still welcome today – handles and foot bars, for example.

The Ancient Greeks had *skapheion*, a general term for digging implements, among them precursors of the shovel and spade. The Romans, as ever, built on the Greek models, making wood-handled tools with metal blades. These included the *pala* (essentially our modern shovel), the *rutrum*, a long-handled spade with no grip, and the *bipalium*. A spade or shovel designed for digging deep trenches, this last tool had a crossbar on which the digger placed his foot for greater leverage. The bar was moved up and down the handle of the *bipalium* to ensure the correct fulcrum for the depth of trench required.

In the distant civilization of mid-1970s Surrey, little had happened to better these Roman tools, but academics were working on it. Professor Peter Davis and his colleagues at Surrey University conducted a series of experiments to examine the effects of digging on the soil and the digger. A small transmitter capsule was swallowed by the subject who was wired up to a monitor. He then attempted a range of what horticulturists call 'cultivation procedures' with various types and sizes of tools – from the good old West Country shovel to the so-called 'automatic spade', which had a foot-lever that purportedly made turning the sod easier.

Conclusions? The spade has scarcely been improved in something like 1,000 years. Digging will always be a back-breaking business, although there are good and bad ways of doing it and right and wrong sizes of implement depending on your own dimensions. It is little wonder that within a few years there was much talk of 'No-Dig Cultivation' in gardening circles, and that some of the older and more laborious styles of digging, like trenching, were abandoned amid widespread relief.

Also this year...

Percy Thrower is dropped from the BBC because he had appeared in commercials for ICI

An exhibition of the 18th-century painter and garden designer Thomas Robins leads to the discovery that one of his gardens survives virtually intact at Painswick in Gloucestershire; its restoration, as Painswick Rococo Garden, attracts great publicity in the 1980s

England has a record hot summer and drought. Over the next few years, an increase in insurance claims for subsidence, blamed on trees extracting water from clay soils, leads to recommendations that urban trees be removed

Graham Stuart Thomas publishes Perennial Garden Plants

Joy Larkcom publishes Vegetables from Small Gardens

Super fruit

Large, fast-ripening and long-lasting, a new kiwi fruit variety arrives from New Zealand. In the last three decades of the century, British consumers were faced with a bounty of 'new' and exotic fruits. Supermarket shelves groaned with custard apples and carambola, guavas and granadillas. What was once outlandish and prized became commonplace – passion fruit was just another ice cream flavour, and in the late 1980s star fruit supplanted parsley as the restaurant garnish of choice. First appearing in British greengrocers in the early 1970s, kiwis were forerunners of this Great Fruit Rush. Curiously, there was nothing especially new about them even then.

Actinidia deliciosa was grown for fruit as long ago as 700AD in its native China, where it is known as *yang tao*. Introduced to Britain by the plant hunter Robert Fortune in 1847, it was cultivated chiefly for its strong, vining habit, handsome felty foliage and white blossoms. Some time later and having realized the problems of pollination (male and female flowers are borne on separate plants), consumers noticed that the vine's bristly, jade-fleshed fruits far outstripped its ornamental value. *Actinidia deliciosa* earned the sobriquet Chinese gooseberry.

Chinese gooseberries were rechristened 'kiwi fruit' after 1906 when they were introduced to New Zealand by Alexander Allison. The kiwi thrived in the country's equable climate and growers bred a wide range of cultivars over a period of 40 years. By 1953, when the first examples of New Zealand fruit arrived at British docks, it was fast becoming one of that country's principal crops. According to the 1981 *New Zealand Kiwifruit Cookbook* (variations on a theme *ad nauseam*), kiwi pavlova is their 'national dessert'; but other nations have stepped in since. Kiwi fruit is now grown on a mass scale in Australia, South Africa, Israel, the US, Chile and Japan. Within the European Union, Italy's bulk production of this widely travelled fruit has led to gluts and price-slashing. What could command a premium in 1977 sells today for less than the price of an English apple.

Also this year...

Death of Arthur Bower, pioneer of soilless composts in the UK

Hampshire County Council takes over management of the 100-acre Hillier Gardens and Arboretum

Architect's dream becomes prisoner's nightmare

In the year of his death, visitors continue to enjoy architect Sir Clough Williams-Ellis's most celebrated creation, Portmeirion. Many years earlier, Williams-Ellis had entered this secluded cove on the northen shore of Traeth Bach, an estuary in north Wales. He was looking for safe anchorage for his yacht – instead he found a ruined Victorian house and a woodland garden whose acid-loving shrubs had gone native, mantling the valley and headland. Enchanted by this hidden place, Williams-Ellis resolved to build a fantasy village there. He turned the house into a hotel facing a miniature quay. Around the cove's leafy bluffs and gulleys, he heaped a variety of remarkable buildings.

He realized his vision of a magical settlement – a daringly complex hybrid which gathers elements of architectural styles through time and from around the world. In addition to the Mediterranean houses, for example, Williams-Ellis built an Italian campanile and a Jacobean town hall. Portmeirion's village 'green' is a delicious inversion of that most traditional of British public spaces. Colonnades and classical statuary flank terraces and formal pools; gilded statues of Thai dancers shimmer among subtropical plantings. This candy-coloured confection becomes still more vivid in spring and summer as rhododendrons, hydrangeas and embothriums burst into bloom, giving the village the appearance of an overgrown and mischievous garden folly.

Williams-Ellis's charming pastiche was a triumph of the picturesque. As the setting of the cult 1960s television series 'The Prisoner', Portmeirion also became one of the nation's favourite landscapes, loved (and sometimes slightly feared) even by those who had never been there.

Also this year...

Will Ingwersen publishes his Manual of Alpine Plants

The Flymo's patent expires, and Qualcast launches its rival Hover Mower

The National Council for the Conservation of Plants and Gardens is founded

Death of gardener, artist and author Alice Coats (b.1905), who wrote such works of garden history as Flowers and their Histories *(1956) and* The Quest for Plants *(1969)*

Death of San Francisco-based landscape architect Thomas Church (b.1902). Designer of more than 4,000 projects, he was father of the low-maintenance Formism with its hallmark paving, sculpted hedges and gravel, and, later, of the California Style which viewed gardens as outdoor living rooms: 'Make your plot of ground produce exactly what you need and want from it.'

Points mean prizes

The showing and judging of plants has always been an important aspect of the Royal Horticultural Society's activities. Even in its infancy, when the Society (then The Horticultural Society of London) was more a learned and exclusive club than the nation's premier gardening charity, new and interesting plants were exhibited at its meetings. But it was in the 1830s, under the direction of its celebrated assistant secretary John Lindley (1799–1865), that flower shows as we would recognize them became a regular feature of the Society's calendar. The best-known shows were established in the next century: Chelsea in 1913 and Hampton Court Palace in 1990. Around these two great gardening festivals there runs a schedule of smaller events held fortnightly or monthly at the Society's Westminster halls.

The London Flower Shows, as they were rechristened in 1999, are perhaps more genuinely representative of the state of British horticulture and the needs of British gardeners than the two annual extravaganzas. Growers from around the country display their wares in lovingly staged exhibits. The plants are brought to the show unforced and in season and presented in settings that recreate their requirements in the garden. The nursery owners are on hand to discuss their offerings, a surprising proportion of which will be new to gardeners. Above all, plants are for sale throughout the event at prices that would make most garden centre owners blush.

At shows the RHS judges exhibits and competitions among plant groups like daffodils and roses, awarding exhibits medals (gold, silver-gilt, silver, bronze) and competition entrants prizes (first, second and third). Individual plants can also win one of a series of certficates of gardenworthiness culminating, after trials and deliberations, in the Award of Garden Merit. Other than to reward excellence among gardeners, two important points of this exercise are to monitor the performance of garden plants and to recognize and spread awareness of what is new or deserves to be better-known.

The Society sets about this task through expert committees made up of volunteers, some of them professional horticulturists, some dedicated amateurs. At the last count, there were 34 RHS committees judging plant groups from alpines to apples and orchids to vegetables. In spring 1979, a judge scrutinizes narcissi at a daffodil competition. The intensity of his gaze is completely justified – in 1999 there were over 25,000 listed narcissus cultivars, a total that had been increasing at a rate of nearly two hundred a year since this photograph was taken. His task is to know them.

Also this year...

The exhibition 'The Garden' is held at the Victoria and Albert Museum

Geoff Hamilton becomes co-presenter of the BBC television programme

'Gardeners' World' from Barnsdale Garden

Allot more allotments

Marcus Fox, Under-Secretary of State for the Environment, meets demonstrators carrying placards and waving garden implements. Their protest outside the Department of the Environment hoped to persuade the government to drop provisions in a bill which, they feared, would jeopardize the allotment system. Members of Friends of the Earth and the National Society of Allotment and Leisure Gardeners handed a letter to Mr Fox, addressed to Michael Heseltine (then Secretary of State for the Environment) informing him that gardeners were concerned about the poor level of provision for allotments.

In 1980 there were 121,000 people on waiting lists who could not get allotments because, protesters claimed, local authorities were not fulfilling their legal duty to provide sufficient allotments to satisfy demand. The letter to Mr Heseltine complained that, despite these figures, 'the Bill contains six clauses which would allow local authorities to fail even more

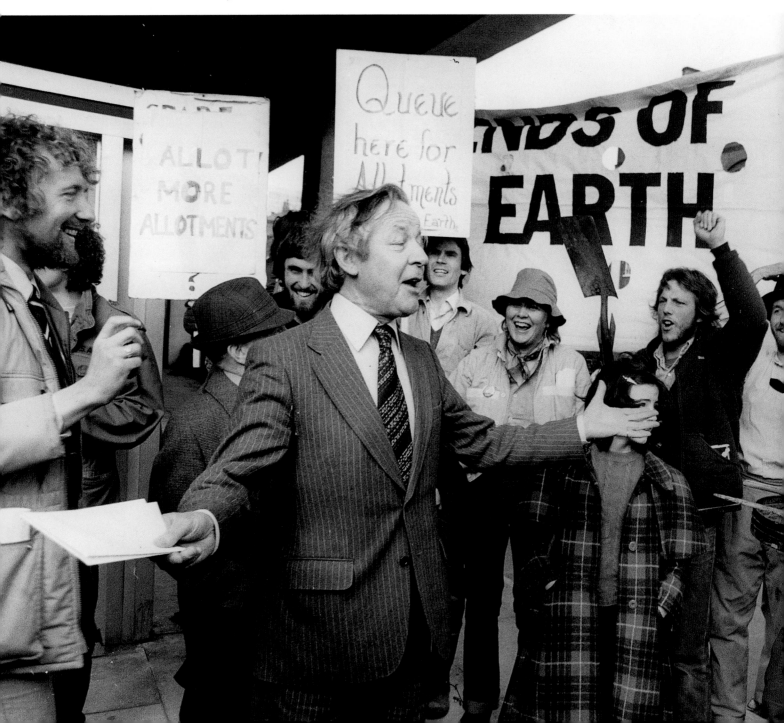

abysmally in the provision of allotments'. The letter, signed by Mr Czech Conroy, campaign director of Friends of the Earth, urged the minister to drop those clauses and replace them with new ones tabled in the Commons by Mr Stephen Ross, Liberal MP for the Isle of Wight, which included proposals requiring the Secretary of State to instruct local authorities to grant temporary allotment licences on vacant land. Mr Fox said that no government would deliberately seek to do away with allotments,

and that he was 'horrified at the suggestion'.

Allotments have a long history in England; small Celtic fields in Cornwall, dating from c.100BC, are still in use today as allotments, and, at the end of the first millennium, the Saxons frequently created new fields by clearing natural woodland, with the freed land being shared out between the participants. Then came 600 years during which more and more common land was appropriated by the church and by the Lords of the Manor; not until Elizabethan times were commoners compensated with 'allotments' of land attached to tenant cottages. Protests about poor provision of allotments are nothing new – it was fear of a peasant revolt that led to the General Enclosure Act of 1845, which allowed enclosures only if land was set aside for allotments – the first legal step towards the modern allotment system. However, of 615,000 acres enclosed in the following 25 years, only 2,200 acres were set aside for allotments (a mere 0.3 per cent), and there was pressure for further legislation. Various Acts were eventually consolidated in The Allotment Act of 1908. During both World Wars the demand for allotments grew due to food shortages; during the Dig for Victory campaign in the Second World War, even public parks were dug up to grow food.

The National Society of Allotment and Leisure Gardeners (NSALG) was formed in 1930, at a time when demand for allotments was falling after the First World War, and more and more land was being used instead for housing, often in breach of the 1908 Act. After the Second World War, demand for allotments fell yet again, and much of the land was taken back by local authorities for development. Today the NSALG campaigns on behalf of allotment holders and vegetable growers throughout the UK. Its mission statement is 'to help all both nationally and internationally to enjoy the recreation of gardening, and thus to promote their health, education and community fellowship'.

Also this year...

The 10-volume New York Botanical Garden Illustrated Encyclopedia of Gardening *edited by T.H. Everett begins to appear*

Arabella Lennox-Boyd begins making her garden at Gresgarth, Lancashire

John Brookes founds a school of garden design at Denmans, Sussex

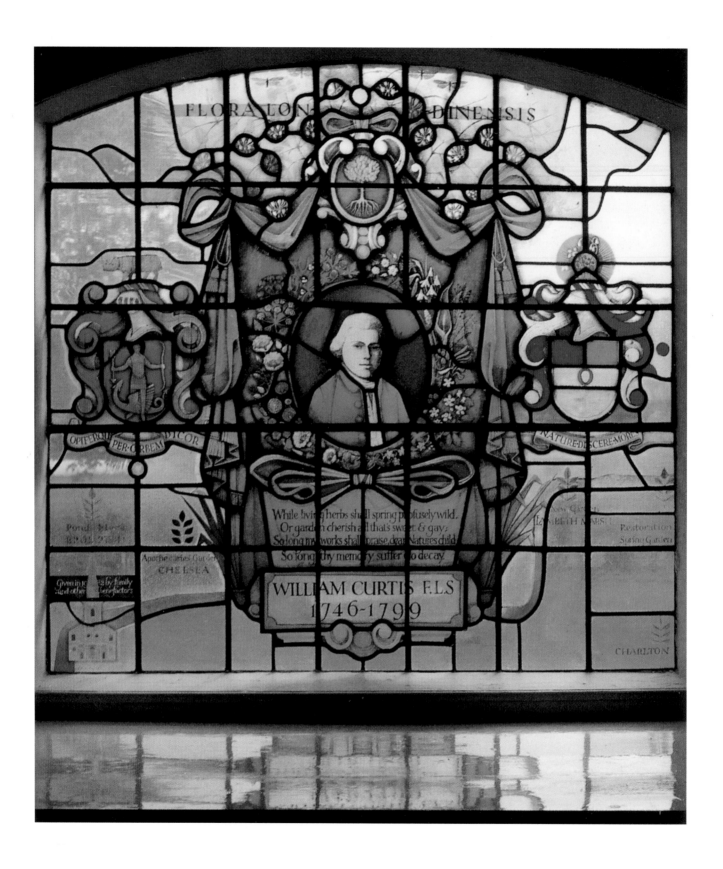

FLORA LON- -DINENSIS

OPIFERQUE PER ORBEM DICOR

NATURE DISCERE MORE

While living herbs shall spring profusely wild,
Or garden cherish all that's sweet & gay;
So long my works shall praise, dear Natures child
So long thy memory suffer no decay.

WILLIAM CURTIS F.L.S
1746-1799

Apothecaries Garden
CHELSEA

Restoration
Spring Garden

CHARLTON

A capital gardener

In 1981 Canon John Morris, Vicar of St Mary's Church, Battersea, set up an appeal for new stained glass windows to commemorate four notable people who were associated with the church around the time of its rebuilding in 1777. They were Benedict Arnold, William Blake, J.M.W. Turner and William Curtis. Of the four luminaries, Curtis is the least well-known; his role in British gardening and botany, however, makes him a more than worthy member of their company.

Born in Alton, Hampshire, in 1746, Curtis was tutored as a child in botany by Thomas Legg, himself a student of the great herbalists Gerard and Parkinson. Having served his apprenticeship with his uncle, the local apothecary, Curtis moved to London, where he studied at St Thomas's Hospital before inheriting an apothecary's practice in the City. Making his first London garden at Bermondsey in 1771, Curtis devoted an acre of land to a collection of British native plants – an interest that would remain with him. Two years later, he became Demonstrator of Plants and *Praefectus Horti* (Superintendent) of the Chelsea Physic Garden, a post he held until 1777. Next, he opened the London Botanic Garden at Lambeth Marsh – a commercial venture, where visitors were asked to pay an annual subscription of one guinea. Two guineas would secure them any surplus seeds and plants. Since the garden could boast some 6,000 holdings by 1783, this was a bargain. 'Greatly troubled...by the smoke of London', the garden was moved to semi-rural Queen's Elm at Brompton in 1789.

Curtis is best remembered as an author and publisher. *Flora Londinensis*, an exquisitely illustrated account of plants found within 10 miles of London, was published in 72 instalments between 1775 and 1798, and is a poignant reminder of the wildlife that once abounded in the city. A financial failure, the *Flora* was never finished, but Curtis's most celebrated publication was altogether more successful. First published in 1787, *The Botanical Magazine* or *The Flower Garden Displayed* soon established a circulation of 3,000. Each issue described newly discovered or introduced plants and was illustrated with hand-coloured plates. By the time Curtis died in 1799, 14 volumes had appeared and *The Botanical Magazine* enjoyed a leading position as a vehicle for botanical and horticultural description – a function it continues to perform to this day.

Conceived in 1981 by stained-glass artist John Hayward, the Curtis window was installed at St Mary's, Battersea, in 1982. Over Curtis's head is the emblem of the Royal Horticultural Society, which contributed to the window appeal as it had already to the restoration of Curtis's grave. Curtis is shown garlanded by flowers from *Flora Londinensis*; to his left are the arms of the Society of Apothecaries, owner of the Chelsea Physic Garden; to his right are the arms of the Linnean Society, of which Curtis was a founder member. Below runs the Thames and the signposts along it mark Curtis's four gardens – at Bermondsey, Charlton, Lambeth Marsh and Brompton.

Also this year...

Professor E.A. Bell succeeds Professor J.P.M. Brennan as Director of Kew

Kew's new, pyramidal Alpine House opens

The Painshill Garden Trust is formed to rescue the famous 18th-century garden from dereliction

The Society of Garden Designers is founded

Death of J.R. Evison, long-standing Parks Superintendent for Brighton. The first flowerbeds in the Brighton

Parks are grassed over

Death of British plantsman and ornithologist Collingwood 'Cherry' Ingram (b.1880). Among his many introductions were Cistus ladanifer var. sulcatus, Cytisus ingramii *and* Hydrangea serratifolia. *His work as a plant breeder resulted in – among others –* Cistus 'Anne Palmer' Prunus 'Kursar' *and* Rubus 'Benenden', *this last named after the location of his Kent home*

The Temperate House

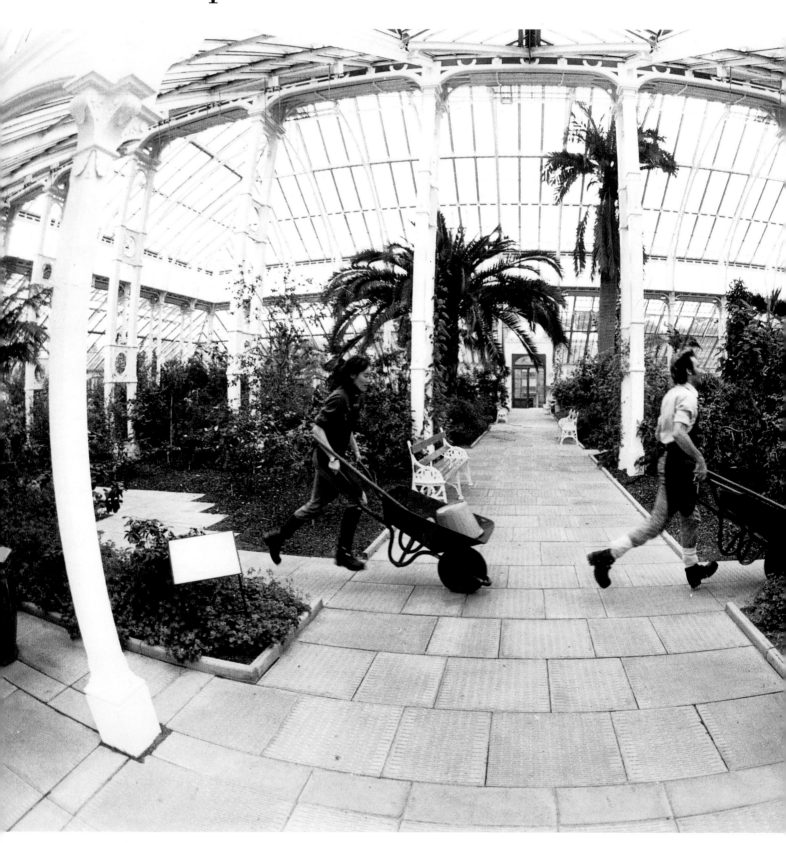

Horticultural Diploma students Caroline Burgess and David Spink practise for the annual clog and apron race in the newly restored Temperate House at the Royal Botanic Gardens, Kew.

Designed by the architect of Kew's Palm House, Decimus Burton, the Temperate House first opened to the public in May 1863. At the time it was two-thirds finished and had yet to gain the two great wings it sports today. Its commissioning and construction had been dogged with problems which included a surprising volley from Sir Joseph Paxton, pioneer of large glass structures and friend of horticulture and botany. Paxton used Parliamentary privilege to demand why the glasshouse cost £25,000 when the job could have been done for £10,000.

Despite all, the Temperate House was Kew's first major glass construction since the Palm House of 1848, and it opened to general acclaim. The house's centre block was 212 feet 6 inches long by 137 feet 6 inches wide and stood 60 feet high. At either end the smaller octagonal annexes were 54 feet across and 25 feet high. Kew's aged Director, Sir William Hooker, had what he wanted – a new growing space that would allow him to move cooler-growing species from the overcrowded and decidedly wet tropical Palm House, and give him room to expand Kew's collections of flora from the world's warm temperate regions.

A century later, the Temperate House was experiencing troubles to do with decay rather than teething. The ironwork was corroded, the masonry crumbling and the glazing liable to drop in unannounced. Closed in 1970, the house did not reopen officially until 12 years later. Major restoration work began in 1978. Most of the plants were moved to temporary quarters, but eight trees were judged too large to budge; swaddled in polythene and warmed with portable stoves, they remained *in situ* as the glasshouse was skeletonized around them. The most famous of these eight stragglers, the Chilean wine palm, *Jubaea chilensis*, had already exercised the ingenuity of Kew's gardeners.

In 1938, the palm's fronds began to push at the sloping glass roof of one side of the Temperate House. It was decided to move the palm to the centre of the house which offered more headroom. Dug out and ready for transplanting, the palm and its rootball were found to weigh 54 tons. It remains unchallenged for the title of the world's largest tree under glass.

Also this year...

The magazines Garden Answers *and* Gardening from Which? *are founded*

At Sutton Place in Surrey, Geoffrey Jellicoe installs Ben Nicholson's white marble wall – possibly his greatest sculptural relief and last major work – *at the end of a hedge-enclosed rectangular pool*

Beth Chatto publishes The Damp Garden

The great gnome strike

One would not imagine that a flower show would stir up too much controversy, but at Chelsea there always seems to be at least one good row each year. In the 1970s visitors came close to open revolt when the RHS introduced a one-way system in order to alleviate the problem of overcrowding in the show's Great Marquee. In 1988, 10,000 RHS members resigned from the Society in protest at the decision to charge them for tickets – a ploy to limit the number of show-goers who, by 1987, were 247,000 strong and raising serious concerns for safety. Exhibitors also have been censured for showing plants that did not pass muster, whether because they were illegally imported, genetically modified, or simply not their own. Meanwhile garden designers have been accused of plagiarism and, in one well-publicized case, frank and 'unacceptable' eroticism.

The schedule of regulations for exhibitors at the Chelsea Flower Show proscribes a number of items. Livestock, for example, can only appear by special permission of the Society's Secretary. This rule was drawn up in the 1950s after a herd of goats ran amok in a show garden. It was also invoked in the case of an exhibitor who attempted to enliven his rock garden with a bevy of Motor Show-type beauties. Article 15 of the schedule forbids 'highly coloured figures, gnomes, fairies or any similar creatures, actual or mythical for use as garden ornaments'. There is no better indicator of the low esteem to which the garden gnome (incredibly a rather desirable object in the 1900s) has sunk over the century.

Equally incredibly, not everyone takes the RHS line on the little monsters. In a decade that witnessed the rise of a statesman

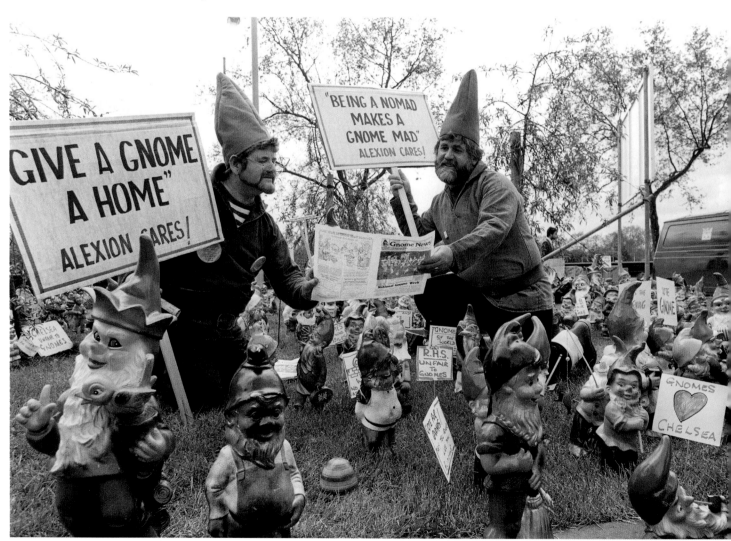

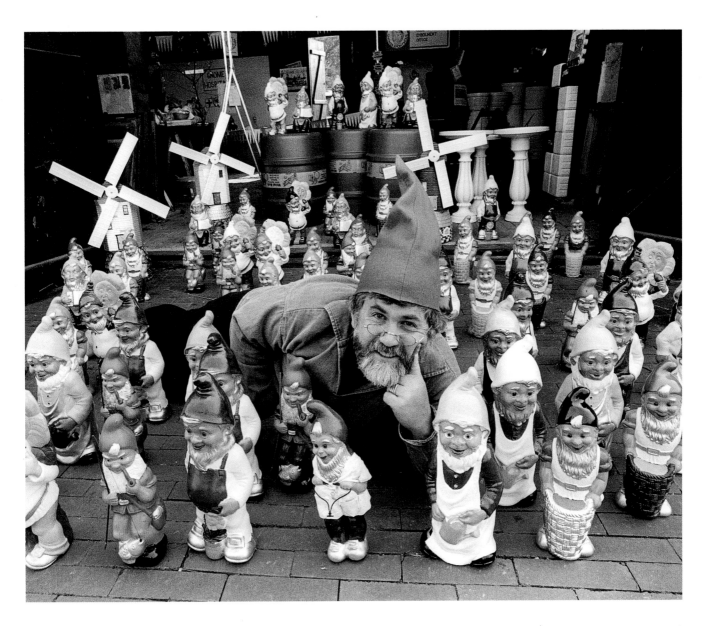

born to a gnome manufacturer, there were various attempts to reinstate these not-so shy figures lurking in the shrubbery on Chelsea's sacred ground. One such was in May 1983 when Alex Adams of Alexion Decor, New Malden, Surrey, decided to take his tribe of garden gnomes to the show. Rebuffed, Mr Adams and friends mounted the barricades on the Chelsea Embankment.

Neither happy nor bashful but in fact rather grumpy to have been treated so sorely, gnome activists have made various attempts to restage The Great Gnome Strike of '83. In 1993 the 130-year-old 'Lampy' staged a sit-in outside the show's entrance and attracted a large enough crowd to block it. Show organizers felt compelled to admit him. A year later, 'Lampy', still disgusted at the Society's gnomist policy, refused to visit Chelsea altogether and instead staged The Ideal Gnome Show at Nottingham with

his owner, Michael Minhall. It did little damage to Chelsea attendance figures, but honour at least was preserved.

Also this year...

Demolition begins of Kew's T-Range of glasshouses

The National Heritage Act introduces registration of historic gardens. English Heritage begins compiling the Register, the first instalment of which appears in 1985

The Institute of Park and Recreation Administration

becomes the Institute of Leisure and Amenity Management, reflecting the reorganization of local authorities in the 1970s under which parks departments were absorbed into 'departments of leisure and amenity'

Death of garden designer Lanning Roper (b.1912)

New home for old plant

At the Royal Botanic Gardens, Kew, surveys conducted in the early 1980s showed that the world's most celebrated glasshouse was in peril. Although it had been restored 30 years earlier and carefully maintained ever since, the Palm House had fallen prey to the very same high humidity and temperatures that had made it such a sanctuary for tender plants. In addition to the house's rusting metalwork, it was discovered that its architect, Decimus Burton, and engineer, Richard Turner, had not always foreseen major structural weaknesses or used building materials of adequate strength.

In September 1984, the Palm House was closed for major repairs. Over one thousand plants were temporarily rehoused. These included *Encephalartos altensteinii*, a magnificent cycad crudely like a stout-trunked palm or prickly-leaved tree fern, but more closely related to the conifers. As a relic of the 200-million-year-old flora of the Mesozoic, this species has some claim to be among Kew's most ancient charges. The Palm House specimen is also the oldest of all the glasshouse plants at Kew, having been sent there from South Africa by the plant collector Francis Masson in 1775. Not everything in the Palm House was so lucky. Some plants were given away to sister botanical institutions. Others, among them some of the tallest palms, could neither survive a move nor be practically rehoused and had to be felled. Wherever possible, plants facing the axe were propagated.

The restored Palm House was finally reopened in November 1990 by Her Majesty Queen Elizabeth The Queen Mother. It appeared more graceful and luminous, more like the Palm House, than ever; but some things had changed. Certainly, the troublesome materials available to Burton and Turner in the 1840s had been subtly replaced with more modern and durable media – mild steel for the arches, stainless steel for the glazing bars. New heating and humidification systems had been installed. In 1991 a display of marine fauna and flora would be opened in what had been the boiler room. It was an example of survival through modification, of evolution, to please any biologist. Happily, two of the Palm House's original features – dark blue-green exterior paintwork and murky green glass – were not reinstated.

Also this year...

The Institute of Horticulture is established

The International Garden Festival, Liverpool, is instituted

Geoffrey Jellicoe begins landscaping the Moody Historical Gardens at Galveston, Texas

The Historic Houses Association institutes its Garden of the Year award – the first winner is Heale House, Wiltshire, where the gardens have been restored over the previous 20 years by Lady Anne Rasch

The topiary cemetery at Tulcan, Ecuador, is declared a national monument

Nurserywoman Hilda Murrell is killed by an unknown assailant. It is suggested in Parliament that she was murdered by British security service officers who were searching for documents relating to the sinking of the Argentine ship Belgrano

Death of British plant collector Edward Kent Balls (b.1892)

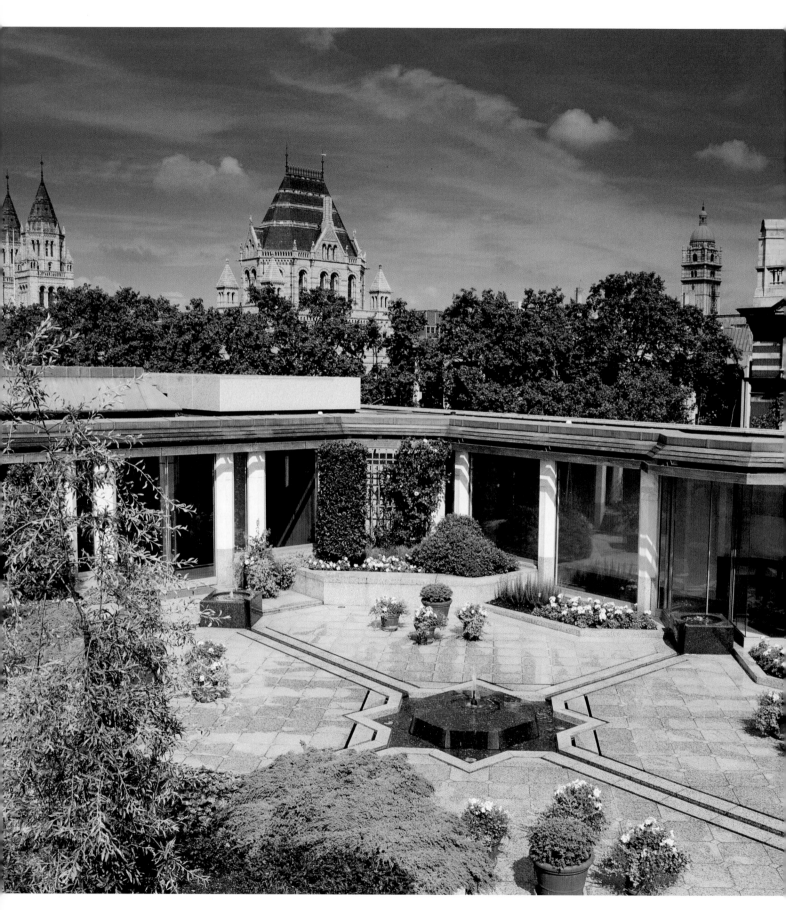

Oasis in the sky

An oasis materializes on the towery skyline of London's museum district. The Ismaili Centre in South Kensington was opened on 24 April by Prime Minister Margaret Thatcher. It was built by His Highness Prince Karim Aga Khan as a place of meeting and worship. Designed by Casson, Condor and Partners, the building aimed to translate the traditional symbolism of Islam into a modern idiom. Their success is nowhere better illustrated than in the roof garden which lies over the second-storey prayer hall.

The garden was planned and executed by Massachusetts roof garden specialists Sasaki Associates Inc., and the planting scheme was drawn up by London-based, American-born designer Lanning Roper, who died two years before its completion. Its location and the international nature of the design team notwithstanding, this is an absolute Islamic garden. At its heart is the idea of the *char bagh*, the paradisiacal enclosure transected by water courses which represent the four rivers of life. This scheme first appeared in the gardens of pre-Islamic Persia and ultimately spread throughout the gardens of the Muslim World.

Design motifs of later vintage also feature in the Ismaili Centre roof garden. The octagon and star, shapes that held special significance for the Seljuk Turks as emblems of life and intellect, appear in the fountain at the garden's midpoint. Narrowly tapering evergreens, symbols of immortality in Mughal gardens, are interpreted here in bay laurel rather than the traditional cypress. The garden is paved with squares of grey granite interspersed with highly polished, diamond-shaped tiles of the same stone. The octagonal fountain is made of shining blue granite, as are four square tanks which feed each rill – each river of life – with a miniature cascade.

The raised borders are planted with evergreens – camellias, *Ceanothus* and *Pieris* – and their edges are softened with spreading junipers and veils of ivy. Colour in the planting scheme is largely limited to blue, white and grey: tones that enhance the garden's cool elegance and which, in concert with the sound of gently running water, create a sense of tranquillity far removed from the traffic below and the darkly institutional towers and domes all around.

Also this year...

The Agriculture & Food Research Council reorganizes its research stations into a composite organization called, at first, the Institute of Horticultural Research, and later Horticultural Research International

Susan Campbell publishes 'A Few Guidelines for the Conservation of Old English Gardens' in Garden History

Death of Sir Harold Hillier (b.1905), plantsman, proprietor of Hillier Nurseries, creator of the Hillier Gardens and Arboretum

Death of garden designer and landscape architect Rusell Page (b.1906)

Topiary at Tulcan

Following the death of Don José Maria Azuel Franco, the Ecuadorean government announced a state grant to preserve the legendary topiary gardens he had created at the cemetery in Tulcan. The capital of the Province of Carchi, Tulcan is a town of some 25,000 souls, 10,000 feet above sea level in the Andean Sierra of Northern Ecuador. Despite its location – a mere 100 miles north of the Equator – the town enjoys an equable climate and plants that one would normally expect to see in British gardens thrive there. Over a quarter century, Don José Franco transformed the funereal cypress trees of Tulcan's cemetery into the world's most remarkable topiary garden.

The Don's 'escultura en verde' included mythical beasts, cartoon creatures, formal obelisks, towers and walls, geometrical forms and monumental heads, which took their inspiration from Ecuado's pre-Colombian culture. In 1984, the government declared his handiwork a national monument. The grant that followed two years later was made to the Don's son, Benigno Salvador Franco, who, since the age of eight, had been helping his father turn a cemetery into a living sculpture park.

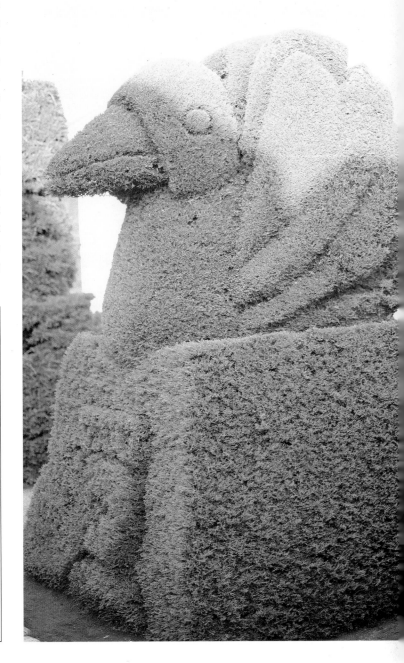

Also this year...

A government bill is introduced to enforce Compulsory Competitive Tendering for local authority services: the beginning of the end for local parks departments

Control of Pesticides Regulations: DDT is banned in Britain, to be followed by Dieldrin

The Henry Doubleday Research Association opens the National Centre for Organic Gardening at Ryton, near Coventry

Roy Strong publishes Creating Small Gardens

The Gardener's Chronicle *changes its name to* Horticulture Week

The National Garden Festival is held at Stoke-on-Trent

Tercentenary of publication of John Ray's great botanical work Historia Plantarum *(vol. 1)*

Death of Thomas Henry Everett (b.1903), English horticulturist and author who worked for much of his career at the New York Botanical Garden

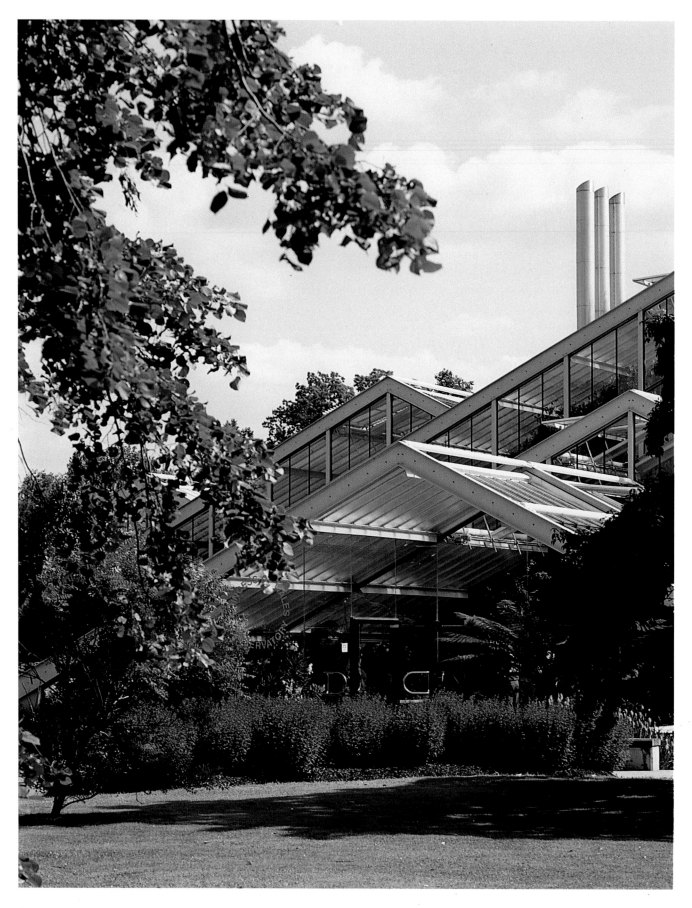

The Princess of Wales Conservatory

At the Royal Botanic Gardens, Kew, HRH Princess Diana opened the Princess of Wales Conservatory on 28 July. Confusion seemed to surround the identity of the princess honoured by the giant glasshouse. Some – notably officials and gardeners with a sense of history – believed the building was dedicated to the memory of Augusta, Princess of Wales and mother of George III, who had commissioned William Chambers' Great Stove of 1767 on a site nearby. Others preferred to believe that Kew's new conservatory honoured Diana herself.

The new conservatory was designed by Gordon Wilson to replace the T-Range, a ramshackle agglomerate of wood-framed glasshouses. It covered an area of 5,370 square yards. Ventilation, shading, water, temperature and humidity were controlled by computer to recreate a range of habitats, from mangrove to desert, rain forest to peat bog, Andean peak to lava field. The result was a unique sanctuary for a broad section of the world's most threatened and beautiful flora.

The construction schedule was punishing. First, 20,000 square yards of soil had to be removed and replaced by 8,000 tons of concrete. By summer 1984 the aluminium frame sections were being welded together. Kew's Curator, John Simmons, allowed himself 18 months to commission and execute the conservatory's many landscapes and engineer its complex suite of climates. Over 1,000 tons of compost and 450 tons of rock had been installed by July 1986. The plants themselves were introduced by spring 1987. Below them, underground tanks were filled with 60,000 gallons of rainwater and deionized mains water – plants adapted to withstand the world's most challenging environments seldom survive the ravages of alkaline Thames Valley water.

Also this year...

Millions of trees and structures are damaged or destroyed as the Great Storm sweeps England on 15–16 October. Standing 500 feet high in the Sussex Weald, the Royal Botanic Gardens, Wakehurst Place take the brunt of the storm: the 500-acre gardens and estate lose 20,000 trees overnight. Storm damage leads to a programme of government grants for repair and replanting of historic gardens

Lady Anne Palmer (later Berry) presents her garden at Rosemoor to the RHS. She later moves to New Zealand and starts a new garden called Hackfalls Arboretum

Kew's Jodrell Laboratory investigates therapies and cures for AIDS

Vacuum-powered leaf sweepers are introduced

Chris Philip publishes the first edition of The Plant Finder

David Wheeler founds the quarterly magazine Hortus

Sotheby's and the RHS mount an exhibition – 'The Glory of the Garden'

The number of visitors at the Chelsea Flower Show at any one time rises to a new high of 36,000

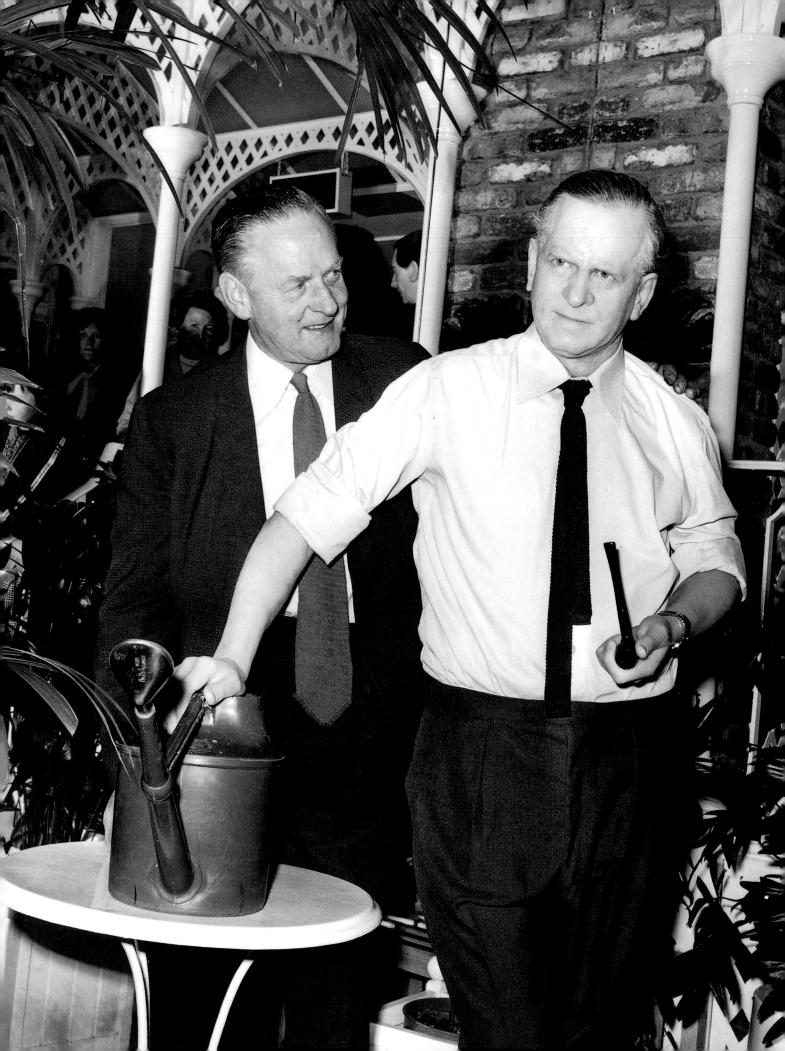

Percy Thrower

'And so Percy goes from us to be replanted in the Hereafter.' It was an apt farewell from the Vicar of Bowmore Heath to Britain's most famous and best-loved gardener, who died on 18 March, 1988 at the age of 75. Percy Thrower was familiar to most people as the host of the BBC television programme 'Gardeners' World' and to many others as a well-respected and highly qualified horticulturalist, exhibitor and judge. Gardening was his life. His father was the head gardener at Horwood House in Buckinghamshire, his wife Connie was the daughter of one of the head gardeners under whom he worked, and it was gardening that brought him into the hearts and living rooms of the nation.

The man who was to become known as Britain's head gardener was born at Little Horwood on 30 January, 1913, and worked for his father in the gardens of Horwood House from the age of 14. Four years later he took a job as an improver at the Royal Gardens in Windsor under C.H. Cook, who later became his father-in-law. While at Windsor he was entrusted with taking charge of the flower decorations for the Royal Enclosure at Ascot. At the age of 22, he began working in amenity horticulture, first as a journeyman-gardener for Leeds City Parks Department, then for the Derby Parks Department where, during the war, part of his job involved growing vegetables for the Dig for Victory campaign. After the war he was appointed Parks Superintendent at Shrewsbury, where he was responsible for reinstating the Shrewsbury Flower Show, which had been a causalty of the war, and where his name became synonymous with the town's fine gardening tradition. He remained in the post until his official retirement from gardening in 1974. He continued as host of 'Gardeners' World' for another two years, until the BBC decided not to renew his contract after he appeared in a television commercial. He also inspired a new generation of gardeners through his appearances as gardener on the 'Blue Peter' television show; his final recording for 'Blue Peter' was made from his hospital bed a week before he died.

Percy Thrower's many honours include being made an Associate of Honour by the Royal Horticultural Society in 1963, receiving the RHS's top accolade, the Victoria Medal of Honour, in 1974, and being awarded the MBE in 1984. He was respected not only for his perfectionism as a gardener but also for his professionalism as a broadcaster; one producer with whom he worked said: 'It was a real pleasure to work with such a professional. He always got his lines and his work right first time.' He usually worked without a script, and said that, 'If you know your subject the plant tells you what to say.'

Also this year...

Professor Ghillean Prance succeeds Professor E.A. Bell as Director of Kew

Thanks to a public fundraising campaign, The National Trust acquires and begins to restore the derelict Victorian garden at Biddulph Grange, Staffordshire

Restored by Geoffrey and Faith Whiten, the gardens of

Lambeth Palace reopen in July

Botanical artist Margaret Mee (b.1909) dies in a car accident in England, having travelled there from Brazil to receive honours and tributes for a lifetime of great painting, devoted conservation work and fearless exploration

The Museum of Garden History

In 1989 an appeal was launched to raise £3 million for the further development of the Museum of Garden History, in the former church of St Mary-at-Lambeth in London's Lambeth Palace Road. The Museum owed its existence to the vision and determination of Rosemary and John Nicholson. In 1976 they had made a pilgrimage to the tomb of the Tradescants, the celebrated 17th-century explorers, plantsmen and antiquaries who gardened amid the (then) unspoilt South Bank countryside. The Church of St Mary-at-Lambeth was the last of five houses of worship to be built on the site since 1062. In its graveyard lay not only the Tradescants but also Captain Bligh of the *Bounty* and Elias Ashmole, who endowed Oxford's Ashmolean Museum using the Tradescant's collections.

The Nicholsons were shocked to find a church which had been decommissioned since 1972 and was derelict and doomed for demolition. They resolved to save the building, and, inspired by the father and son whose tomb they found so choked with weeds, to establish a museum there devoted to the history of gardens and gardening. A few years later, the Tradescant Trust launched its first appeal – to fund the restoration of the church. By the late 1980s, the former church housed displays and collections that illustrated every phase of British gardening. Tools ancient and modern were on show, as were pots, plans, prizes, cloches, Wardian cases (the very objects whose 'safe' conduct would lead to Captain Bligh's being adrift), prints and, above all, plants.

Meanwhile, the churchyard at St Mary's was transformed into one of London's most enchanting secret gardens – a place stocked with the surprising abundance of species available to 17th-century gardeners and centred on a knot garden of the sort that either of the Tradescants might have designed for one of their royal or noble patrons. Near the knot garden stands the Tradescant tomb, carved with vivid images of foreign lands, a fearsome hydra, and an epitaph commemorating

> These famous Antiquarians that had been
> Both Gardeners to the Rose and Lily Queen

Also this year...

Kew's Orangery evolves into a tea room and restaurant

The first Ballerina apple trees are launched at the Chelsea Flower Show

The Orchid Review, first published in 1893, is taken over by the RHS

Rosewarne Experimental Horticulture Station, Cornwall, closes due to government cutbacks

Death of Tom Rochford, leading houseplant nurseryman (b.1904)

Death of garden writer Roy Hay (b.1910)

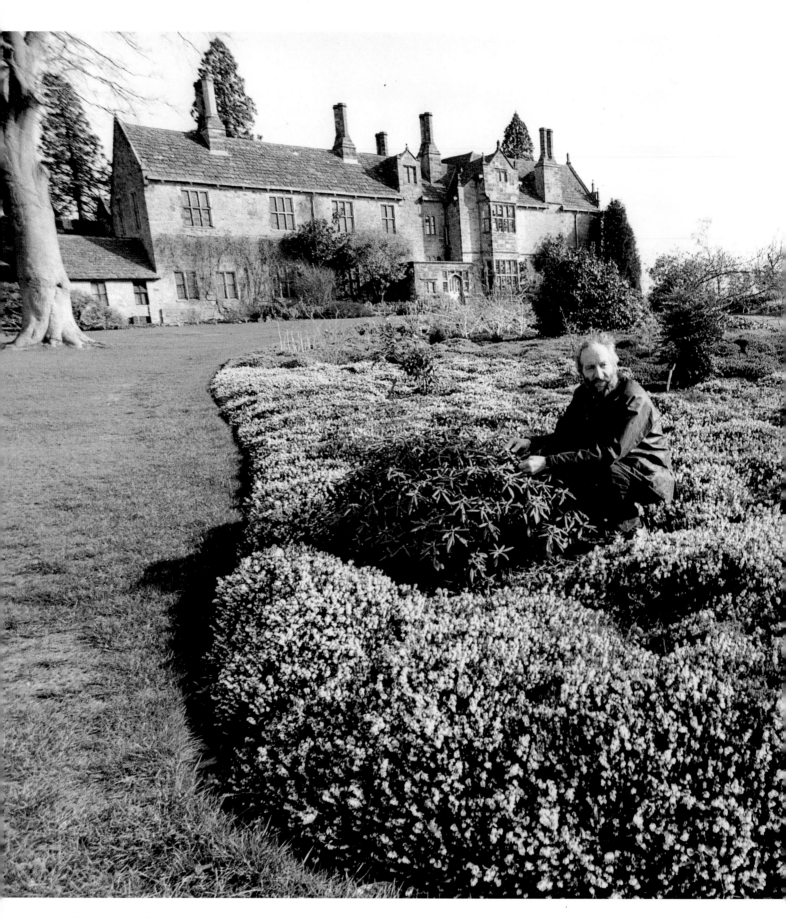

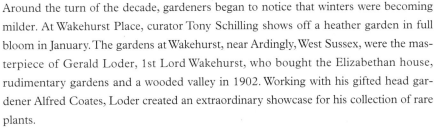
Sussex looks east

Around the turn of the decade, gardeners began to notice that winters were becoming milder. At Wakehurst Place, curator Tony Schilling shows off a heather garden in full bloom in January. The gardens at Wakehurst, near Ardingly, West Sussex, were the masterpiece of Gerald Loder, 1st Lord Wakehurst, who bought the Elizabethan house, rudimentary gardens and a wooded valley in 1902. Working with his gifted head gardener Alfred Coates, Loder created an extraordinary showcase for his collection of rare plants.

The valley was transformed into a Himalayan glade: the woodlands glowed with rhododendrons, magnolias and pocket handkerchief trees; Australasian natives proved unexpectedly hardy; the area known as The Slips became strewn with amethyst each spring as the parasite *Lathraea clandestina* broke through the soil.

After Loder's death in 1936, the estate was bought by wealthy tailor Sir Henry Price who bequeathed it to the National Trust in 1963. Two years later Wakehurst came under the direction of the Royal Botanic Gardens. Kew had long wanted an annexe that offered growing conditions in greater variety and quality than were available on west London's Thames-side. Wakehurst became Kew's 'place in the country'.

A distinguished plant hunter and explorer, Tony Schilling was the ideal candidate to realize Lord Wakehurst's vision of Himalayan valleys in the depths of Sussex. He is pictured here amid another Loder innovation, the 'island bed', a form of free-floating, informal border that became popular in the second half of the century and which was brought to perfection by Alan and Adrian Bloom at Bressingham.

Toward the end of the 1990s, Wakehurst Place would accept a rôle of world importance, not in innovation but conservation, when it was to become home to the Millennium Seed Bank.

Also this year...

Kew opens the Sir Joseph Banks Centre for Economic Botany

The restored Palm House at Kew is reopened

Network Southeast sets up the first Hampton Court Flower Show

The resurrection plant, Selaginella lepidophylla, *is threatened with extinction through over-collecting*

Jacksons of Piccadilly sponsors the first Directory of National Plant Collections

The National Trust acquires Stowe, the pioneering 18th-century landscape garden

At Chelsea, Margaret Thatcher tells British horticulturists to exploit the potential for supplying the home market

A second great storm hits the south-west of England

Death of alpine specialist, nurseryman and author Will Ingwersen (b.1905)

Royal walkabout

During the 1980s and 1990s, garden visiting became a pastime to rival garden-making. The National Gardens Scheme continued to grow both in terms of gardens and garden-goers. By the year 2000 nearly three and a half thousand gardens opened to the public each year under its auspices, netting £1 million for different charities. By 1991 there was one garden, fast-growing in fame but scarcely known, which garden visitors longed to see. Here the lucky few admire a fountain at Highgrove.

Highgrove is the country estate of HRH The Prince of Wales, although he argues that it is not big enough to be classified as an estate, saying that at 300 acres it is a farm. And farming is important to Prince Charles. As well as being a country retreat, Highgrove is the Home Farm of the Duchy of Cornwall, where the Prince has championed organic farming methods. While the house and the farm that surrounds it often steal the limelight, the gardens are a remarkable achievement in themselves, created from scratch by the Prince, who described their condition when he exchanged house contracts on Michaelmas Day 1980 (the traditional handover day for farms): 'As far as the garden was concerned, there wasn't one. Amazingly, there was absolutely nothing around the house. It sat, stark and exposed, without any trace of shelter and without a single flowerbed.'

Nowadays there is far more than flowerbeds – a rose garden, a formal Italian garden, a woodland garden, a hay meadow planted with spring bulbs, and a kitchen garden with tunnels and pagodas trained with roses and sweet peas. These were all created under the personal supervision of the Prince, who, during the planting of the parkland trees, 'stood on the front doorstep with a megaphone directing the planters like a film director, so that an oak or tulip tree when full-grown would grow in exactly the right place'. Prince Charles was particularly keen to create a contrast between the wild and formal areas of the grounds and introduced corn marigolds, ox-eye daisies, corn cockles, and poppies alongside the drive. He also planted the meadow with a variety of bulbs with the aim of creating drifts of flowers in the long grass which he hoped would imitate the foreground in Botticelli's *Primavera*.

His Royal Highness has also planted hedges; created a paved terrace on the west side of the house; commissioned custom-made benches for his more elderly visitors who sometimes had to be rescued by Land-Rover halfway round the garden because of the lack of resting places; and planted a fragrant thyme carpet which runs up the centre of the lawn. 'The smell is the best feature, but I hope it will also attract whole squadrons of butterflies and divisions of bees to feed on the nectar and to rise up, like mobile flowers, as people pass by.'

Also this year...

As part of the Great Japan Festival, the Kyoto Garden Association designs a Japanese garden in Holland Park

The BBC begins to publish a monthly gardening magazine, Gardeners' World

Back from the dead

If any one genus of hardy perennials could be said to have dominated British gardening fashion in the 1990s, it must surely be the hellebores. Throughout the decade, breeders increased the range of colour and form available in these late winter- and early spring-flowering plants. By the century's end we could see doubles, anemone centres and singles in shades of white, green, cream, primrose, apricot, peach, pink, wine red, plum purple, and even slaty black with various combinations of spots, stripes, picottee edging, and colarette nectaries. Many of the hybrids involved the Lenten rose, *Helleborus orientalis,* which, as its name suggests, was once thought to represent the eastern limits of the hellebore's range – northeastern Greece, northern Turkey and the Russian Caucasus. For more than a century, however, rumours had circulated of the existence of a truly oriental hellebore, a plant native to Sichuan and of an ethereal beauty quite unmatched by its western cousins.

Helleborus thibetanus was first seen with European eyes by the French missionary and naturalist Père Armand David (1826–1900). On 15 March, 1869 he was collecting in the principality of Muping (now Baoxing, in Sichuan province) when he encountered large colonies of a 'white-flowered' hellebore on the north-facing slopes at an altitude of 8,000 feet. His journal entry for that day describes his having found 'nothing remarkable', but then we should remember that he had not long before become the first European to see the skin of 'a white and black bear...an interesting novelty for science'. A man who has already discovered the pocket handkerchief tree (*Davidia*) and the giant panda on one trip can perhaps be forgiven for not anticipating the horticultural world's hellebore hysteria.

David sent dried specimens of the plant to the Paris Herbarium where, in 1885, they were described, named and filed fast away. Other explorers in China collected the hellebore toward the close of the 19th century and again in 1914 and 1925, but no living plants or viable seed reached the West, probably for the simple reason that no-one was particularly bothered – hellebores had the best part of a century to go before they would achieve their present vogue. In 1980, with hellebore fever beginning to hit, leading authority on the genus Brian Mathew received a parcel of seeds of this plant that had once been forgotten but was now becoming fabulous, but they were too old to germinate. It was not until 1989 that the celebrated Japanese plant collector Mikinori Ogisu found the winter-blackened foliage of the hellebore amid the snows of Baoxing. Returning to the habitat over the following three years he succeeded in capturing flowering colonies on camera and these, the first-ever photographs of *Helleborus thibetanus* to be published in the West, appeared in *The Garden* magazine in April 1992.

Also this year...

Compulsory Competitive Tendering is introduced into the Royal Parks

Death of Anthony Huxley (b.1920), author and editor

A garden for a changing climate

For British gardeners, the 1990s was a decade of climate-awareness. Winters were palpably milder. In the first half of the decade summer droughts were common and hose pipe bans forced us to rethink garden features that were previously thought indispensable and inviolable. Lawns, water-greedy bedding schemes, borders of damp-loving perennials, all seemed threatened as our green spaces came to look more and more like alfresco herbaria.

At Elmstead Market, near Essex in Colchester, Beth Chatto had been facing the challenges of low water gardening for over thirty years: 'My garden...lies in a corner of south-east England that has the lowest rainfall in Great Britain...Because I cannot grow many of the plants that gardeners living in wetter parts of the British Isles grow so easily and well, I have had to go back to the origins of the plants to find those that naturally prefer a low rainfall.'

The result – Beth Chatto's 'Dry Garden' – became one of the most influential British gardens of recent times and the subject of a pioneering book. In the early 1990s she took the idea further by creating a new garden area at Elmstead Market where archipelagos of perennials and subshrubs punctuate a sea of gravel.

The gravel garden drew not only on the established range of drought-resistant plants but also on species that might traditionally have been used elsewhere – the smaller bulbs, alpines and low-growing herbs. Many examples of this new look relied heavily on the decade's signature plant group, ornamental grasses. Heat-reflective and water-deflective, the gravel mulch provided an ideal environment for plants that suffer not from drought but from damp and splash. Above all, it served as a canvas on which the form and colour of individual plants were shown to rare advantage.

Within a few years, the English summer was back on form. Fears that we were about to join a greater Mediterranean were simply washed away. Saving labour and water and redolent of sunnier climes, the gravel garden had nonetheless established itself as one of the most distinctive gardening styles of the decade.

Also this year...

Dick and Helen Robinson present their Essex garden, Hyde Hall, to the RHS

The RHS takes over the Hampton Court Palace Flower Show which was threatened with closure after Network Southeast withdrew its subsidy

Restoration of an 1830s' parterre at Audley End, Essex is completed by English Heritage

The magazine Gardens Illustrated *is founded*

Prospect Cottage

Having discovered in the mid-1980s that he was HIV positive, film-maker, painter and theatre-designer Derek Jarman began to spend more and more time making a garden amid the shingle that surrounded Prospect Cottage, his retreat on the bleak coast of Dungeness. Little larger than an urban backyard, filled with *objets trouvés*, planted with native coastal plants and at the mercy of one of the harshest climates in England, Prospect Cottage is nonetheless one of the most important British gardens of the century. As an artist's garden, it stands alongside Monet's at Giverny and Hepworth's at St Ives. The garden's special power derives from the fact that it is made from and is part of the surrounding landscape – a landscape that is lunar in its desolation, crossed by telegraph lines, a forlorn railway and dominated by a nuclear power plant.

Jarman's sculptural use of flotsam and jetsam, broken boats, rusted iron and water-worn stones was unique, although pastiches and sincere imitations of it have been appearing in British garden designs since the mid-1990s. Similarly influential was his use of gravel and drought- and salt-resistant plants – hardly things he could have avoided. For the few years before his death in 1996, the garden at Prospect Cottage became one of Jarman's chief sources of inspiration:

> I waited a lifetime to build my garden,
> I built my garden with the colours of healing,
> On the sepia shingle at Dungeness.
> I planted a rose and then an elder,
> Lavender, sage, and Crambe maritima,
> Lovage, parsley, santolina,
> Horehound, fennel, mint and rue.

The making of it is described in *Modern Nature* (1991), one of the most poignant gardening diaries ever written.

Also this year...

Kew's Australian House evolves into an Evolution House

Sir Simon Hornby succeeds Robin Herbert as President of the RHS

The restored Victorian parterre at Waddesdon Manor, Bucks is opened

Some like it hot

In the 1990s plantsman and author Christopher Lloyd introduced British gardeners to two revolutionary notions. Both involved an all-out assault on the canons of good taste that had prevailed in the planting schemes of some of the century's best-loved English gardens. Working with his head gardener and close friend Fergus Garrett, Lloyd shook off the constraints of refined plant form and muted colour; at his celebrated Sussex garden, Great Dixter, the borders were freed from subtly graduated pastel tones and silver filigree. 'Hot' colours burst upon the scene.

Fiery red *Crocosmia* 'Lucifer' consorted with smouldering dahlias; ladybird red *Papaver commutatum* mixed it with the scarlet *Salvia coccinea* (a bedding plant long ago and unjustly dismissed as infra dig). *Coreopsis* vied to outshine *Rudbeckia*. The velvety limes, chocolates and maroons of tender foliage plants – *Coleus* (*Solenostemon*) and *Perilla* – added depth and contrast to the planting. Next, Lloyd challenged the idea that some plants were more suited in temper than others to the English garden. He revolutionized Great Dixter's borders with exotic giants: the Japanese banana *Musa basjoo*, its paddle-leaved relation *Ensete ventricosum*, sugar cane, yuccas, agaves and phormiums brought tropical drama to the quiet courtyards of his famous 15th-century home.

These two themes – 'hot' colours and flamboyant exotics – were soon copied; but we had missed the point, for these too became trends and straitjackets. In the hands of less inspired gardeners than Christopher Lloyd, 'Hot' and 'Subtropical' were themselves as taste-ridden as 'Silver' and 'Cottage', and, as Lloyd himself admitted, 'I loathe the good taste brigade.' The thrust of his design, as can be seen here in this marriage of mauve *Verbena bonariensis* with blood red cannas, was that almost anything might go, if only we are brave enough to experiment. As Lloyd himself said: 'We meet enough unavoidable restrictions in our lives without bringing them unnecessarily into our gardens.'

Also this year...

The restored Privy Garden at Hampton Court Palace is opened

Death of hellebore breeder Helen Ballard (b.1908)

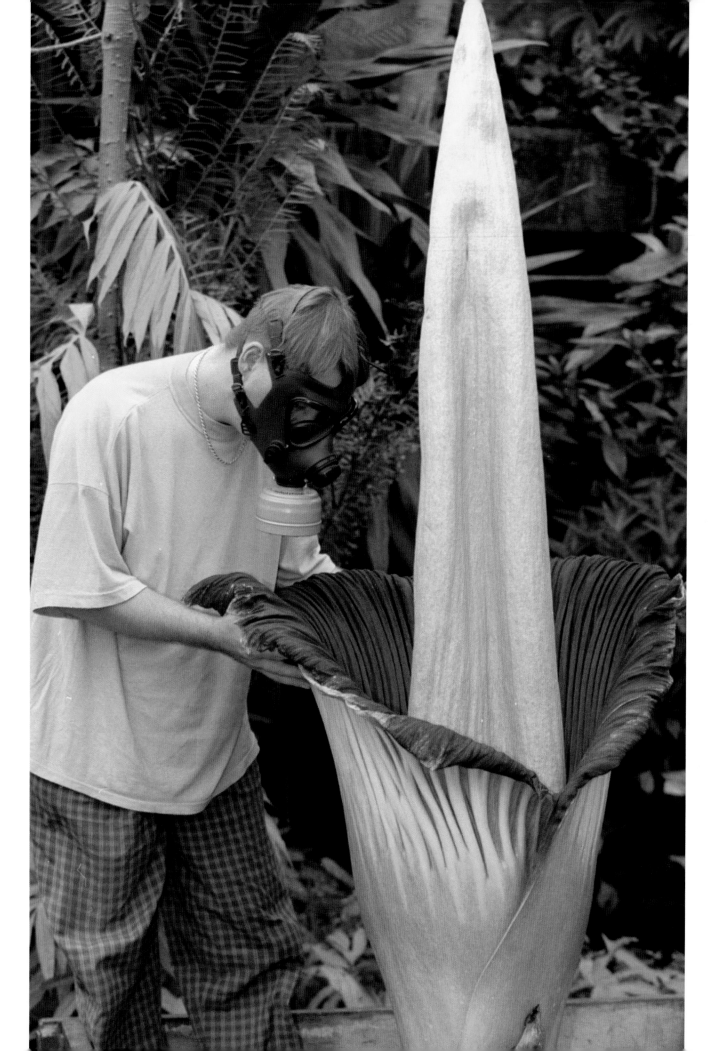

Giant

Kew botanist Peter Boyce approaches the Titan arum, *Amorphophallus titanum*. This remarkable plant was discovered in Sumatra in 1878 by the Italian botanist Odoardo Beccari, who sent its corms to Italy only to have them held by French customs under an order intended to prevent the spread of the grape vine pest *Phylloxera*. The Titan died on the docks of Marseilles. Some of its seeds reached Florence, however, and germinated.

In June 1889 one of the seedlings from this batch flowered at Kew. The Titan's first flowering outside Sumatra attracted huge crowds and saved Beccari from charges of fantasizing. Ever since, its sporadic flowerings have been attended with great excitement and, in 1996, long queues. Admirers seldom linger: the Titan is pollinated by large beetles which are lured into the funnel-like spathe by an overwhelming stench of rotting flesh. In Indonesia, this odour has earned the giant the name *bunga bangkai*, 'corpse flower'. Small and insignificant, the true flowers lurk at the base of the phallus-like spadix. This ensemble of protective spathe and flower-bearing spadix is the typical arum flower head or inflorescence.

With mottled stalks and intricately cut, parasol-like blades, the Titan's solitary leaves can be as much as 20 feet in height and width. They shoot from a corm that is over 4 feet in diameter and weighs upwards of 100lbs. Often more than 6 feet deep and 12 feet in circumference, the spathe will grow at the rate of 4 inches per day. The reeking spadix is over 8 feet tall. Collectively they constitute the largest unbranched inflorescence in the plant kingdom. The prize for the largest single flower goes to the parasite *Rafflesia arnoldii*, another carrion-stinking giant found by Beccari in the Sumatran forests. More than 30 feet long and bearing flowers by the million, the largest branched inflorescence belongs to the Asian palm *Corypha umbraculifera*.

Also this year...

Bicentenary of the death of William Chambers, who designed several of Kew's great buildings (the Pagoda, for example)

The first Scotland/RHS National Gardening Show is held at Strathclyde Park

Death of Derek Jarman, whose garden on shingle at Dungeness becomes a place of pilgrimage

Death of landscape architect Sir Geoffrey Jellicoe (b.1900)

Death of gardener and broadcaster Geoff Hamilton

The dinosaur tree

In terms of plant discoveries, the century was one of surprising novelties, some of them very old indeed. The oldest were the 'living fossils', dinosaur fodder that had somehow survived millions of years of upheaval unchanged. They included the cycads, discovered throughout the century, the dawn redwood found in the 1940s, and, in 1994, the Wollemi pine (*Wollemia nobilis*).

Cathy Offord, Horticultural Research Officer for the Royal Botanic Gardens in Sydney, holds one of a number of Wollemi pine seedlings which the Australian government offered for sale in 1997 in an effort to save the species from extinction. In 1994 David Noble had abseiled into a narrow gorge in the Wollemi National Park. He was puzzled by the strange bark and unfamiliar leaves of a giant tree that he found there, a tree that has since been punningly named after its discoverer (*nobilis* – 'Noble') and the place where it was found (*Wollemia*, after Wollemi).

The 39 examples of this remarkable tree were growing in two small groves only half a mile apart in the Wollemi National Park, an area west of Sydney which comprises 1¼ million acres of some of the most inaccessible and rugged terrain in Australia. The park consists mainly of a sandstone massif crisscrossed by canyons and gorges. *Wollemia nobilis* rises above the surrounding rainforest canopy and has a unique pattern of branching.

Botanists at Sydney's Royal Botanic Gardens described *Wollemia* as 'a beautiful and majestic prehistoric monster', a member of a family which has fossil records dating from the Triassic period, about 200 million years ago. DNA tests have revealed that there is little genetic variation between the surviving trees, which suggests that they may all be descended from a single plant, making the Wollemi pine one of the rarest trees on earth.

Also this year...

The garden makeover show becomes a staple of television as the BBC launches a new series called 'Ground Force'

The Native Elms Foundation aims to locate and propagate British elms that have survived Dutch Elm Disease and may be immune to it

Over one million floral bouquets are left in Kensington Gardens after the death of Diana, Princess of Wales. Agitation and controversy soon begin over proposals to create a memorial garden there

Death of landscape architect Dame Sylvia Crowe (b.1901)

Death of Brazilian landscape designer, plantsman and artist Roberto Burle Marx (b.1909)

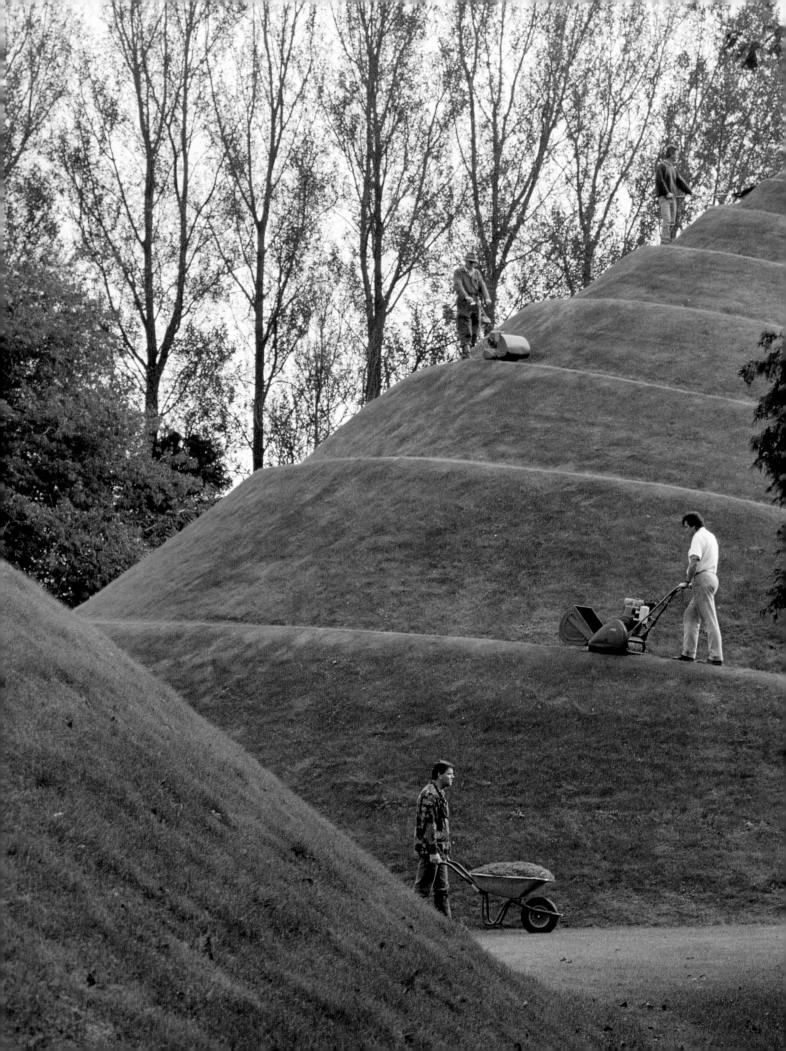

Catastrophe and continuity

The swirling folds of this garden designed by Charles Jencks show his preoccupation with Complexity Theory. Jencks argues that architecture should 'reflect the processes of the universe, its energy, its growths and sudden leaps, its beautiful twists, curls and turns; its catastrophes'. He explains the purpose of the folds and twists of this garden in Dumfriesshire, Scotland, as being 'to orient movement first towards a central lake and then towards a field, resolving the opposite views in a smooth continuity'.

Jencks proposes an architecture that mirrors the wave function of the atom in quantum physics and the strange phenomenon of the soliton, or solitary wave, manifest in tidal bores and in the red spot of Jupiter. In his work, Jencks represents solitons in two ways, either as the travelling hump in a whiplash or as the twist in a flat strip. He also uses a related wave-form in his architecture and designs – the fold, which has emerged from the Catastrophe Theory of René Thom and is reflected in the folding paths of the Dumfriesshire garden, seen here.

In Jencks' designs, the fold can be used to accomplish two opposites: to represent a sudden change of direction or mood, as in the cusp catastrophe where the cusp of the fold forces a reaction in one of two directions; or, conversely, to resolve differences by connecting things which are different in a smooth transition.

But before one becomes too bogged down in theory, what surely matters is that Jencks has created a garden of monumental grandeur with an approach and with materials that bespeak neither chaos nor complexity but control and simplicity.

Also this year...

At the RHS Garden, Wisley, the Garden of the Senses is opened. It contains the Society's first major collection of bonsai

At Gilston Road, London SW10, English Heritage unveils a blue plaque in memory of the plant hunter Robert Fortune (1812–1880)

The government adds 11 animals and 17 plants to the schedule of species protected by the Wildlife and Countryside Act of 1981. As from March the sale of wild bluebell bulbs is banned

A 17th-century parterre at Kirby Hall is reconstructed

The Mediterranean Garden Society is founded

As old as the century

On 19 April, HM Queen Elizabeth The Queen Mother paid a private informal visit to the Royal Horticultural Society's Garden at Wisley. She is a patron of the Society (as is HM The Queen) and a holder of the Victoria Medal of Honour, the Society's highest award. Returning to Wisley for the first time in seven years, she visited several of the garden's departments, including the Alpine House where she is seen here discussing the display with RHS President Sir Simon Hornby (right) and the Senior Supervisor of the Rock Department, Allan Robinson.

On Battleston Hill, Her Majesty was reunited with Colin Crosbie, her former Head Gardener at Royal Lodge, Windsor Great Park, and now Wisley's Superintendent of Woody Plants. They paused to admire *Rhododendron* x *loderi*, one of her favourite plants. In its best form, 'King George', soft pink buds open to pure white blooms with a pale green flash at the base of the trumpet.

The Queen Mother has always taken a close interest in the RHS and is herself a garden-lover – a passion she shared with her brother Sir David Bowes Lyon who was the Society's President. In her and the century's 90s The Queen Mother's association with gardens showed no sign of fading. In July 1997 she opened a new garden created in her honour by Penelope Hobhouse at Walmer Castle in Kent. The castle is the residence of the Lord Warden and Admiral of the Cinque Ports, a post of which The Queen Mother became the first woman holder in 1978. Carrying a silver watering can presented by English Heritage Chairman Sir Jocelyn Stevens, Her Majesty said of the occasion, 'I have been given many presents before but never a garden.'

Also this year...

Andrew Colquhoun follows Gordon Rae as Director General of the RHS

In July the first RHS show at Tatton Park, Cheshire, attracts 102,000 visitors over three days

Professor Peter Crane succeeds Professor Sir Ghillean Prance as Director of Kew

Some 40,000 serious ladder accidents are reported in the UK

Around 300,000 Leyland cypresses are sold in the UK: they now amount to one-fifth of all trees growing in the British Isles

At Christie's, a collection of bonsai, 'property of a European gentleman', go under the hammer – the highest reserve price is £12,000 for a tree less than 4 feet tall

300th anniversary of the birth of American botanical pioneer John Bartram

Bicentenary of the birth of John Lindley, botanist, orchidologist and secretary of the RHS

Celtic dawn

The Great Glasshouse of the newly opened National Botanic Garden of Wales glows in the half-light. Designed by Lord Foster of Thamesbank, it joins a tradition of pioneering glasshouses built for botanic gardens that includes Kew's Palm House and Princess of Wales Conservatory and the St Louis Climatron. Aware of the line in which he was standing, and the influence of structures made for and inspired by plants on building in general, Norman Foster declared 'The midwife of Modernist architecture was botany'.

The glasshouse is a dome with an elliptical plan measuring 95 by 55 metres. Its roof is constructed from 24 hollow, tubular steel arches which rise from a concrete rim to a height of 15 metres. It is glazed with laminated trapezoidal panels, 147 of which open automatically in response to environmental sensors. The panels' outer skin is made of toughened glass and their framework channels rainwater into two 70,000-litre tanks below. In keeping with the concept of a 'green' botanic garden, heat is generated by a biomass boiler which burns waste from the garden and landfill contractors. It emits very little sulphur and nitrogen oxide and only the same amount of carbon dioxide 'that a plant would absorb in its lifetime'.

Designed by landscape contractors Gustafson Porter, the glasshouse's 3,500 metres-square interior is a magnificent assembly of terraces, cliffs, ravines and scree worked in every grade of stone from gravel through boulders to giant walling blocks worthy of the Incas. It is planted with species from the world's Mediterranean-type climates – Chile, south-western Australia, California, southern Europe, northern Africa and South Africa.

Created amid the Georgian parkland of Middleton Hall in Carmarthenshire, the garden is the first national botanic garden to have been undertaken in the British Isles in nearly two centuries.

Also this year...

Over a spring weekend, parks, squares and statues are defaced in central London by the so-called Gardening Guerillas, anti-capitalist demonstrators with no real connection with gardening and not related to bona fide US horticultural activists The Green Guerillas

The RHS replaces the canvas Chelsea marquee with two light and airy pavilions. The old tent – once the largest in the world – is cut into gardeners' aprons, sunhats and shopping bags

New Eden, *a magazine aimed at the young and proving that gardening is 'the*

new rock and roll', closes one year after its launch

A Government Consultation Group looks into the problem of high hedges, especially x Cupressocyparis leylandii *which has become the subject of proposed legislation and the target of lobbies like Hedgeline*

Talented young horticulturist Tom Hart Dyke goes missing with his companion, merchant banker Paul Winder, while orchid hunting on the Panama-Colombia border

A man dies of gunshot wounds in a neighbours' dispute over a garden hedge

Index

Bibliography and Picture credits

BIBLIOGRAPHY

Brown, J. *The Pursuit of Paradise*, HarperCollins*Publishers*, 1999

Chatto, B. *The Dry Garden*, Dent, 1978

Chatto, B. *The Green Tapestry*, HarperCollinsPublishers, 1989

Davies, J. *The Wartime Kitchen and Garden*, BBC Books, 1993

Desmond, R. *Kew – The History of the Royal Botanic Gardens*, The Harvill Press with The Royal Botanic Gardens, Kew, 1995

Facciola, S. *Cornucopia – a source book of edible plants*, Kampong Publications, 1990

Fletcher, H.R. *The Story of the Royal Horticultural Society 1804-1968*, Oxford, 1968

Geddes-Brown, L. *Chelsea the Greatest Flower Show on Earth*, RHS/Dorling Kindersley, 2000

Goode, P., Jellicoe, G. & Lancaster, M. *The Oxford Companion to Gardens*, Oxford, 1986

Griffiths, M. & Huxley, A. (eds) *The New Royal Horticultural Society Dictionary of Gardening*, Macmillan, 1992

Griffiths, M. *The RHS Index of Garden Plants*, Macmillan, 1994

Hadfield, M., Harling, R. & Highton, L. *British Gardeners*, A. Zwemmer in association with Conde Nast Publications, 1980

Hillier Nurseries *The Hillier Manual of Trees and Shrubs*, David & Charles, 1991 (sixth edition)

HRH The Prince of Wales & Clover, C. *Highgrove – Portrait of an Estate*. Chapmans, 1993Huxley, A. *An Illustrated History of Gardening*, Paddington Press, 1978

Jarman, D. *Modern Nature*, Century, 1991

Jekyll, G. *A Gardener's Testament*, Antique Collectors' Club, 1982

Jencks, C. *Le Corbusier and the Tragic View of Architecture*, Penguin, 1973

Jencks, C. *The Architecture of the Jumping Universe*, Academy Editions, 1995

Kellaway, D. (ed) *The Virago Book of Women Gardeners*, Virago Press, 1995

Lacy A., *The Gardener's Eye and other essays*, The Atlantic Monthly Press, 1992

Lancaster, R. *Travels in China - A Plantman's Paradise*, Antique Collectors' Club, 1989

Mabberley, D. *The Plant Book*, Cambridge, 1987

Robinson, W. *The English Flower Garden*, Hamlyn, 1985 (reprinting of 15th ed. of 1933)

Sclater, A. (ed) *The National Botanic Garden of Wales*, HarperCollins*Publishers*, 2000

Smit, T. *The Lost Gardens of Heligan*, Victor Gollancz, 1997

Strong, R. *A Celebration of Gardens*, HarperCollins*Publishers*, 1991

Taylor, P. *Gardens of France*, Mitchell Beazley, 1998

Thomas, G.S. *Gardens of the National Trust*, The National Trust/Weidenfeld and Nicolson, 1979